GIFTS OF THE SPIRIT

Works by Nineteenth-Century

&

Contemporary Native American Artists

GIFTS OF THE SPIRIT

Works by Nineteenth-Century

Contemporary Native American Artists

FOREWORD BY

Dan L. Monroe

EXHIBITION CURATORS

Dan L. Monroe

Richard Conn

Richard W. Hill Sr.

Suzan Shown Harjo

John R. Grimes

AN EXHIBITION AT THE PEABODY ESSEX MUSEUM, SALEM, MASSACHUSETTS
14 NOVEMBER 1996 THROUGH 18 MAY 1997

The cover image
is taken from the painting
entitled *Dream of Ancient Life*
by Dan V. Lomahaftewa and
is reproduced on pages 210 and 229
(oil on canvas).

The *Peabody Essex Museum Collections*
is an annual book series
published by the
Peabody Essex Museum in
Salem, Massachusetts.

Gifts of the Spirit:
*Works by Nineteenth-Century
and Contemporary Native American Artists*
is volume 132 in the series and
carries the
ISBN number 0-88389-110-7
(copyrighted in 1996 by the
Peabody Essex Museum).

This book was designed by
Nélida Nassar of Nassar Design of
Boston, Massachusetts,
in Minion and Houghton typefaces.

It was printed by
Acme Printing of
Wilmington, Massachusetts,
and bound by Acme Bookbinding of
Charlestown, Massachusetts.

Inquiries concerning this volume
should be directed to the Editor,
Peabody Essex Museum Collections,
East India Square,
Salem, Massachusetts 01970.

All photographs,
unless otherwise specified, are those
of the Peabody Essex Museum.

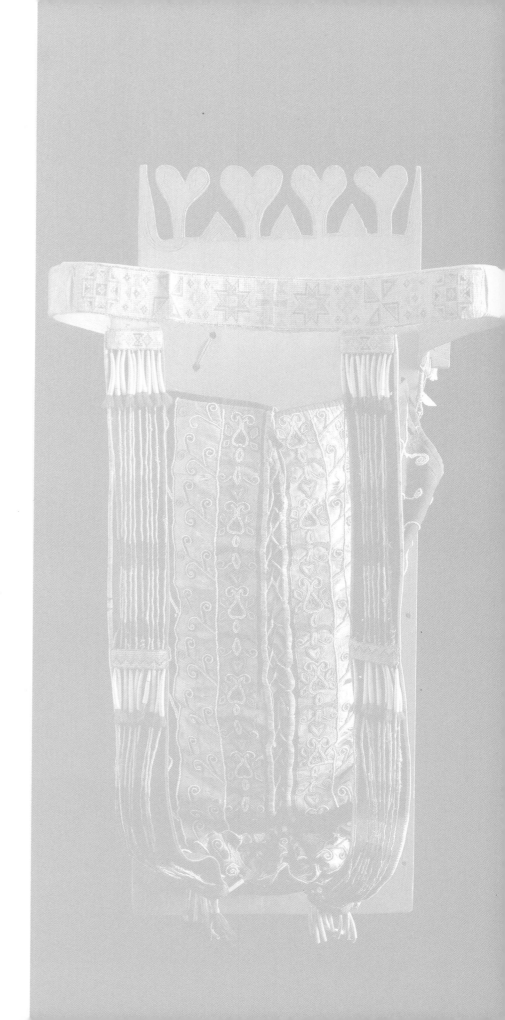

Dan L. Monroe, Executive Director and Chief Executive Officer, Peabody Essex Museum

Gifts of the Spirit celebrates the artistic inspiration and creativity of Native American artists. The idea for the exhibition was born with the discovery of the Peabody Essex Museum's exceptional Native American art collection. Hidden for decades in boxes and cabinets, the collection, until recently, had never been carefully examined or researched. After constructing new, high-quality storage for the collection, it was possible, for the first time, to evaluate its scope and significance. We discovered, to quote Richard Conn, one of the guest curators of the exhibition, "an embarrassment of riches." The collection contains scores of masterworks, many of which are among the oldest, finest, and rarest of their kind. The collection is also distinctive because, unlike many Native American art collections, it is generally well documented.

Gifts of the Spirit was organized by five co-curators, each of whom brought a different perspective and background to the project and to the understanding of Native American art, culture, and history. This approach to organizing an exhibition carries many risks and potential liabilities. We accepted these in order to bring a far richer body of knowledge and set of viewpoints to bear on Native American art than any individual could provide alone. As expected, we discovered substantial differences among our ideas, values, and outlooks. We also discovered shared views, and it is this common ground around which the exhibition is organized.

By presenting nineteenth-century works, drawn entirely from the Peabody Essex Museum collection, along with a selection of works created by contemporary artists who are Native Americans, we sought to provide a relatively rare opportunity for viewers to discover both continuity and change in the artistic vision and expression of Native American art and artists. Too often, people have the impression that Native American art came to an end in the nineteenth century. No attempt has been made, however, to provide a comprehensive overview of nineteenth- and twentieth-century Native American art; that is a task far beyond the scope of this exhibition.

Aesthetic value was the primary criterion for the selection of 150 works of art from among the more than twenty thousand in the museum's Native American art collection. Contemporary artists were chosen on the basis of the quality of their work and its relationship to objects selected from the Peabody Essex Museum collection.

Wherever possible, we have identified individual Native American artists. In all instances, we recognize that art was made by an individual. Identifying individual artists from the nineteenth century, or earlier, is often impossible. Most historical Native American art was collected in the nineteenth and early twentieth centuries as ethnological specimens, not as works of art. The names of individual artists were usually considered as incidental and far less important than the tribal affiliation of the artist and the functional use of a work of art. This collecting practice, grounded in nineteenth- and early twentieth-century ideas, unfortunately continues to conceal the individual artists and creates the mistaken notion that Native American art is, somehow, a tribal enterprise. We hope, at the very least, to underscore the lost identity and integrity of individual artists caused by this practice.

Rather than advancing a set of didactic ideas about Native American art, which encompasses the work of thousands of artists working in hundreds of distinctly different cultures over thousands of years, we wish to emphasize the integrity of individual works and to provide opportunities for viewers to discover relationships among them.

Finally, in keeping with the Peabody Essex Museum's mission as a museum of art and culture, we have tried to provide artistic, historical, and cultural vantage points on Native American art in the essays included in this publication.

In the end, individual works of art are the focus of this exhibition. If viewers discover in the exhibition or the publication but a fraction of the extraordinarily rich, diverse, and complex artistic spirit and expression that characterize the work of Native American artists, then we will be satisfied that this effort has fulfilled our hopes.

This has been a complicated and challenging project. We are deeply indebted to Richard Conn, Suzan Shown Harjo, and Richard Hill, our guest curators. Without their courage and patience in undertaking an unusual collaborative effort and their extraordinary knowledge, commitment, and enthusiasm, neither the exhibition nor the publication would have been possible.

We especially recognize and appreciate the tremendous generosity and enthusiasm of the contemporary artists who have participated in the creation of the exhibition and this publication. They continue a long tradition of artistic innovation that expresses the individual and col-

lective experience of Native Americans. We thank Marcus Amerman, Arthur Amiotte, Delmar Boni, David P. Bradley, Barry Coffin, Steven Deo, Anita Fields, Harry Fonseca, Laura Fragua, Richard Glazer-Danay, John Gonzales, Clancy Gray, Bob Haozous, Linda Haukaas, Tom Haukaas, Hachivi Edgar Heap of Birds, Valjean McCarty Hessing, John Jay Hoover, Conrad House, Tom Huff, Jerry Ingram, Alex Janvier, Tony Jojola, Jean LaMarr, Dan V. Lomahaftewa, Truman Lowe, Judith Lowry, Jack Malotte, Teresa MacPhee Marshall, George Morrison, Norval Morrisseau, Shelley Niro, Marvin Oliver, Martin Red Bear, Diego Romero, Mateo Romero, Frank Sheridan, Bently Spang, Susan Stewart, Don Tenoso, Brian Tripp, Lonnie Vigil, Denise Wallace, Lutz Whitebird, and Richard Ray Whitman for so willingly lending, and in some instances creating, works for *Gifts of the Spirit*.

Several institutions and individuals graciously and generously supported *Gifts of the Spirit* by lending contemporary art. We thank the Bartlesville Community Center, Bartlesville, Oklahoma, Allen Longacre, director; the Canadian Museum of Contemporary Photography, Ottawa, Ontario, Sue Lagasi, registrar; the Denver Art Museum, Lewis Sharp, director, Nancy Blomberg, curator of Native American art, Michele Assaf, registrar, and Cynthia Nakamura, coordinator of photography; the Heard Museum, Phoenix, Dr. Martin Sullivan, director, and Martin Pearce-Moses, archivist; the Indian Art Centre, Hull, Quebec, Barry Ace, acting manager; the Institute of American Indian Arts, Santa Fe, Fred Nahwooksy, director, Charles Dailey, interim director, and Eunice Kahn, collections manager; the Oakland Museum, Dennis Power, executive director, and Arthur Monroe, registrar; and the School of American Research, Santa Fe, Dr. Douglas W. Schwartz, president, and Christy Sturm, coordinator of photography, for their assistance.

We also wish to thank John Caltagirone, the Harjo family, Rick Ximenes (agent for Dan V. Lomahaftewa), and two anonymous individuals for loaning works to the exhibition.

The organization of an exhibition and the creation of a publication involve many staff members at the Peabody Essex Museum. Very special, and heartfelt, thanks are due to Fred Johnson, exhibition designer; Mike Gaudet, Dat Truong, and Garrick Manninen, exhibition installers; Will La Moy, publication editor and production manager; Jane Ward, assistant publication editor; Peggy Dorsey, manuscript editor; Lucy But-

ler, registrar; Mark Sexton, Jeff Dykes, and John Koza, photographers; Kathy Flynn, coordinator of photography; Connie Wood, Dorothy Chen-Courtin, and Gloria Sax, public relations staff; Peter Fetchko, director of curatorial operations; Jim Forbes, Beth Grimes, Janet Halpin, Becky Putnam, David Buchanan, Deborah Wetmore, Chris McDermott, and Irene Curran, development staff; Rick Guttenberg, Ellen Soares, Marianne McDermott, Daisy Nell Means, and Jennifer Evans, education staff; Christy Sorenson, multimedia technician; Anna Geraghty and Toshi Miyamura, designers of the associated printed material; Will Phippen, conservator; and Carol O'Connell, assistant to the director. Only through their unflagging patience, talent, dedication, and especially strong teamwork, along with that of many other staff, has the project come to fruition.

The Peabody Essex Museum is blessed with extraordinary volunteers who contribute long hours, hard work, creative ideas, and plain good cheer to projects such as this one. I thank Mitch and Jim Krebs, Susanna Weld, Jean Fallon, Catherine Wygant Monroe, and Stephanie Loo Ritari for their guidance and help.

John Grimes, curator of Native American art and archaeology, and Karen Kramer, project coordinator, warrant more thanks than I can ever offer for their tremendous contributions in making *Gifts of the Spirit* a reality. Wearing two hats throughout this project as coordinating curator for the exhibition and as deputy director for facilities expansion, John has freely given exceptional insight, patience, and untold hours to the exhibition and publication. Karen Kramer held the center together with consummate skill and grace throughout the project.

The trustees and overseers of the Peabody Essex Museum have lent enthusiasm, encouragement, and support, which we deeply appreciate.

Gifts of the Spirit has been made possible, in part, by grants from the National Endowment for the Arts, the Massachusetts Foundation for the Humanities, the Massachusetts Cultural Council, The Rockefeller Foundation, the Boston Safe Deposit & Trust Company as trustee of the Alice P. Chase Trust, and the Hurdle Hill Foundation. We must also thank Tim Mangini and WGBH for the loan of audio and video equipment that helped to complete a multimedia component of the exhibition, and Philip Clendaniel for the expertise he contributed towards the development of the multimedia kiosks associated with the exhibition.

Native American Art and American History

Native American art represents and reflects more than ten thousand years of artistic expression created by thousands of individual artists. When Columbus landed in the Caribbean in 1492, more than five hundred cultures occupied the Americas, from the Arctic to the tip of South America. The population of the Americas probably exceeded fifty million people.[1] These peoples had occupied the Americas for at least twelve thousand years. By 1492, entire civilizations had emerged, built cities featuring some of the world's greatest monumental architecture, and then disappeared.[2] When Hernán Cortés captured and destroyed Tenochtitlán, the Aztec capital, early in the sixteenth century, it had a larger population than London or Paris. Prior to European contact, a lively, long-distance trade of goods, values, and artistic ideas existed among Native American cultures: "People who worshipped different gods, inhabited different worlds, and were sometimes unaware of one another's existence were linked together nonetheless: buffalo robes warmed people who had never seen a buffalo; cornmeal was eaten by people who had never planted corn; and ocean shells decorated the clothing of people who lived a thousand miles from the sea."[3]

The arrival of Columbus and successive migrations of people from Europe changed everything for Native Americans. The single most significant impact on Native peoples was unintention-al: the spead of European diseases to people who had little or no immunity to them. Within 150 years of Columbus's arrival, up to ninety percent of the indigenous population in the Americas was dead, killed by diseases that rapidly spread throughout the Americas. This massive devastation, among the largest in scale in human history, preceded most of the colonization of North America, and dramatically changed Native American cultures before many Native people ever saw a White person.[4]

To Europeans, the Americas represented un-dreamed of opportunities. A Spanish conquistador neatly summed up European interest in the Americas when he said, "We came here to serve God and his Majesty, to give light to those who were in the darkness and to get rich, as men desire to do."[5]

To acquire these riches, Europeans had to take land and resources from Native peoples. Ultimately, force or the threat of it and displacement of people from their homelands proved the most effective ways to accomplish this end. Taking land by force, chicanery, displacement, or murder raised ethical and legal questions for European colonists. From the initial point of contact to the present, some found it difficult to ignore or rationalize the injustices in the treatment of Native peoples. Bartolomé de las Casas, a Spanish priest, condemned and publicized atrocities committed by his countrymen. Roger Williams

Dan L. Monroe, Executive Director and Chief Executive Officer, Peabody Essex Museum

was expelled from the Massachusetts Bay Colony in part for opposing the Puritans' seizing of Native American lands.

Although Europeans would not have survived in the Americas without assistance from Native peoples, soon after their arrival, they categorized Native Americans as heathens and savages. John Smith and Samuel Purchas characterized Native people as "cruell beasts."[6] Most Americans subscribed to the characterization of Native people as savages or primitives, in one form or another, well into the twentieth century. At the same time, many Americans admired Native American independence and knowledge of the land. Conflicting viewpoints about Native people and cultures have, therefore, long been a part of the American experience. General Philip H. Sheridan, who remarked that "The only good Indians I ever saw were dead," represented one popular nineteenth-century perspective. Other Whites saw Native people as noble examples of humanity untainted by the corrupting influences of civilization. Regardless of individual viewpoints, it was necessary for European nations, and later for Americans, to justify their actions towards indigenous peoples. Their justifications shaped politics, culture, history, and public perceptions of all things Native American, including art. These rationalizations continue to influence the way we see Native Americans and their art today. By briefly examining some of these ideas and

some of the outcomes they have helped to create, it is possible to correct some old misconceptions and arrive at a richer understanding and appreciation of Native American art.

The Spanish pursued the simplest justification for their actions, which included widespread atrocities in Central and South America and California, by simply denying that Native Americans were human. Bartolomé de las Casas and others forced the crown and the pope to reject this stand and to recognize the humanity of Native Americans. The Spanish and other Europeans then adopted the position that the primary reason for taking Native American lands was to save souls. Since many Native peoples refused to convert voluntarily to Christianity, seizing their lands and destroying their cultures proved the only way to bring them to the true path.

Samuel Purchas argued that God intended the land to be cultivated rather than left in the hands of savages who simply ranged through it while hunting, rather than using it for agriculture. He concluded that European settlers deserved title to Native-owned or controlled land as a "wage" for converting the "Savage Countries" to God's intended purposes.

The Puritans developed similar lines of reasoning, once humorously characterized as follows: "Voted, that the earth is the Lord's and the fullness thereof; voted, that the earth is given to the Saints; voted, that we are the Saints."[7] Since the

Puritans were among God's chosen people, and since they needed land controlled by Native peoples, it followed that in taking this land they were fulfilling God's will. The popular doctrine of manifest destiny similarly claimed that it was God's will for America to expand from coast to coast, spreading civilization as it did so. Of course, Native Americans who remained obstacles to this inevitable outcome would, unfortunately, be swept aside by the tide of history.

Other rationales were "scientifically" based. Social Darwinists, operating loosely on ideas advanced in Darwin's *On the Origin of Species* published in 1859, argued that cultures and races compete for limited natural resources, and ultimately the fittest win. The less well-equipped either adjust to their lower status or are doomed to extinction. The Social Darwinists, and those who embraced their ideas, held that Native Americans were obviously less well-adapted than Whites and were thus doomed to full assimilation or extermination.

These and other conceptions about Native people and cultures, born of the need to justify the taking of lands and the extermination or forced displacement of Native peoples, resulted in a general denigration of Native American people and cultures. Inevitably, this devaluation affected perceptions of Native American art.

Nothing made by Native people was recognized as art until well into the twentieth century. Europeans and Americans believed that only their painting and sculpture, plus the work of their cultural predecessors, the ancient Greeks and Romans, constituted fine art. All other people and cultures merely produced curiosities, or curios as they came to be known. The attitude towards Native Americans created by the history of Indian-White relations continues to affect many people's understanding of Native American art today, often in ways they do not consciously recognize.

For example, very few historical objects of Native American art are associated with an individual artist. Instead, objects are usually identified by tribe. This is true for most of the historical objects in this exhibition and for the vast majority of Native American art seen in museums and galleries. Most collections of Native American art consist of nineteenth- and early twentieth-century objects. Since the collectors

and curators responsible for these collections did not consider the objects works of art but rather ethnological specimens, there was no compelling reason to try to link the art to an artist. It simply did not matter who made an artifact so long as it helped to document a culture or way of life. Thus, it was entirely satisfactory to note that an object was associated with a certain tribe, that it was created at a particular time, and that it was used for this or that purpose. The historical failure—and present inability—to link Native American art with its creators not only reflects our past; it perpetuates the deindividualization of Native American art and artists. All objects become tribal, rather than the work of individual artists.[8]

Native American art is also often presented and interpreted in very different ways than European or American art. It is not uncommon for exhibitions of Native American art to feature a significantly greater number of objects per square meter of exhibit space than is used to display three-dimensional Euro-American works of equivalent size. Interpretive labels often emphasize the function of the objects, rather than their aesthetic qualities, whether they are evaluated from a Euro-American or a tribal perspective. Frequently, historical works of art from various tribes in one geographical area are shown together, thereby implying a regional cohesion that may not exist. Large murals, usually made from nineteenth-century photographs, are often used to provide "context" for the objects. If these same methods were used to present an exhibition of Impressionist art, we would see large photographic murals of scenes in Paris or Provence located near the paintings. Artworks would be organized by geographic areas. A Monet painting of a haystack might be identified as "Oil Painting, French, late nineteenth century." The interpretive labels might state that these objects were principally made to decorate European or American homes, often as a sign of the elevated social standing of the owner. These same differences in exhibition design also apply to other non-Western art. Few people would be pleased to see their artistic heritage presented in the ways Native American and other forms of "ethnic" art have been.

Other differences in the way Native American art is portrayed are less subtle. Several of this

country's finest collections of Native American art are housed in exhibition halls that would not be tolerated for the presentation of European or American art. Thus, the way Native American and other non-Western art is presented conveys several messages that, taken together, place lower significance and value on Native American art than on Euro-American art.

Another important consequence of the history of Indian-White relations is the location of most Native American art collections. The vast majority of these collections reside not in art museums, but rather in natural history or ethnology museums. During the nineteenth century and well into the twentieth, Native American art and cultures were categorized as "primitive" and studied in the context of natural history or ethnology. At the time most historical collections of Native American art were formed, some people even questioned their value as ethnological specimens. Frederick Ward Putnam, a leading nineteenth-century ethnologist and director of the Peabody Museum of Ethnology at Harvard, had to justify his acquisition of such "specimens" to the local elite, many of whom questioned the "worthiness" of primitive cultures and postulated their "lack of artistic qualities." Putnam countered that he was involved in science, not art.[9]

The museum world still maintains dividing lines between art, natural history, and ethnology. Thus, most Native American art collections remain in institutions dedicated to science, where most curators feel uncomfortable dealing with Native American objects as works of art rather than as illustrations of culture. The result has been a tendency to isolate historical Native American art from other forms of world art as well as from modern and contemporary Native American art. While these circumstances survive as a residue of the history of Indian-White relations, they nonetheless tend to diminish Native American art as art and make it difficult for the public to see the line of continuity and connection among historical, modern, and contemporary Native American art. Although ideas and institutions are changing, it will likely be a considerable time before significant numbers of people will be capable of seeing masterworks of Native American art as the equal of the iconic works of European or American art.

Native American Art and Ethnology

Anthropologists and ethnologists have had a tremendous influence on the way we see and understand Native American art. They helped to collect and preserve millions of Native American objects, they documented Native American cultures, and some among them have been strong advocates for Native people. They have also been among the primary interpreters of Native American art and cultures. The relationship between these collectors and interpreters, on the one hand, and Native people on the other, has been complex. The early practice of collecting Native remains along with funerary goods without permission caused deep emotional scars. Until the last decade or so, it was not uncommon to see Native American human remains publicly exhibited. Many Native people objected to being the subjects of anthropological studies; such scrutiny underscored the inequalities in the relationship between Whites and Native Americans. Finally, there is often a gulf between the way scientists see Native American cultures and the way Native people see their traditions.

One of the defining notions about Native American art has its origins in these fields of professional study. Formed in the nineteenth century, this concept has become ingrained in most people's minds and has had negative consequences for Native American art. The idea is deceptively simple: Native Americans produce works of art that essentially replicate styles, materials, and methods that have been passed down, largely unchanged, from generation to generation from time immemorial. Such art is referred to as "traditional" Native American art, and it is often assumed to represent Native American cultures in some pure and ancient form.

During the period between 1880 and 1930, museums and universities collected millions of Native American objects. Most were acquired to illustrate the various stages of development through which societies were presumed to move, culminating in Euro-American culture, which was assumed to occupy the pinnacle of human achievement. The concept of this cultural evolution was first developed by Lewis Henry Morgan, one of the founders of ethnology; he commented that "it is undeniable that portions of the human family have existed in a state of sav-

agery, other portions in a state of barbarism, and still other portions in a state of civilization. . . . it seems equally so that these three distinct conditions are connected with each other in a natural as well as necessary sequence of progress."[10] This idea informed ethnological thinking and practices well into the twentieth century.

This vision of cultural development in combination with what became known as the "vanishing Red man" theory helped to inculcate the notion of "traditional" Native American art. The vanishing Red man theory held that Native Americans were doomed to extinction by the onslaught of civilization. Scientists, policymakers, and the public accepted this concept throughout the last third of the nineteenth century.

There were and are serious flaws in the belief in a linear, hierarchical development of culture from savagery to civilization. The vanishing Red man theory was, on the other hand, credible. By the end of the nineteenth century, Native Americans everywhere were falling before the scythes of disease, warfare, and forced displacement from homelands. The massacre of more than two hundred men, women, and children at Wounded Knee, South Dakota, in 1890 marked the end of military conflict and the beginning of reservation life for nearly all Native Americans, except for those in Alaska. The Native American population in the United States had declined from perhaps twelve million in 1492 to two hundred thousand by 1900. The government was forcefully implementing policies aimed at eradicating Native American cultures and religions, to the point of making their practice a criminal offense. Native children were required to attend boarding schools far from their homes so that they might become "civilized." (The contemporary work in this exhibition entitled *The Indoctrination* by Steven Deo, a Muscogee/Yuchi artist, comments on the trauma of the boarding school experience for large numbers of Native American children [pages 162 and 184].) It was, in short, entirely reasonable at the end of the nineteenth century to assume that Native American cultures—and very likely Native American people themselves—might soon disappear entirely. These conditions stimulated ethnologists and anthropologists to collect and study objects and information related to "traditional" Native American cultures before

they vanished. By "traditional," most ethnologists and anthropologists meant cultures as they existed prior to the influence of Whites.

There are, of course, deep flaws in the notion that any culture can remain static and unchanging over vast periods of time. In fact, most Native American cultures existed in a state of constant flux. Plains Indian culture did not, for example, exist until tribes that had lived on the periphery of the plains acquired horses in the 1700s. Plains cultures emerged, flourished, and largely disappeared within a period of two hundred years. It is impossible to reconcile this fact with the idea that Native American cultures and art existed, largely unchanged, for thousands of years. Also, by the time ethnologists and anthropologists began to collect Native American objects systematically, most Native American cultures had long had contact with Whites and had adopted a wide variety of Western technologies, materials, and even values.

What caused ethnologists and anthropologists to overlook these obvious facts? Most likely, it was competition and the need to raise funds to carry out fieldwork, acquisitions, exhibitions, and publications. Competition to acquire Native American objects among individual scientists and institutions was intense, especially during the period from 1880 to 1930. These activities were expensive; not even the largest institutions could afford to engage in such endeavors without private or governmental support. To obtain this funding, scientists had to devise compelling case statements, and they arrived at one that was nearly universally employed because it was exceedingly successful. The basic rationale was that Native American cultures represented the primitive stages of culture that preceded civilization. Society necessarily had much to learn about Western prehistory by studying primitive Native American religions, cultures, and social systems that had existed for hundreds or thousands of years. Scientists argued that, because these cultures were bound for extinction due to the inexorable advance of civilization, a concerted effort had to be made to acquire objects and other documentation before these cultures vanished forever.

This primary theme, with its variations, generated millions of dollars from private and public sources. Anyone who seriously questioned its

basic assumptions would jeopardize the desperately needed financial support. Privately, many ethnologists complained about the difficulty they had in finding truly "authentic," or "traditional" objects since so many of these reflected the influence of White culture or that of some other Native American group.

There are several problems inherent in the notion of "traditional" Native American art. As previously noted, many Native American cultures are remarkable, not for their unchanging values, lifestyles, and beliefs, but rather for the remarkable speed with which they embraced innovations, both material and conceptual. Nearly all tribes readily adopted ideas, materials, or technologies from Whites or from other Native peoples that they perceived as useful. With few exceptions, Native American art reflects this extraordinary adaptability. The evidence for this is overwhelming, both before and after the first points of contact. Native people had, after all, established and maintained vast trading networks for thousands of years.

This is not to suggest that Native people or cultures were completely malleable. They made heroic efforts to resist intrusions they perceived as harmful to themselves or their cultures. Yet, had Native peoples and their cultures not been able to respond to drastically altered conditions, they would have ceased to exist.

Viewed from this perspective, we should expect to find many examples of Native American art that reflect changes in styles, materials, and methods. The beautifully carved argillite feast dish made by Tom Price, a nineteenth-century Haida artist, illustrates the impact of new tools on Native American art (pages 102 and 122). The Haida live at the extreme southern end of southeastern Alaska and on Queen Charlotte Island in British Columbia. By 1888, when this feast dish was made, the Haida had long been creating objects to sell to traders. Almost certainly, this feast dish was made for this export trade. The Haida began carving argillite for these traders, many of them from New England, when they came to the Pacific Northwest in search of sea otter furs early in the nineteenth century. As a result of these circumstances, some Haida were among the first Native Americans to become full-time artists. Newly acquired metal tools from this trade enabled them to produce their extraordinary carvings in much greater quantities and with greater speed and precision than ever before. While this beautiful argillite dish features an expressly Northwest Coast design and the sea monster it depicts is drawn from Haida culture, many argillite carvings from this period feature Western images. It is doubtful that the Haida produced argillite feast dishes like this one before the sea otter trade created a market for their work.

The Dakota quillwork cradle created early in the nineteenth century is likewise an extraordinary work (pages 94 and 97). Notice, however, that it makes use of metal that was no doubt acquired through trade with Whites or with other tribes. Metal was not commonly used by North American tribes prior to the establishment of trade with Whites. Yet, it is incorporated into innumerable works of Native American art, and, clearly, its use did not reflect artistic traditions that were many generations old.

The Crow quiver and bow case from the mid-nineteenth century incorporate red wool and glass beads, both of which were acquired through trading (page 107). Glass beads, almost universally associated with Native American art, were quickly adopted by tribes as soon as they became available. In many tribes, beads replaced or supplemented porcupine quills. New artistic elements were developed in response to the design opportunities made possible by beads. Some tribes readily adopted styles obviously obtained from Whites; for example, some of the floral patterns found on beadwork derive from European costumes or craftwork.

The abstract and elegant Dakota bird flute made before 1850 conveys the essence of the bird it depicts with a deceptively sophisticated simplicity that predates by a half-century or more similar work by Constantin Brancusi and others (pages 129 and 138). The eye is a small piece of brass, which again could only have been obtained through trading; it was certainly not a traditional material. The rare nineteenth-century Aleut hat is among the finest of its kind (pages 130 and 146). The beads on it were very likely acquired from Russians who, beginning in the late eighteenth century, enslaved the Aleut population and put them to work capturing sea otters for the China trade. Again, the Aleuts readily adopted the beads provided by the Russians and

incorporated them into the design of a hat that was probably made for trade or sale rather than for daily or ceremonial use.

Numerous other examples could be cited, including instances of artistic styles as well as materials, tools, or methods, being transferred from one tribe to another or from White traders to various tribes. Thus, it is highly questionable to claim that Native American artistic traditions existed and were practiced almost unchanged over many centuries. While Native American artists worked within artistic traditions, just as artists from other cultures did, they maintained a flexibility that belies the notion of a "traditional" Native American art.

The belief in "traditional" Native American art has several negative consequences. It reinforces the erroneous idea that Native Americans unimaginatively reproduced certain forms of art generation after generation. It also tends to freeze Native American artistic expression in the nineteenth century since most "traditional" Native American art was made and collected in this period. This, in turn, limits people's awareness and appreciation of the dynamic changes and developments in Native American artistic expression. While creating or recreating "traditional" Native American art provides some important economic benefits to Native American artists, it may also limit artistic exploration and expression by encouraging many artists to produce what are essentially replicas of historical pieces.

The idea of "traditional" Native American art also creates some strange classifications for contemporary Native American artists. Some Native American artists produce "traditional" work and some do not. Those who do not produce "traditional" Native American art because they use styles, materials, or methods that were not employed in the nineteenth or early twentieth centuries, are often described as "nontraditional, contemporary" Native American artists—as opposed to "traditional, contemporary" Native American artists. All Native American artists are classified by ethnic category, although we do not typically classify White American artists as "White American contemporary artists." Many of the contemporary artists represented in this exhibition have commented upon the strange position these various classifications impose on

them, in large part because the notion of "traditional" Native American art seems to be incompatible with the continuum of artistic development that is widely attributed to European and American art.

Just as it is most productive to look at various developments in European and American art in relation to each other and to the times in which they occurred, so it is most appropriate to assume this same approach for Native American art. Historical Native American art responded to the needs of the artist and the conditions and circumstances of his or her culture. Contemporary Native American art does the same. Since conditions and circumstances are subject to dramatic change, there are sometimes huge shifts in historical, modern, and contemporary Native American art. Yet, there are underlying ideas, values, and themes—and sometimes even styles, methods, and materials—that link them together. Richard Glazer-Danay's *Bingo War Bonnet* (pages 100 and 109) is, for example, directly related to earlier Hodenosaunee artistic expressions, as illustrated by the late nineteenth-century embroidered cap. By looking at such works anew, it is possible to see many connections of this sort among historical, modern, and contemporary works of Native American art. Rick Hill, one of the co-curators of this exhibition, concisely responded to the stereotype of "traditional" Native American art with the title he selected for another show: *Creativity Is Our Tradition.*

Native American Art and Art History
Near the turn of the century, Franz Boas and a handful of other ethnologists advanced the radical idea that Native American art was art rather than curiosities or craftwork. The idea seemed absurd to most people since Native American art did not use the canons or materials of Western art. It took forty years for the concept to take hold.

John Sloan, the well-known American artist, and Oliver La Farge, an anthropologist and writer, organized the *Exposition of Indian Tribal Art* in New York in 1931. This was the first show to present Native American art as art. Although modestly successful, the show did not attract much national attention. A later exhibition, *Indian Art of the United States,* presented in 1941 at the Museum of Modern Art, for the first time

firmly established the idea that Native American art is art. René d'Harnoncourt, who eventually became director of the museum, organized, designed, and promoted this exhibition—with spectacular results. The exhibition (and its companion publication coauthored by d'Harnoncourt and Frederic H. Douglas) drew record crowds and generated a tremendous amount of national and international press attention. Presented in bold, new installations that treated the objects exhibited as works of art rather than as ethnological specimens and brilliantly promoted, the exhibition gave new status and credibility to Native American art and, in so doing, helped to create the modern Indian art market.

While *Indian Art of the United States* firmly established Native American art as art, it continued to be conceived of as "primitive art." Art historians defined and used the term "primitive art" in a technical and fairly neutral way.[11] Few people knew or used the technical term, however, and it became politically undesirable to continue its use because of the negative connotations. Now it is common to refer to Native American art as "ethnic" or "tribal" art, but these designations have their own inherent problems. All people belong to one ethnic group or another; by this standard, all artists are ethnic artists. Tribes do not make art; individuals do. Given the dictionary definition of "tribe," White American artists constitute a tribe since they share a more or less common culture.

It is perhaps time to recognize that all cultures produce art and that there is little merit in attempting to classify art in ways that connote the intrinsic superiority of one culture's art over that of another. Having said this, it is also fair to acknowledge that there are differences as well as similarities between Euro-American and Native American art.

Prior to reservation days, art was a central and vital part of the life of nearly every Native American, regardless of tribal affiliation. Virtually all Native people made objects for personal or ceremonial use, and aesthetic considerations were essential in the creation of most of these objects. Art was so entirely integrated into everyday life that there was no term for it as a distinct and separate entity or enterprise in any Native American language. In all but a few instances, making any object meant incorporating art into

it. Some individuals were recognized as having exceptional artistic talent, and they were sometimes commissioned to create works, but in no tribe, before reservation life, did individuals rely on the making of art as their principal livelihood. Europeans and Americans had a class of people known as artists, but Native Americans did not.

Native people did not, prior to reservation days, look upon objects as works of art in the way that Europeans or Americans do. Created objects, of which art was an integral part, functioned in a fully integrated personal, social, and often spiritual context to a degree not common in European or American art. Native American art was not a commodity in the period before the reservations, although art has long been a commodity in European and American cultures.

Native American art, like European or American art, often employs special symbols, materials, or styles that convey powerful messages to those who share the artist's culture. Native American art, however, more commonly integrates visual, kinetic, and auditory elements than European or American art does. For example, the Chilkat blanket featured in the exhibition was designed to be viewed by firelight while kept in motion by a dancer (pages 94 and 99).

While there are some clear, if not self-evident, differences between Native American and Euro-American art, others that have been suggested are less clear. Some scholars and writers have maintained that historical Native American art involved the application of decorative designs to functional objects, thereby differentiating it from European or American art, which was made to provide an aesthetic experience rather than to perform a function. This assertion is not very persuasive. In historical Native American art, the aesthetic elements of an object were usually central to its value and meaning, rather than mere decorative embellishments. The fact that almost all historical Native American art was associated with other functions does not differentiate it from a great deal of Euro-American art. The latter also often has social, political, or religious purposes.

There is a tendency to emphasize the influence of Euro-American art upon Native American art, especially since 1900. Many modern and contemporary Native American artists have

freely adopted European and American artistic traditions. Less well known is the fact that many European and American artists have been greatly affected by Native American art, among them Max Ernst, John Sloan, Marsden Hartley, Adolf Gottlieb, and Jackson Pollack, to name but a few.

While many differences and similarities among artistic traditions may be explored, the new art history has increasingly recognized that there is no intrinsic superiority in artistic expression. During the nineteenth and twentieth centuries, as peoples and cultures became increasingly interconnected, artistic traditions were traded and adapted in ever widening ways. As we near the end of this century, and as we increasingly drop assumptions of artistic and cultural hierarchies and more fully appreciate the rich diversity of human artistic expression, a debate has arisen as to whether or not it is truly possible to transcend our cultural bounds to comprehend artistic traditions that are different from our own.

Two extreme views have been advanced. Some ethnologists have argued that this is impossible, while art historians assert that art has intrinsic values that supersede cultural limitations and that these can be read by all human beings. It is possible, for example, to appreciate the objects in this exhibition purely on the basis of aesthetic force and merit. If one understands the history of the artist and the tribe, the period in which the object was made, and the purposes and meanings the work has to people of that culture, the experience will be far richer. Of course, the same observations may be made about Italian Renaissance art.

Native American art presents significant challenges to viewers because these cultures are so diverse. Nonetheless, by discarding some of the old ways of viewing and describing Native American art, we can, instead, see it for what it is: a rich, extraordinarily varied, and sophisticated artistic tradition that is the equal of any other culture's artistic expression.

New ideas and approaches in ethnology, anthropology, and art history—and recently new sympathies towards and understanding of the Native American experience—have begun to produce new and richer ways of seeing Native American art and artists. There are connections between the nine-thousand-year-old spear point included in this exhibition (which demonstrates a careful attention to design and symmetry far transcending any functional requirement) and other historical and contemporary works of Native American art. There are also fascinating relationships between European, American, and Native American art to be investigated. Above all, Native American art reflects a continuum of cultural and artistic change over several thousand years. It is a truly American form with deep roots in our physical, political, social, and cultural landscape. Artists who are Native Americans continue to express themselves while coexisting in two cultures and simultaneously preserving key elements of their own unique cultural traditions, but their work, whether contemporary or from the distant past, is ultimately directed to all of us.

1.

FRANCIS JENNINGS

The Invasion of America: Indians, Colonialism, and the Cant of Conquest (New York: W. W. Norton, 1975). Until the last half of the twentieth century, population estimates for the Americas prior to and immediately following European conquest were extraordinarily low. Most likely, these estimates were made to help justify conquest and colonialism.

2.

ROGER KENNEDY

Hidden Cities: The Discovery and Loss of Ancient North American Civilization (New York: Free Press, 1994).

3.

GEOFFREY WARD

The West: An Illustrated History (Boston: Little, Brown and Company, 1996), 17.

4.

ALFRED W. CROSBY JR.

The Columbian Exchange: Biological and Cultural Consequences of 1492 (Westport, Conn.: Greenwood Press, 1973);

HENRY F. DOBYNS

Their Numbers Became Thinned: Native American Population Dynamics in North America (Knoxville, Tenn.: University of Tennessee Press, 1973);

ANN F. RAMENOFSKY

Vectors of Death: The Archaeology of European Contact (Albuquerque, N.Mex.: University of New Mexico Press, 1987); and

RUSSELL THORNTON

American Indian Holocaust and Survival: A Population History since 1492 (Norman, Okla.: University of Oklahoma Press, 1990).

5.

WARD

The West, 17.

6.

Travels and Works of Captain John Smith (New York, 1967?); Samuel Purchas, *Hakluytus Posthumus; or, Purchas His Pilgrimes* (London, 1625).

7.

GEORGE F. WILLISON

Saints and Strangers (London: W. Heinemann, [1946]).

8.

Interestingly, Native American people are able to identify the owners or makers of a surprising number of objects once they have access to collections.

9.

JANET CATHERINE BERLO

The Early Years of Native American Art History (Seattle, Wash.: University of Washington Press, 1992), 55.

10.

LEWIS HENRY MORGAN

Ancient Society; or, Researches in the Lines of Human Progess from Savagery, through Barbarism to Civilization (London: Macmillan, 1877).

11.

WILLIAM RUBIN, ED.

"Primitivism" in Twentieth-Century Art: Affinity of the Tribal and the Modern (New York: Museum of Modern Art, 1984).

Richard Conn, Chief Curator Emeritus, Denver Art Museum

Why Museums Exist and Why They Collect

The Peabody Essex Museum and similar institutions throughout this country have in common that their activities and purposes revolve around collecting designated materials and holding them for the benefit of present and future generations. This business of collecting is so central that, if one compared the mission statements of representative museums throughout the country, one would probably find a phrase something like "to gather, preserve, and interpret." The intent of these words reflects the general professional opinion that museums exist for their collections: to amass them, to conserve them with the requisite physical care in order to prolong their existence indefinitely, and to interpret them through exhibitions, publications, and all other appropriate means for the education and enjoyment of the public. Today, at the end of the twentieth century, the museum profession has become, of necessity, very imaginative in seeking out new ways to extend general awareness of their collections. Whether this is done via television, the classroom, organized tour and travel programs, collectors' groups, or the like, the basic association with the collections from museum to museum is still central.

Historically, museums have pursued every appropriate avenue to build their collections. At this point, the issue of inappropriate means may also be raised, bringing to mind controversial situations like those of the Elgin marbles in the British Museum or the Byzantine bronze horses in Venice. Such things have happened, and time does not always correct them. However, in the great majority of cases, museums have acquired their holdings in more prosaic and less questionable ways.

The basic means of collection growth are gifts, loans, purchases, and trades. Let us examine these briefly. Art and history museums have long relied principally on gifts and loans, usually from private sources. Many fine objects, which the museums would otherwise never have obtained, have come into their collections by these means. There is here a remarkable record of the generosity of many public-minded donors. The Peabody Essex Museum has been fortunate in having had such benefactors. A striking example would be Dr. Charles Goddard Weld, a local physician and surgeon who not only contributed substantially to the collections, but also provided funds for an important addition to the museum

20

building. Dr. Weld's interests in art and history were diverse, but he is especially remembered for his gifts of Japanese art.

However, gifts and loans are not always the complete answer to collection building. Often, when a new museum is struggling to grow and gain in importance, it will accept objects less selectively. Only later does it become evident that the museum has become the community's attic filled with a disorganized hodgepodge of unrelated material. Then comes the delicate job of deciding what to continue exhibiting, what to put in storage or return to the donors, and how to accomplish all this without lawsuits or ruffled feathers.

Another difficulty that may arise from relying too much on gifts and loans is that, although the donors and lenders may have been very generous, they may not have had the objects the museum needed the most. One often-applied solution here is for a museum to draw up a thoughtfully considered collecting plan that identifies exactly what it proposes to collect, and likewise those areas in which the museum chooses not to deal. Loans have their own intrinsic drawback in that they are always subject to potential withdrawal. Thus, most museums hesitate to give lent objects critical places in ongoing exhibitions unless a suitable replacement is at hand.

As art and history museums rely on gifts, science museums depend principally on collections made directly in the field by their own staff. Geologists, botanists, and other specialists go where the desired specimens are to be found and gather them. This method works well for the scientists because the precise information as to where and when something was collected is considered as important as the object itself. Art and history museums may occasionally engage in some field collecting, most often in the area of archaeological excavations. Their expeditions in search of artifacts generally take the form of gift solicitations.

Although one hears of museums paying fantastic sums for celebrated treasures, acquisition by purchase tends to be the exception and not the rule. For one thing, there is a tacit tradition in many American museums—especially those funded by tax dollars—that public funds are to be used for operations and salaries, but seldom or never to purchase materials for the collections. If it is decided that a public museum is

justified in buying something, the funding agency, be it federal, state, or municipal, will usually provide for this with a special appropriation. Another factor that limits purchases is that the market in some areas, most notably art, has risen so high that few museums can afford to compete. Those fabulous museum purchases one reads about are generally made possible because a donor or a foundation has given the museum the means to do so.

This leaves one further method for acquisition: trading. Simply put, a museum finds something it wants in another's collection, whether public or private. If the owner is willing to consider trading, negotiations begin and continue until both sides are satisfied. It may sound simple, but it is not. Trading of museum materials is somewhat like making the perfect marriage. One side may have found just what it wants, but may not be willing to give away what the other asks in return. Then there remains the official business of the transfer. Curators must write out detailed justifications for disposal and evaluations of the incoming materials. And, there is sure to be at least one review by senior staff and the museum's governing body.

By judicious application of all these means and with lots of luck and patience, museum collections do grow and increase in both monetary and intrinsic worth. It is a nerve-racking process requiring dedication and fortitude, but one that can provide delicious satisfaction when a treasure is located and successfully brought into the collections.

Over the years of its existence, the Peabody Essex Museum has been familiar with all these general methods of acquiring material, and its collections testify to the skills of several generations of staff in employing them profitably. Three important examples will illustrate their success.

At some point in the late seventeenth century, Samuel Poore of Newbury, Massachusetts, acquired a decorated leather pouch from one of the local Algonkian groups (figure 1). It has been stained dark brownish-black with walnut husks, and the porcupine quill embroidery has been dyed in several contrasting pastel shades. This has been called a container for hunting charms on the basis of its resemblance to an animal hide. The pouch passed through several generations of the Poore family and was finally given to the museum in 1950 by Edward S. Moseley. It is an important piece because of its excellence and fine craftsmanship as well as its rarity. New England Algonkian culture was overwhelmed by the early European colonists, and very few examples of its original arts remain.[1]

A second important acquisition is a handsome southeastern sash collected by John Cochrane sometime before 1840 and given to the museum by Millicent Nichols in 1953 (figure 2). The wide central section was made by braiding woolen yarn with glass beads inserted as the work progressed. Although most native peoples east of the Mississippi knew this braiding process, the southeastern examples are distinguished by the particular way the beads are inserted, and by its composition of short central sections with very long end fringes. Elsewhere in native North America, these sashes have more prominent central areas with shorter and less complex fringes. The museum records do not say where Cochrane collected this piece, but it was probably in the Southeast before removal of the native people began in the 1830s. Those groups, such as the Choctaw and Seminole who made sashes in this style, produced very few of them after their relocation to Indian Territory (now Oklahoma).

A third example is the magnificent Dakota (Eastern Sioux) cradle obtained in a trade with the Maine Historical Society in 1949 (figure 3). The Dakota, living on the edges of the plains, share some elements of culture with forest tribes to their immediate east. Two of these shared elements are seen in this cradle: the wooden frame (backboard and fender bar) and the birdlike Thunder figures in the quillwork front panel. This cradle is noteworthy for its considerable decoration. Usually, these were made by the

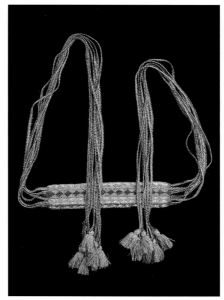

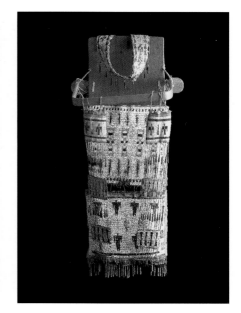

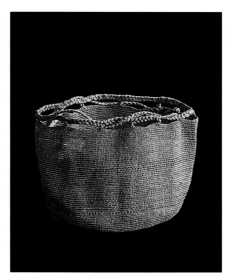

Figure 1
Pouch with Tassels
Pawtucket Artist
17th Century
E28561

Figure 2
Sash
Southeastern Artist
Early 19th Century
E30723

Figure 3
Quillwork Cradle
Dakota Artist
Early 19th Century
E27984

Figure 4
Basket
Inuit Artist
Early 19th Century
E3620

women of the expectant mother's immediate family, both to honor her and to prepare a welcome for the child. Thus, this cradle is a very strong expression of love and family pride. The Smithsonian Institution has a very similar cradle that was collected in the 1830s by the artist George Catlin. Some parts of a third, also very similar, cradle are to be found in the Rautenstrauch-Joest Museum in Cologne, Germany. It is conceivable that the same person or persons made all three.

In addition to all these conventional means of collection building, there have been two unusual situations arising from other activities centered in Salem that have served the Peabody Essex Museum to advantage. The first of these has grown out of Salem's celebrated maritime commercial activities.

Salem, the Sea, and Unexpected Riches

The story of Salem's trading ventures into the East Indies is well known. Before the American Revolution, colonial merchants had been restricted to the New World, and in particular the Caribbean, where they acquired valuable experience in international commerce. After independence, Yankee seagoers began to visit curious places like Sumatra and Java, bringing home valuable goods like spices, tea, and fine calicos. Some of the splendid homes in Salem represent the profits of these voyages. Less well known are the activities of others who turned south to Cape Horn and then west into the Pacific. Some of them were whalers who ranged widely over this vastness looking for the leviathans that would yield up sperm oil, baleen, and ambergris. They also stopped here and there along the Pacific's shores and at its many islands to fill water casks and perhaps cut some spar timber. Naturally, they would encounter the resident native peoples. The principal benefit for the Peabody Essex Museum from these trading encounters is the fine Oceanic collections for which it is famous. Judging by the comprehensiveness of this material, it would appear that the sailing vessels

visited virtually every island where there were people and were privileged to see the indigenous cultures in their true form.

While the shipping trade was vigorous in the late eighteenth century and continued until Salem's shallow harbor could no longer accommodate deep-draft ships, another group of maritime businessmen were active for a shorter time period. These were the maritime fur traders, coming both from England and New England and competing with one another. The shrewd native people were quick to notice the distinction between the two groups and called their visitors "Boston men" or "King George men." From the initial voyages of Captain James Cook and the Spanish who had preceded him, it was known that fine furs were to be had along the Pacific Coast of North America. These firs were from beaver, marten, and ermine, but foremost was that of the lustrous sea otter found from California north to the Aleutian Islands. Captain Cook's artist, John Webber, had produced drawings of native men and women wearing ankle-length capes of these precious pelts and, upon hearing of these riches, the traders began outfitting their ships.

However, the maritime fur trade proved to be something quite unlike the popular notion of the crafty trader cheating the naive Indian. In the heart of the sea otter territory (today coastal British Columbia and southeastern Alaska), there had long been a formal trading system in place between the various coastal villages and the tribes of the interior that the natives now imposed upon their uninvited visitors. When a trading ship approached a village, it had to anchor offshore and await the arrival of canoes bearing the village leaders. Then, following local custom, the actual trading could be conducted only after the appropriate formalities of gift exchanges and reciprocal feasting had been observed. It must have been a remarkable cultural confrontation as the Yankees dined upon bland, saltless native foods and the local hosts were treated to salt pork and ship biscuits. Par-

ticipants of the day did note wryly that neither group was impressed with the other's cuisine. The native trading system specified that each visitor be assigned to a designated trading partner with whom all business had to be conducted. The trader could not "shop around" for less sophisticated sellers. One accepted the Raven Chief's offer, or one pulled up anchor. Perhaps the greatest surprise came when the native people disdained beads and other trinkets and firmly demanded iron. They had seen from their first contacts with Europeans how useful this material was for making harpoon and spear points, adzes for canoe and house construction, and finer tools for carving masks, feast bowls, spoons, and the many other things they created from their abundant supply of wood. The demand for iron sometimes went to extremes. In 1803, an American trading ship was ambushed at Nootka Sound, and all but two of the crew were killed. One of these men, John Jewitt, was the ship's armorer who had been observed by the Indians working with iron. Thus, he was spared to become the personal slave of the village chief, for whom he made iron tools and weapons. In time, Jewitt was ransomed and returned home to write his memoirs.[2]

If the traders found commerce along the Northwest Coast exacting, they struck a windfall on the Asian Pacific shore. The Chinese, it turned out, esteemed sea otter furs greatly and would pay well for them. So, the traders bought all they could and set out for Canton, where they could exchange the furs for silks, porcelains, and other luxury goods that would bring good prices in England or the United States. This was also to benefit the Peabody Essex Museum in time as marvelous examples of Chinese export porcelains and other wares found their way into New England homes and eventually into the museum's splendid collections.

Apart from this commerce, the officers of whaling and trading ships did acquire some outstanding examples of native art. There are objects from the Aleutians, from the California Channel Islands, and from the long stretches of the northern Pacific Coast in between. Why did they do this? Since these garments, carvings, and other Native American materials were not collected in great quantities and were not hailed as examples of fine art, we can assume that the collecting impulse at work was neither a primarily commercial nor an aesthetic one. At this juncture, the East India Marine Society should be discussed. Founded in 1799, this select body was open only to shipmasters who had sailed to or beyond the Cape of Good Hope (and later Cape Horn). One of the society's objectives was "to form a Museum of natural and artificial curiosities, particularly such as are to be found beyond the Cape of Good Hope and Cape Horn."[3] The items so collected were displayed in cabinets in East India Marine Hall, where some are still to be seen today. A number of the fine pieces in the Peabody Essex Museum collections were acquired by society members carrying out this obligation. Note the expression "artificial curiosities." This phrase was first used by Captain James Cook in reference to the strange pieces he gathered around the Pacific and that today can be found in the British Museum, in Vienna, and elsewhere. Probably most of the traders and whalers considered whatever they collected to be exotic curiosities from a foreign world about which they knew very little. They could admire the skill manifested in a fine wood carving or textile, but it is not evident that they regarded these as works of art or as objects of financial value.

An inquiry into the motives of early collecting also brings up speculation about the means. It is known that in some cases, objects of considerable importance were given by their native owners as gifts to their European trading partners. The intent here was probably to enhance the trading relationship and to insure that the Yankee or British ship's officer would return next year with more iron. It has been suggested that there may also have been theft with the collusion of some native people.[4] This seems unlikely. Con-

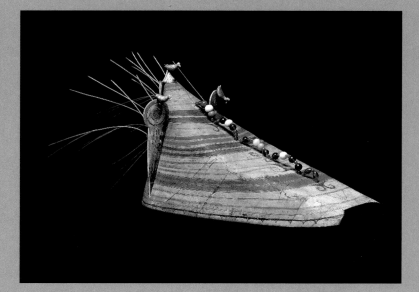

Figure 5
Cape
Aleut Artist
Early 19th Century
E7344

Figure 6
Hat with Walrus Whiskers
Aleut Artist
Early 19th Century
E3486

sider that the traders were always greatly outnumbered; this meant that they could not afford to take foolish risks. Remember also that they were in themselves a curiosity to the native people whenever they did come ashore. Thus, it would have been very difficult to walk about unobserved, enter one of the houses undetected, find the treasures that would have been carefully stored away, and get back to the beach carrying something recognizable as the property of a village leader. While there may have been some "unauthorized removals," it seems likelier that most of those things acquired by the maritime traders came as gifts or purchases.

The maritime fur trade began late in the eighteenth century, almost as soon as word of the furs reached London, Boston, and elsewhere. It ended in the mid-nineteenth century, when the Hudson's Bay Company had made its way across Canada and established trading posts on land, enforcing its right under royal charter to a monopoly of the trade. Similarly, the Russians in Alaska tried, with less success, to keep outside traders away.[5] But the real coup de grâce was the rapid and serious depletion of sea otters. By the 1840s, it was estimated that only a few thousand of them survived, and by the 1860s, there were very few to be seen in the wild.[6] Thankfully, an international agreement turned the tide, and today sea otters have been reestablished throughout most of their original range.

A sampling of the treasures collected by maritime fur traders now in the Peabody Essex Museum will reveal their importance as authentic documents of early Northwest coastal art. Among the first to have been acquired is a small utilitarian basket from the Aleutian Islands obtained in 1803 by Captain Johnson Briggs (figure 4). While there are probably older examples in Russian collections, and while this example is undecorated, it illustrates the skill and quality of workmanship that Aleut basketmakers put into something made expressly for everyday use. Its simple utility is in marked contrast to the more elaborate late nineteenth-century examples made for sale.

A second example of Aleut material is one of the fine rain garments collected by Seth Barker in 1835. Both Aleuts and Alaskan Inuit made these garments of split and dried sea lion or walrus intestine. They were worn whenever working outdoors and probably did a lot to make life in the inhospitable Aleutian Islands less unpleasant. It is principally the earliest surviving examples that are so richly decorated as this (figure 5). One sees finely detailed bands of embroidery at the throat and elsewhere. These have been made from native materials such as feathers, bird down, thin strips of painted leather, and fur. There are comparable examples in Russian collections made by Lisiansky and Etolin, but few of this age in North American museums. This garment was, however, not made in the traditional Aleut pattern of a pullover coat with a hood. Rather, it shows European influence in its front opening and in the added shoulder cape. Possibly it was made to order for Captain Barker or in imitation of something worn by a Russian trader.

A final example of Aleut workmanship is a hunter's hat collected at Unalaska by Captain William Osgood in 1829 (figure 6). It is made of a thin wooden piece that was steamed, bent into a cone-like shape, and then fancifully decorated with paint, sea lion or walrus bristles, glass beads, and carved bone or ivory plaques. Today, we are not certain whether Aleut people actually wore these hats while hunting, although some early nineteenth-century visitors sketched them in their skin boats doing exactly that. It might be said that the hats represented a form of wealth and status, since the basic material—wood—did not grow naturally on their stormy islands and was available only as driftwood washed in from Asia. It has also been suggested that the elongated front extension of the hat served to reduce the glare of the sun on the water. These wooden hats are truly among the most handsome objects made in the native New World, displaying both outstanding craftsmanship and refinement in decoration.

In 1827, Captain Daniel Cross visited the northern Pacific Coast and acquired a handsome wooden face mask (figure 7). Although the museum catalogue says he acquired this at Nootka Sound, it is not in the Nootka style and was perhaps made further north in the Queen Charlotte Islands. The mask represents a woman of high status, as shown by the ornament inserted in her lower lip and by the heraldic face painting. The lip plug, or labret, was worn only by women of noble families and was considered a sign of great importance. The face painting tells us the subject's clan and family affiliation. These crests were and still are very important since they also validate rights and privileges in which the owners share.

Sometime later, a small human figure possibly made by the same carver came to Salem via the Andover Newton Theological School (figure 8). Since this body sent no missionaries to British Columbia, it is suggested that the original collector must also have been a seafaring man. This figurine shows the same face painting and lip ornament as other works cited below by the unknown artist.

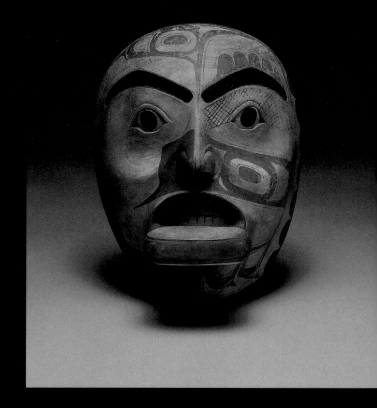

Figure 7
Djilakons
Haida Artist
Early 19th Century
E3483

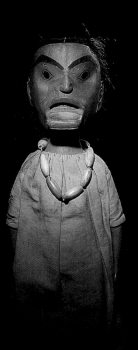

The mask and the figurine would ordinarily have been used to reinforce clan and family property rights. Periodically, every noble family held potlatches, or great feasts, at which the legends explaining the family's special claims to property, tangible and otherwise, were recited while being acted out by dancers and singers. In most cases, these legends recount a meeting between one of the family's most ancient ancestors and some supernatural force that bestowed upon them hereditary rights, such as the exclusive use of choice fishing spots or certain siren names, and invariably the ancestor came away with the right to use the supernatural being's image as a family crest. The mask of the noble lady and the figurine of her were most likely made for one of these dramatic representations intended to impress the audience with the strength of the claims being put forward.

Here a question arises. From the first, European visitors to the northern Pacific Coast were attracted by portrait masks such as this, but always found the native owners reluctant to give or sell them. Yet, there exist a number of other masks representing the same woman and most

Figure 8
Djilakons Doll
Haida Artist
Early 19th Century
E53452

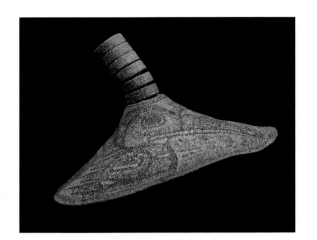

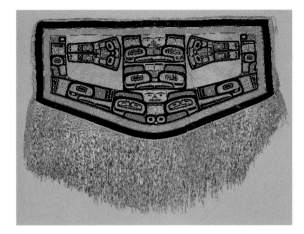

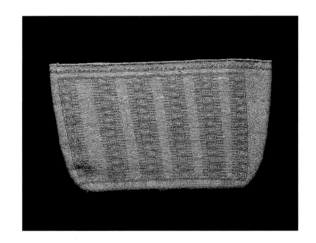

Figure 9
Raven Crest Hat
Tlingit Artist
Early 19th Century
E3647

Figure 10
Chilkat Blanket
Tlingit Artist
Early 19th Century
E3648

Figure 11
Wallet
Puget Sound Artist
Ca. 1830
E3624

definitely made by the same carver in places such as the Peabody Museum at Harvard University, the Smithsonian Institution, and the Musée de l'Homme in Paris. On the inside of one is written a misspelled name that may identify the subject as Djilakons, a legendary ancestress of the Haida eagle moiety. Is this representative of the beginning of Haida art made for export?[7]

In 1832, two Salem shipmasters acquired important examples of heraldic clothing from southeastern Alaska. A Captain Bradshaw did not himself visit the area, but somehow he came into possession of a remarkable basketry hat (figure 9). It is made with spruce root in a twining process common in that area. The Tlingit people of the region made simple, undecorated basket hats that they wore as protection against rain while working outdoors, but the more elaborate examples, like this, were reserved for important social occasions. There are also elements here that suggest that such a hat would have been reserved for a chief or the head of a powerful family. These include the cylindrical basketry rings just above the crown, the heraldic figures, and the native blue paint. The crest figures represent the raven, who plays a central role in Tlingit mythology and who was the source of many interactions with mankind in the earliest times. The blue paint is made of corroded native copper that occurs throughout southeastern Alaska and was used both for an opaque paint and a dyestuff.

In this same year, Captain R. B. Forbes presented the museum with an unusual native ceremonial robe (figure 10). Commonly called "Chilkat blankets," these distinctive pentagonal garments are named after the Chilkat branch of the Tlingit living along the Lynn Canal (south of present Skagway) who specialized in making them. However, this is not a true textile, but rather a modification of regional twined basketry done in more flexible elements of red cedar bast and mountain goat yarn. The colors are all from native materials including the pale

blue-green derived from the native copper mentioned above. Ordinarily, the figures that appear on these Chilkat blankets are conventionalized renderings of clan and family crests that completely fill the central five-sided field. In this example, there is something different: the keystone-like figures in the lateral fields refer to man-made objects. The real prototypes are plaques of native copper that function as wealth symbols. The actual copper plaques often have names, and their histories are known in detail. They are not negotiable but serve as proof of superior rank, somewhat like a "von" or "de" before one's name or a coat of arms over the porte cochere.

Captain Forbes also gave the museum an outstanding small basketry wallet, probably from the Twana people of the present-day Hood's Canal region in Puget Sound (figure 11). Modern basketmakers in the area still use some of the same "box" and "mountain" figures in their work.[8] Since Captain Forbes visited neither Alaska nor Puget Sound, it is assumed that he also obtained these fine pieces by trade or purchase from another seafarer, American or otherwise.[9]

One last example might be the fine group of Chumash baskets, although the collectors' names and dates have not been recorded. The Chumash are a little-known group who occupied the islands in California's Santa Barbara Channel. They were a maritime people who even hunted small whales. It is often mentioned that they were the only native group in North America who made planked canoes. Any Chumash material in museum collections is precious because the group, under the duress of forced proselytizing, had lost most of its traditional arts and culture by the end of Spanish rule in California. Thus, the Peabody Essex Museum's Chumash baskets would have to have been collected no later than the middle 1840s.

Missionaries as Collectors
A second important and unusual source of Peabody Essex Museum collections arose from the

activities of nineteenth-century missionaries. At the beginning of the last century, the American Board of Foreign Missions had its headquarters in Salem from which it sent its representatives throughout the world. Among their earliest North American embassies were those to the Cherokee in 1816, the Choctaws in 1818, and other southeastern groups within the next decade. By 1820, they had also penetrated to the Osages in Missouri and from there moved into the Great Lakes and further onto the plains. From time to time, these missionaries collected or were given examples of native handicrafts, which they often sent back to Salem as curiosities. By the time the Andover Newton Theological School was established, the American Board of Foreign Missions had accumulated a modest collection for which they lacked adequate storage facilities. This collection was presented to the school, and in turn by them to the museum beginning in the 1940s. Although the study of native culture was not a primary goal for the missionaries, they did manage to collect some very handsome and important objects.

One such object is a Dakota dance leader's flute, collected at Lac Qui Parle in southwestern Minnesota. This long wooden pipe has one end carved as a snipe (figure 12). It would have been carried by a leader in the Grass Dance, which was at that time evolving from a victory celebration into a social dance. As he danced, the leader would blow one or two notes to signal the singers to repeat the dance song one more time. This was also an indication to the dancers that an end was coming, which was important since it is a fine point of good Plains dancing to stop exactly on the last drumbeat. Lac Qui Parle on the Minnesota River had been an important trading site and was visited by the scientist Joseph Nicollet in the 1830s.[10] This instrument was presented to the Andover Newton Theological School by the noted missionary Steven Return Riggs, who compiled the first Dakota grammar and dictionary in the mid-nineteenth century.[11] It is not certain Riggs collected this piece himself or acquired it

from a fellow missionary. Stylistically, it appears to predate his arrival in Minnesota.

Another important missionary family working in the western Great Lakes was the Boutwells, and the Peabody Essex Museum holds several objects acquired by them. One is a birchbark container collected in 1831 by Miles Boutwell (figure 13). The Ojibwa and other native people of the region had been making objects of bark and decorating them with colored porcupine quills for generations. This example was made according to native technology, but the vase-like shape shows European influence. Probably the maker was copying something she had seen in a missionary's home or in a church. A second piece from this family is an Ojibwa cradle, collected by Mrs. William Boutwell some twenty years later (figure 14). It is made in a traditional style with a flat hardwood backboard and decorated wrappings for the child. The unusual wooden slat projecting forward from the top is a fender to protect the child's head if the cradle should tip over. Its baroque shape was achieved by steaming and bending the wood. This same process was used to make snowshoe frames and canoe bow and stern pieces. The only departure from strict tradition in this cradle is the use of European wool cloth and glass beads for decoration. Earlier, they would have been deerskin and colored porcupine quills. The beaded decoration shows the Ojibwa preference for floral design.

It often happened that Christian missionaries were curious about native religious practices (which they had come to supplant) and would collect pieces used in traditional ceremonies. One example of this is a dyed leather pouch from the Great Lakes with the figure of Mitota Kokaid, the underwater panther (figure 15). This supernatural being is the ruler and guardian of lakes, rivers, and the whole world of water. This little pouch would have held charms and herb medicines used when addressing prayers to Mitota Kokaid. It is not recorded when or by whom this was collected, but its style suggests this must have been before 1850.

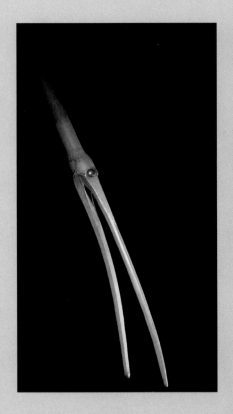

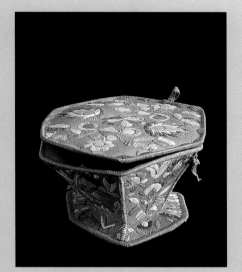

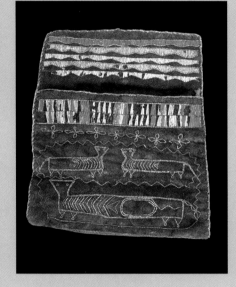

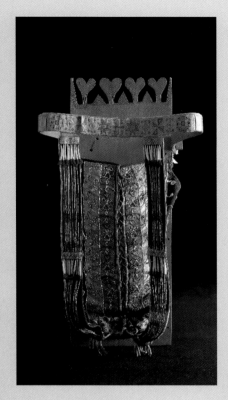

Figure 12
Bird Flute
Dakota Artist
Early–mid-19th Century
E25415

Figure 13
Bark Box
Ojibwa Artist
1831
E53440

Figure 15
Pouch with Water Panthers
Ojibwa Artist
Late 18th–Early 19th
Century
E53449

Figure 14
Cradleboard
Ojibwa Artist
19th Century
E25409

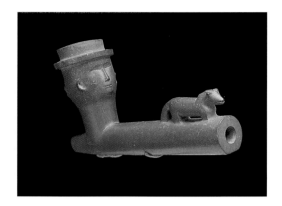

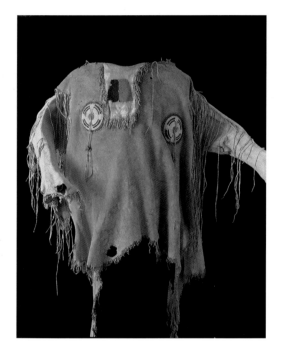

Another piece from an unidentified missionary collector is a catlinite pipe bowl representing a little man and a dog (figure 16). It has been suggested that this carving has many stylistic elements in common with works made by Running Cloud, a Sisseton Lakota carver active in the 1830s. These similarities include details of facial features and the overall arrangement of the figures. If this attribution is correct, then it is an important work by one of the earliest Lakota carvers known to us by name.[12]

A final example of missionary collecting is a Northern Plains man's shirt acquired by Dr. E. D. Rushford probably in the late 1830s or early 1840s (figure 17). The body has been painted dark brown, and the shirt is decorated with circular ornaments with porcupine quills wrapped over horsehair bundle cores. This method was practiced by most Northern Plains people until the mid-nineteenth century, and there are similar examples in the Linden Museum in Stuttgart, Germany, collected in the 1830s by Prince Maximilian of Wied. Such a shirt would have been reserved for important occasions, and Dr. Rushford must have been highly respected to merit it. The quilled discs are purely decorative, however, and hold no symbolic significance.

The examples described here are but a few of the many outstanding Native American materials in the Peabody Essex Museum collections. Although long noted for its holdings in other areas such as American decorative arts, early American architecture, maritime art and history, Oceanic art and culture, Asian art, and Asian export art, the museum can take great satisfaction in the energy of the many early collectors and donors who have brought together this premier Native American collection.

Figure 16
Portrait Pipe
Running Cloud
Sisseton Lakota Artist
Ca. 1840
E53453

Figure 17
Man's Shirt
Northern Plains Artist
1830–50
E26323

1.

For more information on this pouch, see *New England Begins: The Seventeenth Century* (Boston, Mass.: Museum of Fine Arts, 1982), 1:77.

2.
JOHN R. JEWITT
A Narrative of the Adventures and Sufferings of John R. Jewitt (Middletown, Conn.: Loomis and Richards, 1815). This account is also available in *White Slaves of the Nootka* (Surrey, B.C.: Heritage House Publishing, 1994).

3.
WALTER MUIR WHITEHILL
The East India Marine Society and the Peabody Museum of Salem: A Sesquicentennial History (Salem, Mass.: Peabody Museum, 1949), 6.

4.
DOUGLAS COLE AND DAVID DARLING
"History of the Early Period" in *Handbook of North American Indians* (Washington, D.C.: Smithsonian Institution, 1990), 7:119-34.

5.
DOUGLAS COLE
Captured Heritage: The Scramble for Northwest Coast Artifacts (Vancouver, B.C.: Douglas and McIntyre, 1985).

6.
VICTOR H. CAHALANE
Mammals of North America (New York: Macmillan Co., 1954), 203-9.

7.

Information about these masks and their whereabouts has been kindly furnished by Bill Holm, curator emeritus of the Thomas Bruce Memorial Washington State Museum in Seattle, Washington.

8.

Identification of this wallet and comparative remarks have been graciously provided by Mary D. Schlick, a well-known authority on Northwestern basketry.

9.
MARY MOLLOY
"Boston Men" on the Northwest Coast: Commerce, Collecting, and Cultural Perceptions in the American Fur Trade, 1799–1844 (Ph.D. diss., Brown University, 1994).

10.
JOSEPH NICOLLET
The Journals of Joseph Nicollet: A Scientist on the Mississippi Headwaters (St. Paul, Minn.: Minnesota Historical Society, 1970).

11.
STEVEN RETURN RIGGS
A Grammar and Dictionary of the Dakota Language (Washington, D.C.: Smithsonian Institution, 1852).

12.
JOHN C. EWERS
Plains Indian Sculpture: A Traditional Art from America's Heartland (Washington, D.C.: Smithsonian Institution, 1986).

Richard W. Hill Sr., Assistant Professor, State University of New York at Buffalo

"When I found the shops at Niagara Falls full of dainty Indian beadwork," noted Mark Twain in 1869, "and stunning moccasins, and equally stunning toy figures representing human beings who carried weapons in holes bored through their arms and bodies, and had feet shaped like pies, I was filled with emotions. I knew that now, at last, I was going to come face to face with the noble Red Man." In his satirical essay on his day at Niagara Falls, Twain denigrates the overt commercialism that consumed the falls and questions the authenticity of both the Indian crafts he found there in abundance as well as the Indians themselves. Iroquois Indians could be found selling their crafted goods by the rapids near the falls, and many of these beaded "whimsies" have ended up in museums as priceless treasures. Twain, however, did not find Niagara such a treasure trove; nor was he pleased with these Indians, who, he writes, turned out to be Irishmen who resented Twain for mistaking them as Indians. They thrashed him and threw him over the falls. He ended up in a hospital and spoke with a doctor. " 'It is an awful savage tribe of Indians that do the beadwork and moccasins for Niagara Falls, Doctor. Where are they from?' The doctor answered, 'Limerick, my son.' " Twain, in poking fun at the Irish, reflects his own misgivings about the popular image of the noble Red Man.[1]

While Twain's story was mostly a fantasy, the beadwork and moccasins made by Indians were real. A guidebook published in the 1840s described the Niagara region as an area where "the greatest market for splendid Indian work of every variety" could be found. Indian shops sprang up all around the falls, such as one depicted in 1856 by the artist Joachim F. Richardt in his painting entitled *The Emporium of Indian Curiosities*. This was an actual store on Goat Island near the great falls. A sign behind the store reads "Wholesale and Retail Indian Store." Across the dirt road in front of the store are four Iroquois women with a white blanket on the ground covered with their handiwork.

Indians could be found selling their work around the falls as well. The earliest written reference that I have been able to find regarding this beadwork is by Nathaniel Hawthorne in 1835. Hawthorne writes that, in the tollhouse that guards the entrance to Goat Island above the falls, Indian craftwork attracted his attention: "some Indian moccasins, and other trifles, made of deer-skin and embroidered with beads" were found there. He also noted that he purchased a walking cane: "Out of a number of twisted sticks, the manufacture of a Tuscarora Indian, I selected one of curled maple, curiously convoluted, and adorned with the carved images of a snake and a fish. Using this as my pilgrim's staff, I crossed the bridge."[2]

Dolores Elliot, who teaches in Binghamton, New York, and collects Iroquois beadwork, came across the earliest known photograph of Tuscarora women selling beadwork by the falls. It is actually a colorized stereo view that was most likely taken before 1870. Spread out in front of them are their white blankets covered with beaded pincushions, picture frames, and other items that have become known as "whimsies," a term that was first used to describe the fancy beadwork in the 1860s. That old photograph has been an important connection for me. It is a connection to the area where I grew up, which is near Niagara Falls, New York. It is a connection to the women in the photograph, who are most likely Tuscarora, and to the reservation where I live. It is also a connection to the beadwork they offered for sale. This essay is an attempt to explain those connections and comment on why they are so important to me.

Meeting an Old Friend

When I come across a piece of Iroquois beadwork in a museum, it calls like an ancestral voice. The message of that beadwork is layered with meaning. On one level, it is a form of visual literacy among my own people in that it is the way we talk to one another across the generations. Beadwork becomes a visual reminder of the personal ideas and communal values of a generation that is given like a gift to the future. There are symbols, designs, and colors that are repeatedly used to communicate a communal sense of identity. At the same time, that identity is not frozen in time; it is cumulative, and each generation adds its creative energy to that mix. Being Iroquois entails being connected to all of the generations and all of the experiences of all of our people.

I also identify with the beadwork on a personal level because I have sewn beadwork myself. I know what it takes to conceive of art in beads and what it takes to make it happen. Beadwork has been a way in which I manifest my own thoughts about myself. Therefore, I see myself in these older pieces. Through beadwork, I have been able to connect to my predecessors by taking what they have started and making it anew for my generation. The old art makes me want to make new art, not to steal its creativity, but to drive my own in order to explain my worldview through art. Art becomes part of my dialogue backward in time to demonstrate that ideas carry forward, and that my hopes can be communicated to the Indians who are yet to be born. For generations, my people have been making visual reminders of our life experiences. The artistic transformation of natural or manmade materials into objects of belief and identity is a personal and communal process that is

hard to explain. On one level, it is very basic to human needs. Clothes, utensils, and instruments are made to be used in life. The process is a simple transformation for the sake of utility. On another level, it is deeply imbued with meaning. Natural materials have powers associated with them—bone, feather, bark, husk—that convey the objects created to another level of being. Certain designs and metaphors have the ability to span generations, and bring with them a special responsibility to understand their meaning in order to refit it to a new generation.

Still, there is a personal power in creativity. While the traditional Iroquoian view acknowledges that the source of creation rests solely with the Creator, and that artists often are guided by that universal entity, there is also a concept of personal power, called *orenda* by the Seneca. Individuals gain power through the cultural experiences of our community. Knowledge, understanding, and successful action can contribute to that power. Creativity, I believe, also adds to that power. By making things that have a deeper meaning, we gain more creative power as artists.

To me, art for the Iroquois is really a pattern of expression rather than a set of design rules that I must follow. Art, even with something so seemingly mundane as beadwork, is a way of manifesting thinking. Such art reflects the collective memories of our people, memories about the land in which we live and of what happened to our people. It is not just about recall, though. This art also projects new thoughts about what constitutes a common culture, an ongoing tribal identity. I marvel at the idea of taking the same kind of small beads, woven cloth, and spun thread to make something that fits into an established visual literacy of our people, but can also be my own message to future generations, who will also be seeking cultural connections.

While in a ritual sense it is very important that I affirm my linkages to ancestors through words, music, song, dance, foods, and offerings of thanks, the arts become the way in which those expres-

sions are individualized. This is crucially important for the Iroquois people. We are a confederacy of six different nations, united together under one law of peace. Within the Iroquois Confederacy, each member nation retains its own identity. Each has a role to play, and we perceive ourselves as six families who think with one mind and one heart and speak with one voice on matters that affect us all. We call ourselves the Hodenosaunee, meaning People Who Are Building an Extended House. That house is a metaphor for the peaceful way of life that results from the unity of choosing reason over violence. We are all unique individuals within that metaphysical longhouse. We have unique names, talents, and manners in which we express ourselves.

Often tribal societies are seen as places where individualism is inhibited. In reality, individualism is prized by Indians, but within limits. Each individual is thought to have a special skill that contributes to the welfare of the group. The ability to make things with your own hands, to individualize communal thought, is an honored tradition. Every time that I come across a piece of beadwork made by an Iroquois person, I feel that I am meeting an old friend. That beadwork and its creator speak to me. What follows is my record of that dialogue.

The Glass Beads Meet the Indians

Tiny glass beads have caused a quiet revolution in the arts of the Iroquois Indians of western New York. Beadwork, in one form or another, exists in nearly every Indian home. When I first visited the Peabody Essex Museum, I wondered how many ships arrived here with goods loaded for the trade with the Indians to the west. The glass beads may well have been unloaded here, making a fantastic journey from the European factories to the Indian homes.

It begins with the arrival of Columbus. He carried glass beads with him and gave them as gifts to the Indians he met on the shore. In exchange, he took their gold, silver, freedom, and most of their land. Those first glass beads proved to be

quite expensive. The French explorer Jacques Cartier visited the Iroquois village of Hochelaga along the St. Lawrence in 1535, near the present-day site of Montreal. He noted that the most precious items to the Indians were beads made from ocean clamshells. These were the sacred wampum beads, small tubular beads that were used in rituals and to record agreements. A string of shell beads already had deep meaning for the Iroquois. Cartier offered glass beads to the Indians he met. He quickly learned that those Iroquoians had already been aware of the European trade. Stories of the glass beads and other goods had moved upstream faster than his ship. By 1550, the first European trade goods reached the Seneca Indians, who lived in upstate New York. Metal tools, such as copper and brass kettles and steel knives and axes, were in high demand among the Iroquois men. Steel needles instead of bone awls, spun thread instead of deer sinew, and glass beads instead of quills became popular entities among the women. The tiny seed beads, like those we still use today, were available in the 1500s.

Obtaining beads from a White trader was certainly easier than wrestling quills out of a porcupine. I have done both. Beads came in many new colors, while quills had to be boiled and colored with dyes. (The aroma of boiling quills is not the most pleasant one.) While stripping sinew from a deer is something that every Indian should perhaps do once, spun thread was easier to obtain and use than stiff sinew. Metal needles were sharper and more durable than bone needles; if one uses a small bone awl to puncture leather, and then uses a glovemaker's needle on that same piece of leather, one will immediately see why the steel needle was preferred. The tiny glass beads could make more intricate designs than the quills, which had to be moistened and twisted into place. The decision to use the new materials was probably not a hard one for that generation. There was no argument about whether it was traditional or not. If anything, my ancestors "Indianized" the

glass bead, making it a permanent part of our collective cultural legacy.

There must have been a cultural reason why the Iroquois so readily incorporated beads into our worldview beyond their pragmatic use. If clear, white, or red beads were among the first to be traded, then it would make sense. Clear glass beads, or color encased in glass, would have appealed greatly to the first Iroquois encountering them. The Iroquois words for "glass" are derived from the words for "white flint." This makes sense in that glass and flint appear similar when broken. Flint has very important connotations in the Iroquoian worldview. Most likely, the Indians that Cartier met were the Mohawks. They call themselves the People of the Flint, because this material is abundant in their lands. To the Iroquois, flint is associated with one of the twin creators of the earth. This was the evil-minded one who was eventually sent underground. The Thunder Beings use flint-tipped arrows to send lightning toward the earth to keep all of the serpents in their underground dominion. There are stories about the use of crystals and their origin from lightning among the Iroquois; the natural "glass" has special attributes assigned to it. The glass beads could have been appealing because of all of these associations.

The color white conjures up concepts such as goodness, life, and peace. When I worked on an Iroquois advisory committee for the interpretation of a seventeenth-century Seneca village, we wrestled with the meaning of the name for the site. We decided that its real name was Ganondagan, which we translated to mean "village of peace." However, the literal translation was "white town," with the term "white" being a metaphor for the idea of peace (meaning, clear thinking). In addition, the Iroquois believed that bright light was a good thing, or a metaphor for clear thinking. Fire was associated with the power of the sun and the "brightness" that burns within each of us. It is entirely possible that the Iroquois of old saw glass beads as tiny manifes-

tations of their metaphors for the power of fire and light. Light, in the form of the sun, moon, and stars, also has cultural significance. The white starlight across the dark night sky has often reminded me of Iroquois beadwork on clothing. The beads look like cultural constellations and patterns in the nighttime sky. The reference to the Sky World in the designs is another cultural metaphor in that the Iroquois believe that life came from above. Purple, black, and dark blue would have been references to the dark seaworld or the underworld, a place where the Serpent Beings live.

The wampum belts also show that purple is associated with death, tragedy, and mourning. White in the wampum belts was a symbol of peace, good tidings, and renewal. A white line of beads could very well represent the path of peace and good times that we are to seek in our life. The path of peace is visualized as four white roots that grow from a tall pine tree that was planted as a symbol of the Iroquois Confederacy. That tree of peace was placed in the territory of the Onondaga nation, the capital of the confederacy. People in search of peace follow those white roots to their source. This path that connects people in peace is often seen in the wampum belts as a row of white beads that links two squares, diamonds, or circles. For me, the sewing of tiny white beads on a dark cloth recalls this notion. It is as if each time we create, we relive our sacred history through that thin white line of beads.

By 1608, the French explorer Samuel Champlain had built a trading settlement at Quebec and most likely came into contact with my father's distant relatives, the Mohawks. In exchange for beaver furs, corn, and Indian-made goods, the French traded cloth, metal tools, and beads. The Iroquois must have thought that the Europeans were a formidable people with their ships, metal armor, and guns. Unfortunately for the French, they chose a policy of extermination of the Iroquois. The Iroquois turned to the Dutch and the English, who eagerly offered trade goods to gain the favor of the confederacy, not so much because of their affection for the In-

dians, but because of their hatred of the French. An economic war was thus exported from Europe, and the Indians were caught in the middle; the quality and diversity of the trading goods that became available to them were just as powerful incentives as muskets, powder, and shot.

The glass beads were not an insignificant object to the Europeans either. Europeans had several centuries of practice at making glass beads. Venice and Bohemia became the leading production centers. The colonial fur trade grew rapidly, and the Iroquois, because of their strategic position and powerful union of the Five Nations, benefited from the competing European interests. The good graces of Indian allies were sought and secured by means of the trading goods. In 1613, the Dutch began making glass beads. In retaliation for losses to the Dutch and French, the Senate of the Republic of Venice issued the following law:

If any worker or artisan transports his art into a foreign country to the detriment of the Republic, he shall be sent an order to return; if he does not obey, his nearest relatives shall be imprisoned, so as to be reduced to obedience by his interest in them; if he returns, the past will be pardoned. . . . if, in spite of the imprisonment of his relatives, he is still determined to live abroad, an emissary will be charged to kill him and after his death, his relatives will be set at liberty.

By 1620, the Iroquois Indians, who fiercely controlled the waterways of the region, were bringing five to seven thousand beaver furs to Albany each year. By 1650, that annual total reached sixty thousand, but it was reduced to fifteen thousand by 1670 as the beaver population began to thin and as other Indians found their way to other trading posts. However, those two generations of fur trading changed Iroquoian life forever. The Indians became dependent upon the trade goods, and the Indian household changed dramatically. It is impossible to estimate how many beads made it to Iroquois country. The archaeological finds of Seneca villages from that period show that over fifty percent of the household goods were of European manufacture. Glass beads are by far the most numerous of those items recovered from Indian graves

and village sites. Glass beads seem to last forever. Beads also figure into the diplomatic protocol that was adopted by the French and English as they pursued alliances with various Indian nations. Giving and receiving presents was the standard procedure for all meetings. Generosity was admired by the Indians. The English and French were expected to give condolence gifts for warriors killed in battle or by colonists. Gifts could represent a desire for peace, a reward for good conduct, a request for loyalty, a declaration of war, a tribute to a person or a nation, a mark of distinction to the leaders, or a token of thanks or friendship. Wampum had served in this capacity during the previous century. Beaver furs, deerskins, muskrat skins, and tobacco were also traded as a sign of respect. Trade silver became popular. Indian agents would also give sugar, beef, rice, fruit, pork, butter, bread, tea, and liquor to feed the delegates to conferences as well as to make up for the fact that the English settlers often drove away the game.

The English took over the trade with the Iroquois from the Dutch, and, by 1703, one thick beaver hide was worth either one yard of broadcloth, twenty skeins of thread, two yards of cotton, six knives, two small axes, three dozen fishhooks, or two large kettles. Beads were offered by the pound. The decline in both the quality of the fur available and the consumer demand for it began to affect the bead-making industry. In the 1730s, eighty-five percent of the bead factories closed in Europe. Venice remained the major center, and most of the beads seen in historic Iroquoian beadwork probably came from the island of Murano in Venice. In 1760, one good beaver hide could be traded for a six-foot string of small blue beads. By 1807, that same hide would be the equivalent of two pounds of beads. By the early nineteenth century, there were over five hundred different types of beads being produced for the trade in America. Today, Venetian beads are still a favorite of the Iroquois beadworkers as are those from the former Czechoslovakia and, to a lesser degree, those from Japan.

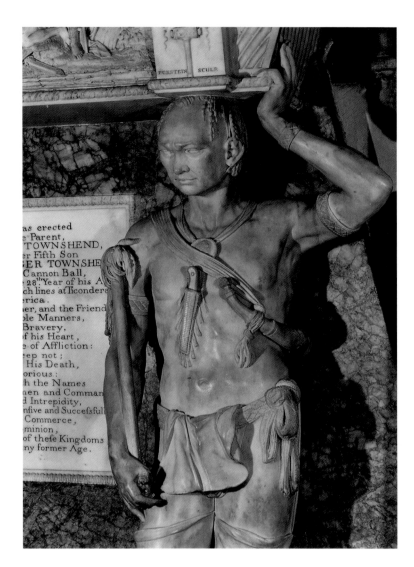

Figure 1
Detail of Roger Townshend Monument (1761) in Westminster Abbey, London, England
Courtesy of the Dean and Chapter of Westminster.

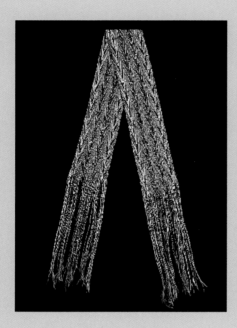

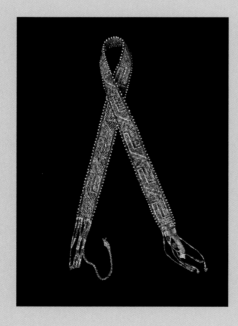

Figure 2
Sash
Iroquois Artist
18th–19th Century
E13649

Figure 3
Burden Strap
Iroquois Artist
18th Century
E68210

In 1761, the English artists Joseph Ekstein and Thomas Carter sculpted a monument to Lieutenant Colonel Roger Townshend, who was killed at Ticonderoga in 1759 (figure 1). This unusual statue still stands in Westminster Abbey, and in that work we can see how the Iroquois men dressed during that period, employing a unique combination of native aesthetics and European trade goods. It shows two Iroquois men holding a casket above their heads. They wear tight-fitting leather leggings that go up to the mid-thigh, with wide side flaps. These leggings were popular trade items that both European and Indian men wore. They made travel through the woods and fields much more comfortable than the wool pants of the Europeans. They were more durable and offered more protection than cotton pants. Often, they would be decorated with quillwork, moose hair embroidery, or glass beads in a style that is very similar to the Iroquois and Huron moccasins in this volume. Quillwork remained a viable art form into the first half of the nineteenth century.

The Iroquois figures in that sculpture are also shown wearing very small breechcloths that are worn like a dipper, folded over a sash. The sashes were often woven by hand, with tiny white beads laced in the threads to form patterns of zigzags or arrowheads (figure 2). Burden straps, used to carry large loads, were woven of corn husk and hemp and decorated with the thick hair of the moose (figure 3). This strap shows that geometric patterns were also popular at this time, but the exact meaning of such designs is not known. Each figure has a decorated knife sheath on its chest, hanging from decorated necklaces. These sheaths were highly prized and beautifully decorated, usually with intricate quillwork. The Iroquois models are similar to the one designated E3676 (figure 4). The knife handles would also have been wrapped with dyed quills. This practice of wrapping quills was employed throughout the Northeast and Great Lakes region. There is a great affinity between the Iroquois quillwork and that of the Ojibwa, Potowatami, Winnebago, and Lakota, as may be seen in a quill-wrapped flute or a pipe (figure 5).

We can see powder horns hung across the chests of these figures as well. The decorated powder horn was in use by most men on the frontier. Some had stylized designs similar to quilled and beaded patterns; others had scenes from daily life. Still others had maps or battles depicted on them. It becomes difficult to tell Indian-decorated powder horns from those produced by the colonists. It appears that the powder horn was one common object through which patterns and designs were exchanged.

These marble Indians wear decorated armbands, leg garters, and moccasins that are similar to those in the collections of the Peabody Essex Museum. These things were often traded or given to military officers, missionaries, and dignitaries who visited the Iroquoian communities. In the older moccasins (figures 6 and 7), we see red quills, red ribbon, and red-dyed deer hair hanging from silver cones around the side flaps of moccasins for both men and women. White beads were used most often in this mix as delicate pattern markers to highlight the quilled zones. The contrast of the shiny white bead against the glossy red quills is a very attractive effect in the Iroquoian aesthetic. It is hard to imagine them giving these moccasins away, but showing respect through the bestowing of gifts was customary in that era. However, the European tradition was different; they took the gifts and then demanded land. Give them moccasins, and they will walk all over you.

Traders often sold Iroquois-made knife cases, moccasins, leggings, snowshoes, shot pouches, sashes, and other accessories to non-Indians. The so-called frontiersman dressed more like an Indian than a European. Indian-made garments, moccasins, shot bags, sashes, necklaces, and other goods would also be traded or given away. Most likely, the Indian agents would commission Indian craftspeople to produce articles to be given as gifts to other Indians. The extent of this kind of production can be seen in the portrait of Sir John Caldwell, an English officer stationed at Fort Detroit in the 1780s. He is seen decked out in Indian clothes from head to toe. While most of what he wears was made by the Ojibwa of the

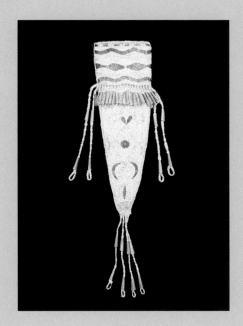

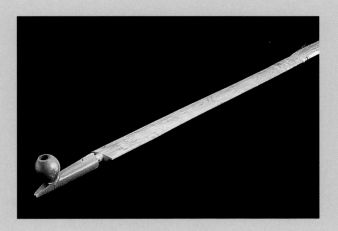

Figure 4
Knife Sheath
Lakota Artist
Late 18th–Early 19th Century
E3676

Figure 5
Pipe
Lakota Artist
Early 19th Century
E3690

Great Lakes, the similarity to Iroquoian work is very marked for that period (see the quill-decorated bags in figures 8 and 9). The confluence of Indian designs and European materials makes an impressive combination in anyone's terms. Museums are full of the kind of items that are seen in Sir Caldwell's portrait. Officers built up their cabinets of Indian curiosities, and these were frequently donated or bequeathed to museums.

There is also a deep sense of history to the beadwork that is in museums, not only in how it came about, but in how these pieces ended up in museums rather than in our homes. The fine examples of Iroquois and Huron quillwork and beadwork in the Peabody Essex Museum are part of my cultural inheritance and a part of American history. You have to remember that the Iroquois think in metaphorical terms; we see meaning in the choices made by the makers of these objects as much as we see meaning in their physical designs. The floral patterns recall our woodland environment that links the Iroquois and Huron together culturally. The animal symbols reflect our family clans that connect us to the animals that walk the earth, the birds that fly in the skies, and the animals that live in the water. Both Iroquois and Huron art consistently represent the animals, plants, flowers, and people that are part of the larger cultural worldview.

On the other hand, European designs on furniture, cookware, quilts, and household objects made during the colonial era also featured plants and animals, and there was much artistic interplay between the eastern Indians and the White colonists. There are historic patterns of trade and commerce woven into the fabric of the older works. To me, this is a statement of survivability, not acculturation. It takes a fertile imagination to incorporate foreign materials and make new art that is still reflective of ancient Iroquoian ideals. Certain glass beads were used at certain times, certain styles emerged during different periods, and, for the Tuscarora Indians, the beadwork also recalls a tradition of selling such things to the tourists who visit Niagara Falls. For over a century, the men and women from my reservation have made beadwork that could be used either in the Iroquois home or the Victorian parlor. In this way, the tiny glass beads are a history of my own people.

Morgan Meets the Iroquois

In 1851, Lewis Henry Morgan (1818–81), a Rochester politician and lawyer, published *The League of the Ho-dé-no-sau-nee, or Iroquois.* Often referred to as the father of ethnography, Morgan was actually the beneficiary of the thought and reflections of the Seneca Indian Hasanoanda (Ely S. Parker, 1830–95), who would eventually become the first Indian secretary of Indian affairs in Washington, D.C. It was Parker, a teenage interpreter for his own people, who actually introduced Morgan to Iroquois traditions and arts.

Morgan wrote that Iroquois objects "speak a language which is silent, but yet more eloquent than the written page."[3] Morgan collected many examples of the arts during this critical era when the creative explosion from the fur trade era was being tailored to meet the tastes of a Victorian clientele. Morgan himself was an example of how this country was beginning to rethink the Indian. He had joined a men's social club in 1844 that was organized to "save" the Indian (from what or for what other purpose is not certain), but the club called itself the Grand Order of the Iroquois. These were well-to-do White men who gathered in their reading rooms and dressed like Indians, assumed Indian names, collected Indian objects, studied Indian history, and became the reformers of social policy towards the poor Indian. During that time, Indians were depicted in a highly romanticized manner, evident in the works of James Fenimore Cooper. Alexis de Tocqueville, the French politician and writer, had published his classic work, translated as *Democracy in America,* and this created a sympathetic image of the Indian as well. The critically important concept of "manifest destiny" would appear for the first time in 1845. Replicating Indian manners and customs after their fashion was a way for these professional men to preserve aspects of Indian life that they found inspiring.

Morgan was named a "Grand Sachem" in this organization. In spite of this somewhat bombastic title, he was genuinely enthralled by what the creative imagination of Indians could produce, and he admired their technology, their use of materials, and the symbols of their art. He assembled his own private collection for his

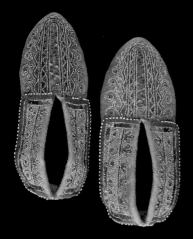

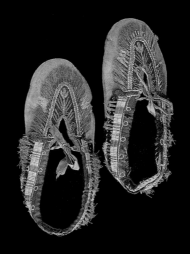

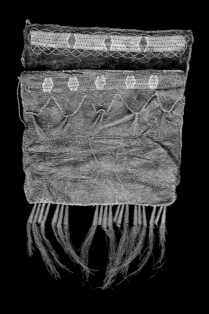

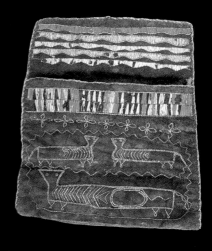

Figure 6
Moccasins with Blue and Red
Iroquois Artist
Late 18th–Early 19th Century
E26326

Figure 7
Moccasins with Orange and
Blue Fringe
Huron Artist
Late 18th–Early 19th Century
E3708

Figure 8
Pouch with Thunderbird
Great Lakes Artist
Late 18th–Early 19th Century
E6637

Figure 9
Pouch with Water Panthers
Ojibwa Artist
Late 18th–Early 19th Century
E53449

"Indian Cabinet," and most of that material was later donated to the University of Rochester and now rests in the Rochester Museum and Science Center. He also collected for the New York State Museum in Albany. Tragically, much of what he had contributed to this latter repository was destroyed by a fire in 1911. Of the five hundred objects that Morgan sent to Albany, only fifty survived. When I read the list of the one thousand Native American objects that were destroyed, I could not help but feel that I was reading the obituaries of lost relatives. I mourned the loss of art that would never again be seen. Lost were beautiful examples of Iroquoian quillwork and intricate beadwork on leather clothing. Not so strangely, medicine masks that were hung on the walls were not harmed. Indian stories about that fire made much of this fact. In the end, I had to view the fire as a purification of sorts, the returning of objects to their sources, a freeing of them from their ethnological fate. In my young mind, these objects were never intended to become the booty of the cultural wars between museums and Indians.

Morgan's publications included several color plates and dozens of line drawings of many of the works purified by the fire, so that we can get a sense of the design and use of color that was employed by the Seneca of that period. What makes Morgan's work important in the study of Iroquoian art history is that he collected as broadly as possible, rather than preselecting what he considered to be the "best" examples of art. It represents a cross section of the world of the Iroquois as shown through the things they made. However, for Morgan and museum curators ever since, there was an impulse to classify the objects. Morgan saw two primary divisions (containers and tools), and he devised an arrangement of object types that has become an anthropologist's checklist for defining a culture: house; cradleboard; dress; band (beaded, woven, and metal); ornament; container; war and hunting tool; transportation; fire-making; smoking tool; cooking tool; singing tool; gaming tool; ceremonial item; and the ever-useful "miscellaneous." Many museum exhibitions about Indians are organized around such definitions that have a tendency to segment native culture and leave "art" as a catchall rather

than an underlying visual literacy that informs all of the objects.

Yet, Morgan did have a preconceived idea of what constituted an "Indian" object. In one report on a Seneca beaded purse, he stated that it "was not an original Indian article, but a naturalized invention." Any outside influence on the stylization of design was considered a contamination of the cultural purity of the object in the view of Morgan and his contemporaries. This prejudice is still seen in Indian art exhibitions where artificial definitions of "traditional" and "contemporary" create categories in which the art is interpreted. We have to begin to dismantle such notions that are ultimately more oriented towards increasing valutions rather than towards enhancing ethnographic purity.

By collecting only the objects that have obvious "Indian" visual connections, we do not get an accurate reflection of what life was like for the Iroquois at that time. In the 1840s, the material culture of the Seneca included many objects that were not made by the Seneca or were the combination of Seneca and non-Seneca creativity. We do not see the Indian-made axe handle or the Indian-made chair and table as expressive of an indigenous art. We do not see what books the Indians were reading, or how they adapted household objects to their own use. Creative thinking is often not considered in the object-oriented disciplines. Even the most comprehensive collections do not give a complete picture of the native realities. Most museums, including the Peabody Essex Museum, do not have this kind of comprehensive selection of objects, with the result that one often finds isolated and disconnected examples that appealed to the tastes of the various collectors. Even to prepare this exhibition, we had to find ways to rate the objects, in order to decide what was essential to present. Often, the selections were determined by visual impact, excellence in execution, or rarity of style. This collection is fairly sparse in terms of Iroquois objects, but even these seemingly few pieces can still speak to us about larger beliefs and communal identity.

In my opinion, Morgan's most important achievement was that he recorded the Seneca words for these objects. These terms show us that the Iroquois named things based upon their function. Instead of a "belt," it is called "one uses

it to tie around the waist." Instead of "sash," it is "one uses it to put over the shoulders." Instead of "necklace," it is "what one puts over oneself." These descriptions are more telling than the English one-word names applied by collectors, mainly because the name is tied to the actions of the people using the objects. At first, I thought that this might be some kind of insider's joke, and that the Senecas may have invented names for the gullible scholars. After studying our languages in more detail, these names made sense. It is a different way of thinking about what scholars call material culture. It reinforces the idea of art made for use.

For other objects, the native names also refer more to function. The infamous tomahawk, the much feared weapon of the Iroquois warriors seen in early American art and modern movies, is called *o-sque-sont (a'kwihsq:t* in modern Seneca form) meaning "ax is attached to it." This refers to the wood handle to which the metal ax head was attached. In reality, it was used more as a tool than as a scalping weapon. A walking cane is called "what one leans on." A ladle is "it stirs." A horse saddle, a more recent invention, is named "one uses it to perch on." Again, we can see people using these things as a part of their daily lives, but I have to confess that, after twenty-five years of working in museums, I have yet to find something made by the Iroquois that is named "what one places in a display case and lights effectively."

Morgan's work was centered at the Tonawanda Seneca reservation near Akron, New York, but he also visited other communities over the six years he spent among the Iroquois. Tonawanda is considered the spiritual "fire" of the Seneca Nation. In 1850, most of the people at Tonawanda were traditionalists, known as People of the Longhouse. Tonawanda operated under the ancient system of council chiefs and clan mothers. Seneca women were selling their crafts, along with sassafras and ginseng, on the streets of Buffalo. Even a century later when I was a child living in Buffalo, Seneca women could be found with folding tables covered with beadwork in downtown Buffalo. Today, Iroquoian beadworkers would find it demeaning to sell on the sidewalk, and people now visit the reservations in search of beadwork, baskets, lacrosse sticks, carvings, paintings, and other artwork.

Morgan describes the beading at Tonawanda in an 1850 report:

In doing this work, the eye is the chief reliance. They never work from patterns, or drawings, except as they have seen them in print. They imitate natural objects like flowers, with great accuracy. The art of flowering as they call it is the most difficult of any beadwork, for the reason that in addition to an accurate knowledge of the flower at the stage in which it is to be represented, they must be able to imitate closely. In combining colors they never seek strong contrasts, but choose those which most harmoniously blend with each other. White beads are most used, and usually to separate the other colors. In making their combinations, the following general rules are observed: light green and pink go well together with white between, dark blue and yellow also with white between, red and light blue with white between, dark purple with light purple with white between. For flowering dark green are used for stems with white glass, pink glass and green glass, and yellow glass for the flowers.

I assume that by "pink glass" Morgan meant the beads that are pink in tone, but are translucent or transparent. The question that this raises is whether the Seneca had different styles or color combinations in their beadwork. As a Tuscarora, I wanted to learn of art concepts that belonged to us as opposed to other Iroquois peoples; this question has continued to be important to me over the years. Unless the beadwork is specifically and firmly identified as to its tribal provenance, it is nearly impossible to determine its source. Iroquois beadwork also looks like other beadwork from the Micmacs, Maliceets, and other New England tribes. Yet, it makes sense that, among the Iroquois, there would be regional if not tribal differences. If you see enough old beadwork, you will notice trends and combinations that would imply common sources, but, because of intertribal trading of styles, I do not feel that anyone can state definitively which style was created in what community.

I sought the answers from the beadworkers themselves. My wife and I traveled to each of the Iroquois reservations in 1972 and 1973 to photograph and interview the craftspeople. I learned a great deal from Tuscaroras Louise Henry, Matilda Hill, and Doris Hudson but did not come away with any sense of unique Tuscarora designs. They all noted that designs had been traded back and forth for several generations. I have come to believe that what is important is not individual styles, but that the Iroquois people reinforce

both their personal and group identity through these shared patterns.

The Iroquois world that Morgan entered had been deeply divided about what kind of future lay ahead. Some felt the Iroquois were in the final stages of cultural decline. Others felt that a cultural renaissance was at hand. Handsome Lake, the Seneca prophet, put forth a vision in 1799 for the traditional Iroquois that retained the values and rituals of the past but also gave some advice on coping with the White man's culture. It is my feeling that the code preached by Handsome Lake fueled the desire to keep the arts vital, and the emergence of a new version of an older Iroquoian aesthetic can be seen in the beadwork that emerged from that period. Handsome Lake said that the single-family log cabin instead of the old-style bark longhouse, the raising of livestock rather than the constant hunt, and the men's involvement in farming (a major reversal from the traditional role of the women as the principal agriculturalists) were socially acceptable. Handsome Lake did not, however, tolerate the religion of the Whites, and art may have been viewed as the vehicle by which the Iroquois could remain distinctive within the larger society that was surrounding them. Beadwork on clothing became a marker of that distinctiveness. Women moved from the fields into the beading room, and the more sedentary lifestyle on the reservation allowed for more serious beading.

My visit to the Peabody Essex Museum rekindled my search for tribal designs. There is a series of Seneca leggings in this collection containing some of the earliest examples that I have ever seen, and they allow us to begin to address this question. Each sample has its own Seneca name for the design, which is very rare and relatively unknown by the Iroquois beadworkers of today. It was work commissioned by Frank Speck and his wife, and it was later sold to the museum. However, these unusual pieces raise notions that the designs could have been manufactured and named simply because someone was willing to pay for them. The fact that the pieces include names such as "warbonnet" (which looks more like a Plains Indian headdress), or "drunkard's path" (which is a zigzag pattern), seems to suggest that these were relatively new designs. Even if that is true, the bead-

work still shows the attention to detail that Morgan admired nearly 145 years ago and reflects how a beadworker could absorb new ideas and continually create new patterns of thought.

Morgan uses the term "costume" to refer to Iroquois clothing, and this has continued to bother me. In part, it seemed logical in his time, in that Indians would dress in these clothes only for certain ceremonial and public occasions, almost employing them as dress uniforms. The term, however, has the connotation of stage apparel, which denigrates the real meaning of the clothing. Does the pope don his papal costume when he celebrates Mass? Do funeral homes dress the deceased in a costume? However, the term "costume" has been used for so long, even the Indians use it today. To me, clowns wear costumes; Indians wear clothing. Ritual clothing is sometimes referred to as "outfits" among the longhouse people of today. In reality, the clothes we wear daily are our costumes as we assume roles that are unnatural for us as Indians—curator, professor, museum director, or trustee.

While everyday clothing for the Iroquois was similar to that of their White neighbors, the clothing worn at council meetings, rituals, marriages, and funerals was the visual metaphor for a deeper-held belief system. When you compare the 1849 daguerreotype of Caroline Parker (a Seneca who had helped Morgan collect and name many of the objects he assembled) with the drawing of her dressed in Seneca clothing as the frontispiece to volume two of Morgan's *League of the Ho-dé-no-sau-nee,* it is hard to tell what is real and what is fabricated reality. The daguerreotype is retouched, and a blanket appears awkwardly over her shoulder. That same blanket is seen in the drawing, but the drawn silver brooches are larger than the ones in the photograph. The beadwork on her cuffs is also different from that in the drawing. If the drawing were the only model of the Seneca style of clothing, some of these discrepancies would be significant (figure 10). When we put on our ritual clothing, it is because we feel that we should look our best when we give thanks to the Creator. It is not a dress rehearsal; it is the real thing.

Figure 10
**Daughter of Ely S. Parker
in Native American Dress**
Photographed in Seneca,
New York, by W. H. Jackson
between 1869 and 1873.
Courtesy of the National
Museum of the American
Indian, Smithsonian
Institution.

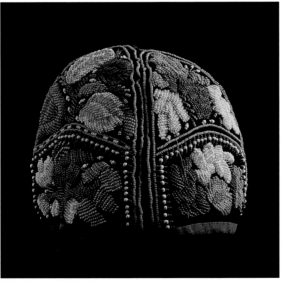

Figure 11
Depiction of Tuscarora Men Wearing Sashes
Courtesy of the National Museum of the Anthropological Archives of the Smithsonian Institution, Washington, D.C.

Figure 12
Cap with Glass Beads
Mohawk Artist
Late 19th Century
E34655

Coping with Change

The Iroquois had cause to wonder if their once famous confederacy was going to survive. Despite radical changes, it is obvious that the Tuscarora did not accept the role of victim, nor did the federal government run their lives. The traditional clan system of council chiefs and clan mothers remained intact as the only form of governance of the nation. It still exists today. The Tuscarora nation used ancient patterns of agriculture to build a new life as they produced more crops and built bigger and better homes in which to live, and, by the 1820s, they were prospering.

About this same time, missionaries were just beginning to make inroads at the Tuscarora reservation, but most people were still practicing their older religion. A major break came in 1820 as the battle over souls turned violent. About seventy of the traditionalists left the reservation because it was becoming increasingly Christian and settled at the Six Nations Reserve, where my grandfather, who is also Tuscarora, would live. Those who remained in the original reservation apparently used their new religion to fuel a period of economic growth. In 1824, a newspaper account noted that "as a nation, or tribe, they are rich, and many of them, as individuals." The Indians even became the principal moneylenders in their county. This was the result of annual lease payments from lands in North Carolina, successful farming, and what one missionary called "correct ideas of property." It was even more remarkable given the fact that the entire community (including the homes, barns, school, church, and livestock) was destroyed by the British and that the reservation was temporarily abandoned until 1815. In less than a decade, Tuscarora arose from the ashes to start rebuilding itself as it had done several times in the previous century.

During the War of 1812, the Tuscarora, Seneca, Onondaga, and Oneida came to the aid of the fledgling United States and helped to turn back the invading British forces. When the British burned down the Indian homes at Tuscarora, which is about five miles from the old fort at Niagara, the Tuscaroras rallied and turned the British back. Tuscaroras served as a guard for the U.S. general Peter Porter and were said to have saved his life. After the war, to reward the Tuscarora for their meritorious service, the Porter family, who had come to own most of the property along the rapids of Niagara Falls, gave the Tuscarora women the right in perpetuity to sell their craftwork to the tourists without the concession fees charged to other vendors. Prior to 1815, Indians and Whites had been making treks to the falls, but western New York was still considered the frontier, and tourism was relatively unknown. No one knows for sure when the selling of beadwork by the falls started, but it was quite active by 1840. The first major hotel, the Cataract House, had been open since 1824. By 1845, there was a tram operated by waterpower that took people to the base of the falls. The first suspension bridge across the gorge below the falls opened in 1848, providing spectacular views. Steamboats were launched that same year below the falls to thrill the visitor with breathtaking perspectives of the crashing waters. From 1830 to 1860, tourism continued to rise.

In 1830, the Tuscarora Temperance Society was formed. They created their own flag, comprised of six stars overlooking an eagle that is wrestling with a horned, fiery serpent. The seven Tuscarora clans are placed across the bottom of the flag. The trend was to move away from the traditional lifestyle, onward and upward to Christian mobility. The Temperance Society promoted the ideals of "temperance, industry, education, and moral reform." Most of the Tuscarora would change from traditionalists at this time to Baptists a generation later. They would burn their own longhouse down along the way as they converted to Christianity. Indian clothing might have been considered a sign of the old way of life from which they were moving away, but beadwork provided a means of remaining industrious. Beadwork also continued to be an important source of income.

Considerable innovation could be seen at this time as well. Maybe such innovation was a way in which the Iroquois coped with change. From about 1840 to 1870, the Scottish Highlander's headgear, called the glengarry bonnet, was introduced among the Iroquois. Soldiers would be seen wearing the cap as part of their official uni-

form, and the Iroquois took the same form and beaded their own reality to it. Whether it was a conscious satire cannot be said for sure, but it is interesting that the glengarry cap of the White military soldiers became the beaded cap of Iroquois women. At first, the caps were sewn with porcupine quills and moose hair embroidery. Beads were then used in later models with asymmetrical floral designs. Towards the end of the century, the Iroquois women began to make more symmetrical designs, with bigger leaves and more colorful beading. On a few glengarry caps from the turn of the century, birds and animals have been added to the floral patterns.

The arts also contributed to the local wealth at Tuscarora. The women were actually cultural mediators, using beadwork to balance the changing social, religious, and economic forces in their community as new bridges were being built to the outside world. Their beadwork was one of those bridges, appealing to all sides as a carrier, if not a unifier, of identity, and returning pride, admiration, and cash to the community. While the Iroquois men began to dress in pants, suits, and top hats, as if competing with their White neighbors, the Iroquois women began to decorate their overdresses with more and more beads and silver brooches. Women's clothing seemed to resist change. It must have been quite a glorious sight to see an Iroquois couple, all dressed up to go to town. For the men, wearing the shoulder sash, a top hat with a silver hatband, and perhaps beaded cuffs and armbands over their topcoat might have been a singular experience (figures 11 and 12).

Both the Tuscarora and Seneca Indians could be found at Niagara Falls selling their work. In 1853, Fredrika Bremer noted that it was the Seneca who lived nearby, and the Seneca women could be seen at the falls selling "embroidery done by hand, of flowers and animals, drawn and finished in a childish manner, but yet well done with dyed fibre of porcupine quills, small mats, baskets, moccasins, and children's rattles, made of a fragrant kind of grass. There are many shops around here full of their work, which is sold at a high price."[4] The Iroquois would still have been making quillwork at that time, but most likely the "mats" she refers to are very much like the

birchbark trays in this exhibition. They are decorated with moose hair, not porcupine quills. While these were sold by the Tuscarora and Seneca, they were probably made by other Indians. It is likely that decorated "mats" labeled as Tuscarora were actually made by the Huron and Algonquian Indians in Canada. The fragrant grass is sweetgrass, which the Iroquois still use in basketmaking. There are many examples of such sweetgrass baskets in the Peabody Essex Museum collections.

Another writer noted in 1876 that the Tuscarora numbered about four hundred residents and that they "reap large profits from the crowds of visitors who repair to the Falls. Their skill is displayed in ingeniously carving out pipes and pipe stems; manufacturing moccasins, shoes, and purses with beads; fans, pincushions, needle-cases, canoes, strings and bracelets—all wrought in brilliant colors. Many of their devices are fanciful, skillfully worked out, grotesquely adorned, and exposed with fine effect."[5] The 1892 census of the Six Nations gives us a pretty good idea of how people made a living. Most of the Iroquois families operated a family farm, as much of the reservation land was leased to outside farmers. The orchards at Tuscarora were in good condition. Each reservation had an annual agricultural fair that had been promoted by the State of New York for several years, but these fairs were on the decline at this time. Crops as well as artwork would have been displayed at these fairs. The census report notes that basketmaking was widespread and that the Iroquois sold their baskets at Niagara and Saratoga, as well as at the state and county fairs. Among the Mohawks, nearly every family had at least one basketmaker. The total income from basketmaking at Akwesasne that year was reported at fifty-five thousand dollars, which was ten times as much as was realized from the sale of crops. There were only ten or twelve beadworkers known at Akwesasne. The report comments that "The Tuscarora near Niagara are especially skillful in beadwork, but every reservation has its experts as well as its novices at this calling."

Tuscarora was also noteworthy in having more productive farmers and a number of better

houses. The census maintained that the typical Tuscarora home included a "second-hand stove, plain bedsteads, tables, utensils, crockery, home-made quilts, muslin curtains, a few cheap chairs or benches, and other absolute essentials." It was in this kind of modest log home that beautiful beadwork was created and carried by horse and buggy to the streets of Niagara Falls, ten miles to the south, to be sold to the tourists.

The Magical Tourist-Trapping Bead

In 1876, a Mohawk lacrosse team toured England, demonstrating the game before Queen Victoria at the Crystal Palace. She gave the game her blessing, and it began to spread across the British Empire. Canada had adopted lacrosse as its national sport, and by 1878 lacrosse was being played in Australia and New Zealand. The Indian players would often wear traditional clothes as a part of their presentation of lacrosse. These clothes became more colorfully adorned to impress the crowds. Peacock feathers were added to the headdresses for more color. Flowing over-dresses, similar to those worn by well-to-do White ladies, began to appear in Iroquois clothing. The Victorian era brought another creative explosion. Beads were the means by which the Iroquois made their impact during this period.

The Mohawks began to develop a style of bead-work that has come to be known as embossed beadwork. This is accomplished by overlapping rows of beads to create raised images. The Mohawks used large, clear beads in increasingly elaborate patterns of floral borders, birds, and clan animals. By the end of the century, most of the work looked like clear cake frosting. They sold their work to tourists near Montreal and at Saratoga Springs, New York. No one knows how that style spread. Perhaps it was through the New York State Fair, where all Iroquois Indians would gather and display their art. Alternatively, the vehicle may have been the annual Grand Council gatherings at Onondaga at which the Mohawks appeared with their beautifully decorated clothing, cradleboards, wrappings, and accessories. The Mohawks were also part of the Wild West shows and traveled extensively. However it happened, the Seneca and Tuscarora women were soon making their own versions of this embossed beadwork.

The tourists sought a romanticized view of nature, and the beadwork was a perfect manifestation of their ideals. "Oh! Bring the atheist here, and he cannot return an atheist," wrote Thomas More in 1804.[6] The falls had religious connotations for the visitors. Tourists flocked to the region around Niagara Falls in search of the sensation of the sublime created by the natural wonder of the falls. They viewed themselves as fashionable and learned, but their fascination with the falls was almost irresistible. The experience of this natural phenomenon seemed to engender a wonderment that was inexpressible. Because the Erie Canal and the railroads were available to bring people to the falls, it was scarcely surprising that it developed into the tourist destination that it did. Tourist shops appeared suddenly, as did hotels and gambling saloons. Hawkers roamed through the crowds. Walls were put up, and people had to pay for a view of the falls.

Indians fitted into the notions that the tourists had about the falls. The oral history presented to the tourists created the image of an ancient sacrifice of a beautiful Indian maiden over the falls to appease the Thunder Beings who lived behind it. This manufactured Indian legend served the tourists well. In 1871, the legend of the falls was codified in a history book, noting that "It is a standing tradition of the Niagara Indians, shared to a great extent now by the white people in the vicinity of the Falls, that the 'Great Spirit,' or Thunderer of Waters, must have, annually, four victims sacrificed to his power." Apparently, at least four people plunged to their deaths each year, leading the author to conclude "So far, therefore, the Indians believe, implicitly, in the fourfold sacrifice; and each year's disasters confirm this belief."[7] In 1881, Lady Mary Hardy alluded to that mystic tale and cited this explanation for such suicides: "The Indians hold that Niagara claims its yearly meed of victims. It may be so. Or does Niagara thus avenge itself on the civilization that has trimmed and tamed its forests and dressed it up in tinsel-coloured lights. But the thunder of water thunders on eternally, and before its terrible sublimity we are dumb, as in the mighty diapason our feeble voices are lost."[8]

Nature was both powerful and dangerous to the nineteenth-century tourist. This was exemplified by artist Frederic Church in his 1857 painting entitled *Niagara Falls*. For the first time, a man-made work captured the feeling of that generation about the grandeur of nature. That painting encouraged more tourists to come in search of a near mystical experience at the falls. The year 1901 brought electricity from the falls to the public in Buffalo during the Pan-American Exposition. One of the promotional images of that event was that of an Indian going over the falls in a canoe, recalling the Maid of the Mist legend. The harnessing of the falls for electricity seemed to be a resounding act of dominance over nature. However, tourism, nature, and the Indians would be reminders of that struggle for generations to come.

In some respects, this image of Indians as both dangerous and beautiful persisted. Indian art was viewed as a colorful reminder of a savage past. People began to assemble Indian artifacts in their parlors and studies. The mainstays of these private collections were Navajo weavings, California Indian baskets, and northeastern beadwork. The Indian beadwork served as a souvenir of the trip to the falls. Early offerings from the Indians would have been reflections of what was used at home—dolls, moccasins, purses, birchbark canoes, feathered headbands, and carved pipes. Indian women could be found selling their beadwork on city street corners and on Goat Island, between the two main falls.

Indian work could also be found on both sides of the border, as Iroquois Indians from the Six Nations Reserve, the homeland of my father, would travel six miles to the falls to sell their goods as well. In 1865, the Civil War correspondent for the *London Times* visited the Canadian side of the falls and found that "the bazaars, where they sell views, sea shells, Indian beadwork and feathers, moccasins, stuffed birds, and the like, were open and anxious for customers, in the middle of winter."

Both Tuscarora men and women would often go from house to house in nearby White settlements selling corn husk mats, baskets, and berries as well as beadwork. Not to be outdone,

and perhaps influenced by the people to whom they sold their beadwork, the Tuscarora log homes began to grow in the 1890s. Parlors were added to the Indian log cabins. Several of the Tuscarora chiefs added libraries to their homes as well. Tables to accommodate photographic albums also started to appear in the Indian homes of this period. These were places where the family gathered to talk after the day's work was over. I can imagine the beadworkers as a part of these settings.

Beadwork grew increasingly more colorful and ornate as competition increased and as it sought to attract the non-Indian eye. "Did you ever do the falls?" was the question of the day for the leisured classes, and the falls had become increasingly identified as a place to meet Indians. By the 1890s, beaded pincushions and small pillows incorporated English words sewn in beads. "Niagara Falls," "Mother," "Remember Me," or "My Favorite" and the date could be seen on more and more work. This mimicked the non-Indian souvenirs that contained such phrases. The Canadian power plant produced a silver paperweight with its corporate logotype that had a powerful-looking Indian man standing in a canoe as he paddled the rapids. He wears the big western headdress that had already become popularized through the Wild West shows, and he is surrounded by arrowheads and fish. The word "Niagara" appears spread across two lines.

I have seen a beaded souvenir with the same approach to lettering. At first, it would appear that the beadworker simply ran out of space, but, more likely, they simply copied the style of the paperweight. The Iroquois women borrowed many ideas. There are beaded horseshoes that date from 1893. High-heeled shoes and boots became beaded ornaments that could be hung on the wall. Pincushions were sometimes so completely covered with beads that there was no room for needles. Needle cases, wall pockets, purses, hearts, small pillows, decorated doilies, and even chickens became objects for beadwork. In the National Museum of the American Indian, there is a single beaded leg that looks as if it were that of a plump burlesque entertainer. I have no idea what its intended use was; perhaps it, too, was a pincushion or simply an ornament.

There were specific trends evident at different periods. Between 1840 and 1890, large clear beads on red, black, brown, yellow, green, or purple velvet were favored. Designs were drawn on paper that was placed on top of the velvet. After the beads were sewn, the excess paper was cut away, but there was still some visible underneath the beadwork. When I first learned of this, I thought that it was a rather sloppy way to sew beads, in that the paper would always show. I later realized that the white paper helped to make the clear beads sparkle a little more, and that this was a pragmatic reason for the paper being placed on top of the velvet. Non-Indian women also sewed beadwork during this period, and often the designs are very similar. The non-Indians most often did not use the paper templates on top of their beadwork, and most of this work was done in clear or yellow-tinted beads. Sometimes translucent and opaque beads of the same color were used in the same pattern to create the illusion of embossed shapes. Metal sequins were also added by Mohawk beadworkers to these kinds of items.

From 1890 to 1910, the beads became smaller, and a few new colors were in use. The paper was still being placed on top of the velvet, but the bottom of the work was covered with glazed chintz fabric. Cotton tape was used for trimming, and large tubular beads began to drape from the pieces as the work appeared more and more like cake frosting. From 1920 to 1950, multicolored opaque beads were used, and backgrounds become black, dark blue, or deep red velvet with silk ribbon edging. Paper designs were now placed under the velvet so that no paper was visible from the outside. The wider range of colors resulted in a new technique. The raised effect of the earlier style was visually enhanced by the clever use of beads. The use of light and dark hues of the same color gave the effect of shadows and highlights. There were other changes as well. The full boot of the 1890s had become a two-dimensional outline of a boot. The hairpin container (Victorian women used long hairpins) had been transformed into a slipper shape that was more of an ornament than a container. Beaded jewelry boxes had almost disappeared altogether. Coin purses, eye-

glass cases, and picture frames can still be seen today.

Historians have called these creations "beaded whimsies," but this has always bothered me. While I understand that, during the Victorian period and even later, people were partial to an overly ornate style and that the heavily beaded pieces often had fairy-tale qualities to them, the notion of this beadwork being considered a whimsy seems to diminish its cultural intent. However, I also realize that the romantic notions at work here were those of the non-Indian buyer. One could argue that there was a sense of felicity among the emerging middle class and that the fanciful Indian beadwork was appealing to this cultural group.

The Indian creations were in vogue both because of the familiarity of the design and its unexpected qualities; they were made by Indians, but they were also perfectly suited to Victorian tastes. In the parlors, oriental rugs lay next to bearskins. Flowers in finely crafted English vases would stand next to the "whimsies" with their beaded flowers made by the Indians. Tennis was played alongside archery tournaments. The sparkle of the beads on household objects in incredible shapes created a strong impression on Victorian minds. It is a study in contrasts, but with a subtle feeling of domination over what was once considered wild. Medicine shows, for example, would travel through the countryside selling an Indian potion called *katongah* that was considered a cure-all. Despite the relative calm in the East, the Indian wars of the West continued. The parlor, however, made Indians safe commodities for the Victorian consumer.

Purses were particularly popular beadwork items. I am convinced that these were first carried by the Tuscarora women who went to the falls to sell other things, and that tourists continually tried to buy them. There were three main types of purses. The first was more of a pouch with a drawstring to close it. There would be a beaded panel on the part of the purse that hangs below the gathered top. The second kind is a six-sided purse where the edges are said by some to represent the six Iroquois nations. These purses have a beaded flap for a cover. The third kind

has a scalloped edge in many shapes and sizes. I would suggest that the more elaborate scalloped-edge purses are the more recent explorations into what could be done with beads, perhaps during the period between 1890 and 1920.

In 1899, Mariana Van Rensselaer suggested that the autumn was the best time to visit Niagara because "It is the most gorgeously multicolored, of course, when the ravine and its islands commemorate its long dead Indians by donning the war-paint of autumn."[9] These notions of fading Indians, Indian summer, intoxicating views, and souvenirs produced a cultural industry for the Indians. It may seem strange that, during the persecution of the Plains Indians for the Ghost Dance, the Iroquois were making a tidy living selling beadwork to the tourists. One must remember that great changes had already taken place in the East. In 1890, the year of the massacre at Wounded Knee, Mohawk men were becoming ironworkers in cities like New York. The economic situation may have been more similar than we think in some areas; Plains Indians in Alberta were photographed in 1899 selling buffalo horns to tourists at train stops. Tourism has continually prompted Indians to produce art for sale. Yet little can now be seen of the Tuscarora or Seneca beadwork in the shops of Niagara Falls. Cheap imports and Japanese beadwork have taken over. No one on the reservation could survive by making beadwork to sell at the falls. The powwow circuit and crafts festivals are the new venues to which the Tuscarora have taken their work in order to keep it viable.

Woven cloth, glass beads, spun thread, and steel needles have tied the Indians of the last seven generations together artistically. Most Indians would not recognize the beads that were traded seven generations ago, but would know the difference between seed beads, pony beads, and crow beads. The reason why white or clear beads appeared in Iroquois beadwork a century ago was because that was about all that was available. The previous generations used what they had. Today, there are more varieties of beads

than ever before, and the beadwork is more colorful, not less traditional. If pink and turquoise beads had been more accessible in 1890, that is what you would have seen in Tuscarora beadwork. A long line of beadworkers from Tuscarora have made their way to the falls. While the names of Delia Patterson, Rihsakwad, Caroline Jacobs, Sofronie Thompson, Matilda Hill, Harriet Pembleton, Doris Hudson, Louise Henry, Mildred Garlow (who was a Seneca living at Tuscarora), Doris Printup, Marge Wilson (a Mohawk living at Tuscarora), Penny Hudson, or Annette Printup Clause (a Cayuga living at Tuscarora) may not make it into any Indian art publications, they have kept a tradition alive. My wife, Linda, and several other women gather each week to sew their beads, discuss life at Tuscarora, and exchange ideas and techniques about sewing. Beadwork is one of the many links that keep the identity of the people of Tuscarora strong. Seldom will you now see Tuscarora women selling their beadwork by the falls. I have not seen a Seneca woman selling beadwork on the streets of Buffalo in the last twenty years. The beaded dresses, moccasins, and necklaces keep flowing from the hands of the beadworkers. The best is now saved for the children, and the clothing of the young Iroquois is being reempowered with beaded patterns of identity.

The Beaded Dress

What amazed me most about seeing Iroquois beadwork from the past was that, in spite of the great diversity in the patterns of expression, one still retained the overall sense of its being Iroquoian. I have seen hundreds of pieces of Iroquois beadwork, old and new, and few are the same. It would appear that the previous generations also relished creativity. As I now watch women dance in the longhouse with their moccasined feet shuffling, their beaded dresses swinging to the beat of the drum, and the colorful calico dress tops slowly twirling, I am amazed by the fact that each dress is different. With each passing dress, I see visual references to the sky dome from which the first woman fell to this place. I see floral patterns that are visual

metaphors for the celestial tree of life, the plants that grew from that Sky Woman's body. I see geometric patterns of Earth Mother, and the Water World that carries the earth. I also see clan animals that distinguish the family connections of the women. I realize that each dress interprets the Iroquois universe in its own way. Each dress is like a visual prayer. Women take the time to make the dress, prepare for the dance, and come forward and express themselves through both their clothing and the communal dance. Just making the dress in itself is not enough; the dress needs to be danced. The dance needs the dress to give it meaning. The dress needs the person to give it motion. It is a partnership that is repeated anytime Iroquois women gather in a circle to dance.

In the past, there were no cultural police to point out dress designs that violated anthropological correctness. There were people who looked for and acknowledged a particularly exceptional design or technique, and the presence of one made the entire gathering feel rewarded. There was pride in the clothing. In 1892, the census report for that year describes the clothing of eighty-year-old Martha Hemlock, a Seneca who dressed in "full regalia" for the "thanksgiving dance." Her attire consisted of "a cape of bright, clean, and stiffly starched calico [and the] dress bore closely uniting rows of silver brooches, 12 deep on the back. From the throat to the bottom hem in front similar silver brooches, mostly of eagles' heads, in pairs, widened out, until the bottom cross row numbered 16. Each brooch, well hammered out and punched through in somewhat artistic openings, had been made long ago from quarter and half dollar pieces and Canadian shillings, and was the representation of so much money, the cape being valued, with a front lapel, at $75."

In previous times, Iroquois women cultivated the crops. The extended family clans would each have their own plot for which they were responsible. They supervised the planting in what is called mound agriculture. This old form of farming was done by building up a mound

of earth, and planting several kernels of corn on top of the mound. Around the corn were planted beans that would climb up the cornstalks. Around the beans were planted squash, whose broad leaves would keep the mound moist and keep the weeds down. These mounds, planted about four or five feet apart, would make a very different impression than the even rows of corn we now see planted in our former homelands. Together, corn, beans, and squash are known as the Three Sisters, our sustenance. The Iroquois believe that each has its own female spiritual essence. Since the earth is also female, it is only logical that women should tend to the growing of crops, nurturing them as they do their own children.

The women would also supervise the two major hoeings of the crops during the growing cycle and orchestrate the harvesting. These were major tasks and required both leadership and cooperation. Imagine what kind of planning it would take to plant, cultivate, and harvest food to feed a village of one thousand people. Men participated as needed to clear the fields, create the mounds, and haul in the harvest. The bounty of the harvest depended both upon the cooperation between men and women as well as the cooperation between humans and the unseen forces of the land.

This relationship with the land in Iroquois culture formulates much of its sense of place and creates the responsibility to the land and the unique relationship to the plants, landforms, animals, and birds that occupy the same place. The Iroquois, like most Indians, have personified the universe. The earth is our mother and provides all that we need to live a happy life. The moon is our grandmother and brings the changing seasons to the earth. The moon also brings forth children through the women. The sun is our elder brother who brings us warmth and light. The winds are our grandfathers who bring life-giving rains.

Each of the Six Nations also relates to its local environment in its own way. The Seneca Nation calls itself the People of the Great Hill because

they believe they emerged from the earth at a place called Bare Hill. The Cayuga Nation calls itself the People of the Great Swamp, as they lived near the wetlands of central New York. The Onondaga call themselves the People of the Hills because they still live in the valleys near Onondaga Hill, south of Syracuse. The Oneida Nation is known as the People of the Standing Stone, a reference to a great white stone near their villages. The Mohawk Nation is called the People of the Land of Flint, as they lived in the Mohawk Valley, south of the Adirondack Mountains. We Tuscarora call ourselves Ska-Roo-Reh, meaning the Hemp-Gathering People, a reference to our previous occupation in our former homelands in North Carolina.

Rituals permeated the patterns of agriculture for the Iroquois, as the men and women gathered throughout the year to pay tribute to the gifts of creation, return thanks to the Creator for all that He has provided, and ask that the natural forces return to bestow their blessings upon the people in the form of food and medicine. While dances, speeches, and feasting were a part of those rituals, so was looking one's best. This is where the elaborately decorated clothing comes into play and why beadwork is so important to the Iroquois of yesterday and today.

I visited the Rochester Museum for the first time in 1973. George Hamell, curator of Iroquois culture, took me through the storage areas. Drawer after drawer was full of Iroquoian treasures. Tray upon tray of silver brooches glistened before my eyes. Layers of beadwork sparkled in their silent cabinets. The clothing came to life from its storage compartments. There were old-style leather dresses as clean as the day they were made, with quills outlining the shape of the dress, tunic, or leggings. There were calico dress tops with silver brooches arranged down the front and around the bottom. There were fully beaded skirts of red, blue, or black broadcloth. To me, it was as if I had experienced a glimpse of heaven on my journey of identity. It

was then that I realized that I had to make things with beads to express that sense of identity.

My wife and I had been actively seeking our place within the longhouse. We both obtained our Indian names, and we busied ourselves in making our clothing. I sewed the beadwork on her skirt. The very act of doing so seemed to connect me to the universe in a new way. In fact, the designs on a woman's dress are a metaphor for the universe. Around the bottom of the dress are parallel lines and rows of triangles. These represent the water upon which the earth floats. Arching over that water is a series of domes that represent the Sky World above, the place from which the first woman fell into this world. Within that dome are small domes or triangles that represent Mother Earth, which is symbolized as a turtle. The Sky Woman was placed upon the back of a giant snapping turtle. The muskrat dove to the bottom of the water and returned with a little lump of clay that, when placed on the back of the turtle, grew magically into an island. Each day, the Sky Woman would walk in an ever-increasing circle, and the land grew in front of her. It is for this reason that we call North America the Great Turtle Island.

Growing from that turtle dome on the woman's dress are three white lines that have been said to represent the Three Sisters—corn, beans, and squash—or, the three main concepts of the great law of peace—unity, righteousness, and law. They show life on Great Turtle Island growing up from the ground. On the top of each sky dome usually sits a double curve as a reference to the life of the Sky World. On the front of the skirt is a large floral pattern of a celestial tree design. This is a flowery tree of colorful fruits and lights that is said to stand in the Sky World.

Each woman's dress is a different interpretation of these figures. What attracts me to the dress is that it explains the female forces within our universe. The decorations on the dress, whether they are done in quills or beads, relate the women to ancient patterns of life, and yet show that those

patterns continue today each time the dress is worn in a dance. The dance is the gathering of the dresses as much as it is the expression of thanksgiving by the people.

When my first wife died of cancer, I wished she could have been buried wearing that dress. I wanted the Creator to see her in her finest clothing. We were no longer married, but that dress was our common bond as much as our daughters were. However, the longhouse people believe that the body should no longer be placed in the ground with any glass or metal. I learned this the hard way. At one time, I was an instructor in the Indian Cultural Awareness Program at the prison in Attica. My wife and I had taught the Indian inmates how to make beadwork. One night during our weekly session, they handed me a small pink necklace that they had made for my newborn daughter. It was a very emotional moment for me. Here I was in Attica, a few feet away from where the infamous riot had occurred, and standing before me like proud uncles were several Indian inmates. For one of the few times in my life, I was completely speechless. That little circle of beads meant the world to me, but it was to become the most tragic gift I ever received.

A guard came into the room and told me I had a phone call. It was my wife telling me I should meet her at the hospital because something was wrong with our daughter. She died before I arrived there. When I saw my wife, I reached into my pocket and pulled out that tiny pink necklace the inmates had made for our daughter. She would never wear it. At her death feast, we had to give it away along with her cradleboard, clothing, and goods. The memory of that beaded necklace and the men who made it for my family will never fade. That is how I look at the artwork made by the Iroquois of the past. Perfection of form is not as important to me as purity of intention. That intention is what motivates the artist to experiment with forms. Artists, by their nature, understand that intention is more significant than what is described as creativity.

Two longhouse friends of mine helped me to prepare my daughter's little body for the funeral. They made her a small dress skirt and leggings, but without any beaded designs. At the graveyard after the longhouse service, the speaker explained that we bury people differently today. In former times, people would be buried with their favorite items, fully dressed in their most beautiful clothes. Food in ceramic jars would be placed with them so that they could eat on their journey to the land beyond the sky. People would be buried with all the things they needed to get by in this life, as well as all of those that would be needed in the afterlife.

The longhouse people were forced to change, however. The speaker explained that, because of the work of archaeologists in the search for such goods, it was decided that the best way to protect the dead was to bury them with things that would completely decay, so that there would be no desire to desecrate their graves in the future. My daughter and my wife had to be buried without the beautiful designs that helped to define them in this world.

I eventually remarried. This time, however, I married in the longhouse. Again I sewed the beads on my wife's dress. I wore leggings that I had made as well. Beads and silver covered our clothing. Our pledge to the Creator in our marriage was heightened because we took the time to make the clothing ourselves. I was sure that He would be happy to see two more Iroquois people dressed in their finest apparel standing in the center of the longhouse.

The same metaphors were at work, the same tiny white beads were used, but the dress was different from the one I made before. Each one has its own personality. Years later, we sewed a dress for my new daughter. I had sewn the designs of the sky dome and the celestial tree before, but now the designs meant more to me. Each bead, every stitch, and each pattern carried more weight.

My family attended the opening of an exhibit that I had worked on for the Custom House Museum in New York City in November of 1992. My daughter wore her beaded dress at the pow-wow we had to celebrate that opening. After the powwow, we went up to the top of the Empire State Building, as I wanted to point out to my children all of the buildings that were made by Iroquois ironworkers. As we returned to the car, I discovered that someone had broken into it and stolen the bag with my daughter's dress as well as the traditional clothing of my two sons.

My daughter was heartbroken. She said that she could never dance again. She was six years old, and I felt so defeated myself, wondering what I had done wrong that the Creator would let such a thing happen. My wife and I had spent months sewing the beadwork on their clothing. I woke early the next morning after a restless night. I prayed to the Creator, reminding him how much that dress meant to all of us. For some reason, I went back to the scene of the theft and walked around for two hours, searching every garbage can, every alley, everywhere, hoping against all odds that I would find the discarded clothing. I wondered if the dress would mean anything to the person who stole it. As I was about to give up, I walked down one final alley. There was an old homeless man holding up my daughter's shawl as if he were trying to figure out what it was. Over his arm was my son's ribbon shirt. I said, "Excuse me, but those are mine." He showed me where he had found them. To my surprise, laid out on the sidewalk was the beaded skirt, her overdress with large brooches, her leggings, and beaded crown; my sons' clothing and moccasins were all there as well. I was so happy that I shoved money in that old man's hands and hailed a cab.

When I returned to the hotel and gave my daughter her dress back, I nearly cried. The Creator wanted my daughter to have her dress. I concluded that He must like the way she looks when she dances in that dress. That same dress made it all the way from New York City to Hopi country in Arizona. My oldest daughter married a Hopi man and had her wedding in 1994. My wife and I took our two youngest children to witness the wedding. My younger daughter, who served as the flower girl, wore her beaded dress that was recovered from the streets of New York, and my son wore his Iroquois clothing. My wife had made a new dress for the older daughter as well. While I realized that my daughter had to be adopted by the Hopi and would live among them, I was still proud that she wore her own version of the dress of identity that Iroquois women have worn for many generations. After the ceremony, one of the new in-laws came up and shook our hands. He leaned towards me and said, "I really like the clothing your family is wearing." I was an especially proud father at that moment. The hours of preparation it took and the miles we traveled were rewarded by that simple compliment.

My only wish now is that someday I will find the time to bead again. Who knows what patterns of expression await to be born of the same glass beads, cloth, and thread that have been used countless times before. The next dress, the next headdress, and the next painting I make will be unique, but they will also be connected to generations upon generations of art made to show the world what it means to be Hodenosaunee. For that opportunity, I will be forever grateful.

1.

SAMUEL L. CLEMENS
"A Day at Niagara," *Buffalo Express,* 21 August
1869; "Niagara," *Sketches New and Old* (Hart-
ford, Conn., 1875), 67, 71.

2.

NATHANIEL HAWTHORNE
"My Visit to Niagara," *New-England Magazine* 8
(February 1835), 92.

3.

LEWIS HENRY MORGAN
League of the Ho-dé-no-sau-nee or Iroquois
(New York, 1901).

4.

FREDRIKA BREMER
*The Homes of the New World; Impressions of
America* (New York, 1853), 1:593.

5.

J. W. FERREE
The Falls of Niagara and the Scenes around Them
(New York, 1876).

6.

LORD JOHN RUSSELL, ED.
*Memoirs, Journal and Correrspondance of
Thomas More* (London, 1853).

7.

"Niagara," *History Magazine,* 2d ser., 9 (January
1871): 79.

8.

LADY MARY HARDY
*Through Cities and Prairie Lands: Sketches of an
American Tour* (New York, 1881), 58.

9.

MARIANA VAN RENSSELAER
Niagara (New York, 1899).

Suzan Shown Harjo, *President and Executive Director of The Morning Star Institute*

Life is the first gift of the Spirit. The journey through it is the second. All children of Creation have received these gifts. Turtles, salmon, and ants have gifts of patience and order. Yellow medicine flowers have gifts of healing and joy. Each living being has power and purpose in the cycle it strives to complete, and in the way it intersects with the lives and journeys of others. It is for this reason that the human children seek and respect relatedness and that tribal prayers the world over are for the good day for all relations, all life.

I entitled this exhibition *Gifts of the Spirit* with respect for the many spiritual, cultural, national, and experiential origins of the wonderful works in it, and with thoughts of talent and tradition as gifts of Creation and art as gifts of the makers. This essay is written in recognition of some of the ways I am related to the Peoples, artists, and works involved in *Gifts of the Spirit*. I also offer this for a better understanding of how others came to possess most of the wealth of Native Peoples, who once were the richest and today are the most economically impoverished people in the United States.

Each of the artists whose work graces *Gifts of the Spirit* is the modern evidence of a distinct, ancient cultural continuum. The Native Nation of each has a unique Creation history and specific laws, cultural and family values, diasporic journeys, and continuing traditions, including making objects of power, celebration, passage, beauty, utility, and good humor. The journey offered in the following pages is the one I know.

One of the artists whose work is featured in this exhibition is Dan V. Lomahaftewa, who is Hopi and Choctaw. His offering is entitled *Dream of Ancient Life,* a painting depicting a small part of the Creation history of the Hopi People—their emergence in this world from underneath the surface of Mother Earth (pages 210 and 229). The Hopi origin place is a specific location on their traditional lands, where they have conducted ceremonies and observances since time immemorial. The painting is an abstraction based upon a design from a pot made thousands of years ago by a Hopi person in one of the oldest villages.

Many other works in *Gifts of the Spirit* also demonstrate the importance of place and

ancient images. *Water Spirit #3* by Truman Lowe is a sculpted construction representing the natural world of his home in the Winnebago Nation in Wisconsin. George Morrison's paintings—*Dark Is the Field. Towards the Night* and *Crimson Ridge. Path to the Sky*—are from his series entitled *Red Rock Variation: Lake Superior Landscape,* and are drawn from his Grand Portage Chippewa home in northern Minnesota. John Gonzales depicts the Underwater Serpent of his San Ildefonso Pueblo history in his incised ceramic plate. Harry Fonseca (Nisenan Maidu) and Richard Glazer-Danay (Caughnawaga Mohawk) use cultural icons in a modern setting in their respective works, *Rose and Coyote Dressed for the Heard Opening* and *Bingo War Bonnet.*

A Journey of the Tsistsistas (Cheyennes) and Gifts of the Great Spirit

Life for the Tsistsistas begins with the Morning Star. I am a Tsistsistas daughter, sister, and mother, and the Tsistsistas journey is a family history. Here is a part of our modern history that can be told.

A very long time ago, the Tsistsistas were sent from the Morning Star to Mother Earth. We were set down in the cold country as bears, who greet the new day with upstretched arms, palms to the sun. This was before the Great Floods—when all the beings understood each other—and just before the large hairy bear-eaters disappeared and the hairy-faced people went away.

Once having learned courage and ceremony, the Tsistsistas were turned into Human Beings and sent to the Beautiful Land. We were instructed to call God by the name of Maheo, the All Being, Great Medicine. The language we were given has no past tense and everything simply Is or Is Coming. It is not unlike the languages of other Peoples of the Beautiful Land—the Algonquian, Massachusett, Mohegan, Passamaquoddy, Penobscot, Pequot, and Wampanoag.

The first Tsistsistas were given prayers for the six directions, paints, songs, stories, and games for ceremonies and for daily use to honor all and for all to enjoy. They were told to tell all who would follow to walk gently and bravely through life; to speak with beauty, good humor, and clarity; to follow the loving, giving, and kindly ways; and to respect Mother Earth and all her children.

One spring, Maheo sent the Morning Star Woman to sustain and encourage the Tsistsistas in their difficult journey as Human Beings. As a grandmother, she brought the Four Gifts to feed the body and spirit—beans, corn, squash, and tobacco. As a young sister, she brought instructions for societal and governance organization for the orderly, peaceful way. Maheo told the Tsistsistas that the Nation would be strong, so long as the hearts of the women were not on the ground. They were given religious and social laws and rules of conduct that were strong enough to carry a people across the Great Waters and through the territory of others.

One day, just as life seemed to be in perfect order, Maheo instructed the Human Beings to flee the coming of the White Destruction. They began a long journey through the territory of the Anishnabe and Mdewakaton Dakota Peoples. By 1492, they were living with the Heviksnipahis, Hevhaitaneos, and other same-speaking relatives, near the countries of the Fox, Kickapoo, and Sac Peoples.

Again, Maheo told them to flee the coming of the White Destruction, and to follow the setting sun. For this journey and the one before, Maheo sent the Tsistsistas a mighty gift—an enchanted boy, who could talk to all the beings and could change into them. His name was Mutsiev, Sweet Medicine, and he lived for four lifetimes. When he grew into manhood and accepted his calling to help the Tsistsistas Nation, he was called the Prophet.

One summer, a red-tailed hawk took Sweet Medicine to the Buffalo Country to Nowahwus, Holy Mountain (Naccovosso, Bear Butte). He followed the ways of a fox, a butterfly, a lizard, and a snake doctor to a wonderful cave. There, he was shown the center of the world and given many gifts, the most sacred of which were the Four Medicines. He stayed in the cave for a long time, and visions came to visit him.

Sweet Medicine saw that men with long hair on their white faces would cover the world. He saw that they would carry many sicknesses of the body and heart, and warned that they were dangerous to the touch. He saw that they would try to destroy the buffalo and other natural animals with thunder-stone sticks, and that the Human Beings would cry from hunger. He said that the people could eat the coming spotted animal with white horns, but that it would carry sickness and would not feed the spirit. He described a same-spirit animal with long hair hanging down its neck and a tail that drags on the ground, and he told the people that it would be good to care for this animal and to ride it.

Sweet Medicine saw that the hairy white men would make holes in Mother Earth in their craving for the gold stone. He warned that they would try to kill all the natural people in their sleep and, failing that, split them up and change their ways with gold-stone leaves and a throat-burning sweet drink. He warned that, if the Tsistsistas followed these strange ways, their days would be turned to nights, their spirit would be broken, and the Human Beings would disappear.

Sweet Medicine gave the sacred Four Medicines to the Tsistsistas, and they were called the Arrow People and the Thunder Arrows. He organized the same-speaking Peoples into new ways of protecting and caring for one another. He established the Societies and gave them names, powers, duties, and ways of being, both religious and secular. He reorganized the Chiefs and gave a pipe for making peace to the Council of Forty-Four. He told the people to choose leaders and friends who could be trusted in battle, who could provide for the old people, and who would not harm a child.

Along the way, Sweet Medicine met a great man with powers like his own, Erect Horns, who had been sent by Maheo to help the Sutaio, Dog People. After a long test of powers, they made a treaty to travel and live together, and the Sutaio became part of the Tsistsistas Nation. The Tsistsistas Four Medicines and the Sutaio Medicine Hat protected and guided them all over their long and ongoing journey.

In the territory of the Buffalo Nation, the Tsistsistas met the Hunkpapa, Minneconjou, Oglala, Sicangu, Sisseton and Wahpeton Dakota and Lakota, the Arikara, Hidatsa, Mandan, and other Friendly Peoples. They became relatives and allies and went to church in the Black Hills and other sacred places. Sweet Medicine gave them more ceremonies, paints, designs, and other gifts for survival. The Tsistsistas were protected in their travels and recognized for who they were from great distances, and the Friendly Peoples also called them the Red Painted, the Rainbow, the Bright Shining, and the Pretty People.

One summer day, Sweet Medicine told the leaders of the Societies to take him to the Bear Medicine Lodge, a holy land of all the Friendly Peoples, which the strangers would call Devils Tower. Having done all that he could on Mother Earth, he decided to die. He reminded the people to travel together in a good way, with care and respect for all; to carry cedar, sage, sweetgrass, and seeds of the Four Gifts to nourish their bodies and spirits; and to greet the new day with smoke and thanksgiving. The Tsistsistas watched Sweet Medicine ascend from the top of Bear Medicine Lodge as a bear and disappear in the direction of the Morning Star.

The Tsistsistas lived along the Red Paint River, where they planted the Four Gifts. There, the Human Beings met the Hinono'el People, the Blue Clouds, who had been on a different path of the same journey. They had not seen each other for a very long time, since the ice cracked in the cold country. The Hinono'el were invited to the Tsistsistas Mohaewas, or Medicine Tipi Ceremony, and they became allies and relatives again.

The Tsistsistas also became friends after battle with the Apache, Comanche, Hohe, and Kiowa Peoples, and met them at Bear Butte, Bear Medicine Lodge, Bunch of Trees, or Buffalo Road Canyon, often with the Friendly Peoples. Along the way, the Tsistsistas had fights with enemies of the Friendly Peoples, such as the Blackfeet, Crow, Pawnee, Shoshone, and Ute Peoples, and made treaties from time to time for trade and for the use of hunting and gathering grounds.

As the Tsistsistas followed the setting sun to the west and south, they also followed the same-spirits—elks, antelopes, deer, buffalo, and horses—and most of the people lived rich, long lives.

Gifts of Veho Civilization

What Sweet Medicine envisioned began to unfold. By that time, the Human Beings were called Cheyennes, and "the prototype Plains Indians" by the hairy white men, whom the Tsistsistas called Veho, Spiders. The Veho called themselves the United States. The Veho called the Anishnabe People the Chippewa; the Dakota and Lakota People, the Sioux; the Hinono'el People, the Arapaho; and the Hohe People, the Assiniboine. The Cheyenne Nation made many treaties with the United States, beginning in 1825, but the Veho broke every promise they ever made, and the Friendly Peoples called them Takers. The Takers tried to move or wipe out the people who lived and prayed near the gold stone that made the Veho crazy.

The Veho brought beads, cloth, horses, and other gifts to the Friendly Peoples. Like all ancient peoples, the Tsistsistas are incorporative and practical, with respect and time for different ways. New ideas, things, and ways are not necessarily suspect to people with a strong culture, and are used or observed to see how they might endure over years, decades, or centuries. Beads were beautiful and durable; guns and horses were effective in hunting; and horses and cloth afforded both mobility and stability. They were of immediate value and worthy of a trial.

The Tsistsistas became leading horse traders on the Plains during the 1800s. Now that they could travel and hunt faster, they had more time to spend in summer and winter camps, enjoying life and making more objects of beauty for honoring passages, for ceremonies, for gifts, for daily life, and for trade.

Gifts of the Spirit unveils magnificent works made by the Friendly Peoples during the 1800s. While the new materials were available, many personal items were made of the same materials and in the same way that they had been for a long time. An example of this from the Peabody Essex Museum collections is a dance bandolier made of hundreds of plumstones strung on hide and graded for optimum musical effect as a percussion instrument. The stunning piece clearly was made by an artist with both visual and musical talents.

As is the case with most of the older works in the exhibition, the early collectors did not note the name of the maker or wearer, the way it was worn or used, the manner in which it was acquired from the owner, or anything beyond the nation. The plumstone bandolier is listed only as an Oglala Lakota necklace, as if an entire people gathered the plumstones; treated, graded, and strung the stones; and, with both a critical eye and ear, fitted and attached them to the hide (figure 2).

The records do note that the plumstone bandolier was part of the Fenstemakers Collection and was donated to the museum in this century by the Pennsylvania State Historical Commission. One of the artists whose work is exhibited here is Arthur Amiotte, who says that the bandolier is of a kind worn by the Omaha Society, a Lakota social dance society. It is likely that the stones came from Pine Ridge, a plumstone-rich area now part of the Oglala Lakota Pine Ridge Sioux Reservation. Amiotte is Oglala Lakota, a Sun Dance leader, and the grandson of Chief Standing Bear. His collage in the exhibition focuses on a more modern time and is entitled *New Horse Power in 1913* (figure 1).

Another old-style example from the collections is a pair of hide moccasins with white and orange designs in porcupine quills made by a Dakota/Lakota woman and/or man. The moccasins were received by the museum in 1822 from a Captain Douglass. The accession record carries a modern note that the side-seamed style, which predates hard-soled moccasins, is rare, and this pair may be the oldest of its kind from this area in existence. There is no record of the name of the person or persons who designed, shaped, quilled, or wore the moccasins (figure 3).

The Hoof Rattle in the exhibition was made by a Tsistsistas Elk Warrior who hunted enough deer for sixteen dewclaws, carved the holder, wrapped it in cloth, tied the dewclaws to it for the proper sound, and used it for making medicine and ceremonial and social music. Each member of the Elk Warrior Society—also called Elk Soldiers, Elk Horn Scrapers, and Hoof Rattle Societies—carries this type of rattle for ceremonial purposes today. The Hoof Rattles are protectors, made of plain or carved antler, bone, or stick wrapped with hide or cloth, with attached elk, antelope, or deer dewclaws. Nothing is known about the way this Hoof Rattle was obtained, but it is highly unlikely that an Elk Warrior would have parted with it willingly (figure 4).

Another of the artists whose work appears in this exhibition, Hachivi Edgar Heap of Birds, is a Cheyenne Elk Warrior headsman and one of the world's top conceptual and textual artists. His gifts are two paintings from his *Neuf Series*. "Neuf" means "Four" in Tsistsistas cosmology. These paintings present the important idea of landscape in human interaction. The works portray the colors of his Oklahoma home of gently rolling hills, forests, and red rock canyons, as well as fish of the Great Barrier Reef of Australia, another place where he has worked with Indigenous Peoples.

The great-great-grandfather of Edgar Heap of Birds was Chief Many Magpies (Heap of Birds). He and my own great-great-grandfather, Chief Bull Bear, were signers of the Medicine Lodge Treaty of 1867 and veterans of many battles together, including ones at Buffalo Road Canyon (Palo Duro Canyon). Many Magpies's son and the great-grandfather of Edgar Heap of Birds was Black Wolf, who was the head of the Elk Warrior Society.

A Journey to the White House and Veho Civilization

The Veho attempted to break the back of the Elk Warriors, Kit Fox Warriors, and other Tsistsistas Societies—particularly the Hotametaneo, Dog Men—and to render them powerless to protect the people. When they were unsuccessful in defeating the Societies, the Veho preyed on the old people, the women, and the children.

Figure 1
New Horse Power in 1913
Arthur Amiotte
Oglala Lakota Artist
1995

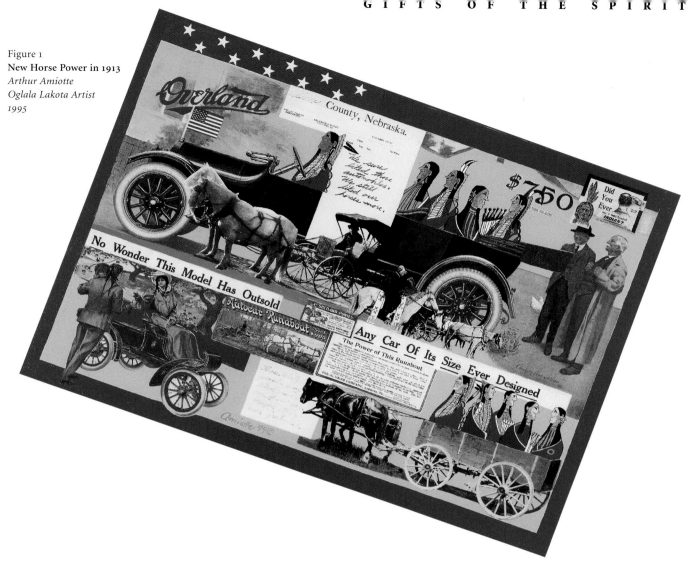

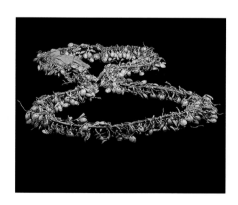

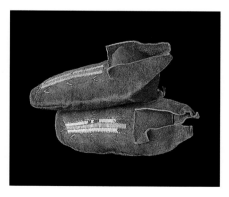

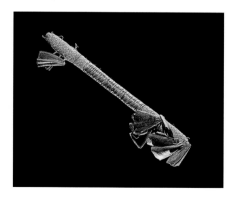

Figure 2
Plumstone Dance Bandolier
Oglala Lakota Artist
19th Century
E28311

Figure 3
Moccasins
Dakota/Lakota Artist
Early 19th Century
E3710

Figure 4
Hoof Rattle
Tsistsistas (Cheyenne) Elk
Warrior Artist
19th Century
E29202

As Sweet Medicine predicted, the Veho tried to turn all the Friendly Peoples against each other, chief-making among the weak who could be bought with flattery, trinkets, money, or whiskey. The Veho tried to destroy everything that sustained and strengthened the Friendly Peoples—the sacred places, their families, their homes, their horses, and the buffalo. The Friendly Peoples' Dreamers were visited by a Medicine Buffalo, who said that the Buffalo Nation was going away. Even today, many Dakota, Kiowa, Lakota, and Tsistsistas people can point to the very passages of time where our ancestors watched some buffalo shrink down and escape Veho destruction.

The Tsistsistas shook hands with the Veho over many papers that always took more land and never brought the promised peace. The Veho touch began to make the Tsistsistas sick, first with a cholera epidemic in 1849 and later with measles, influenza, malaria, tuberculosis, and grief. Many of the Friendly Peoples died relying on the word of the Veho and trying to stop them from covering the world.

Certain memories of that time have burned through generations of Tsistsistas as prime examples of the treachery and cruelty of the Veho: the Sand Creek Massacre on 29 November 1864; the Washita Massacre on 27 November 1868; and the brutal assaults on the Dog Men and other Societies and families at Summit Springs in 1869, at Palo Duro Canyon in 1874 and 1875, and at Fort Robinson in 1879.

In March of 1863, a year before the Sand Creek Massacre happened, two Cheyenne Peace Chiefs, Black Kettle and Starving Bear (Lean Bear), led a delegation to Washington. At the White House, President Abraham Lincoln gave peace medals and other gifts to the Apache, Arapaho, Caddo, Cheyenne, Comanche, and Kiowa Chiefs, whose neutrality he sought in the Civil War.

Starving Bear spoke for the Southern Plains delegation, reaffirming their friendship. However, he said, there were many Veho in their countries, where they were not supposed to be, and that they were not peaceful people. Lincoln described the great numbers, land, and wealth of the world's "pale-faced people," and declared that more of them were coming.

The president illustrated his points with a large globe, and the world was explained by the Smithsonian Institution's first secretary, Joseph Henry. Lincoln told the Chiefs that, in order to become as rich as their "pale-faced brethren," they would have to give up their ways, give up hunting and eating wild game, take up farming, and become more peaceful, like his people, who "are not, as a race, so much disposed to fight and kill one another as our red brethren."

The Chiefs returned home, passing near places where the peaceful "pale-faced brethren" in bluecoats and graycoats were fighting each other. Home, for the Cheyennes and Arapahos, was the 51.2 million acres of land the Nations had reserved in the 1851 Treaty of Fort Laramie in present-day Colorado, Kansas, Nebraska, and Wyoming, along with hunting, fishing, and gathering places beyond the reservation lands.

After the Pike's Peak gold rush of 1858, Denver City and the other mining camps were settled illegally on the Treaty lands, and Colorado was on a campaign to clear the territory of all Indians. Over the next four decades of nearly successful genocide, coerced treaties, land seizures, and allotments, the Cheyenne and Arapaho lands were reduced to only five hundred thousand acres.

In May of 1864, Black Kettle and Starving Bear were camped in Kansas Territory on their hunting grounds, when they saw four cavalry columns and a cannon approaching. Starving Bear put on his peace medal, told the others to remain behind, and rode out to shake hands with the officer in charge. The troops were from the "Bloodless Third" Colorado Volunteers, raised solely to fight Indians and, under orders from their commander, Colonel John M. Chivington, to "kill Cheyennes whenever and wher-

ever found." The officer in charge ordered his soldiers to open fire. Starving Bear—holding his papers of safe transit from Lincoln—was murdered with many bullets.

Starving Bear's murder was followed by a series of volunteers' attacks on Cheyenne people, and retaliations by the Dog Men Society. The Chief of the Dog Men at that time was Otoahnacco, Bull Bear (Buffalo Bear). He was Starving Bear's younger brother and my mother's great-grandfather. The Veho wrote variously that Bull Bear was between six feet six inches and seven feet tall. He was known among the Tsistsistas for the power of his words and voice, but was not considered unusually tall by Cheyenne standards.

In addition to being a Dog Men leader, Bull Bear was also a Peace Chief, beginning in 1854, and was admired for his bravery and sense of justice. Once, when told by an army officer that his superior wanted the Cheyennes to live like white men, Bull Bear is recorded as responding, "You tell the white chief, Indian maybe not so low yet."

Bull Bear and the Dog Men were known as Dog Soldiers and Northern Cheyennes, and about half of all the Tsistsistas were members of this Society. They were related to the Lakota/Dakota Peoples and could speak their languages. The Veho viewed the Dog Men as central to a Great Plains intertribal military alliance, which they feared, and the Dog Men families were placed on the "hostile Indians" list of those to be hunted and killed.

Governor John Evans of Colorado issued a proclamation in June of 1864, ordering all "friendly Indians of the plains" to go to Fort Lyon on Cheyenne and Arapaho Treaty lands in southeastern Colorado Territory, in order to avoid "being killed by mistake" in the "war on hostile Indians." At this time, most of the Friendly Peoples were in ceremonies along the Powder River and were unaware of the proclamation, which was followed by a stronger one in August, as they were hunting and preparing their

Bunch of Trees winter camp along the Smoky Hill River in Kansas. The second communication from Evans authorized all Colorado citizens "to go in pursuit of all hostile Indians on the plains" and to confiscate and keep any Indian property they wanted.

In September, Black Kettle, Bull Bear, Chief White Antelope, and an Arapaho delegation traveled four hundred miles to Fort Weld near Denver City to meet with Evans and Chivington, who negotiated a secure camp near Fort Lyon, in southeastern Colorado along Sand Creek. The Arapahos split up their camp near Fort Lyon; Chief Little Raven went south, across the Arkansas River, and Chief Left Hand joined Black Kettle at Sand Creek.

Chivington, a Methodist preacher in the gold-mining camps, immediately held public meetings to gain support for killing the "hostile Cheyennes," saying that they stood between the citizens of Colorado and twenty million dollars in gold that year alone. Two weeks before his attack at Sand Creek, when asked if he meant that Cheyenne babies should be killed, too, he answered, "Nits make lice." Chivington assembled seven hundred troops and two mountain howitzers, and stopped at Fort Lyon the day before his attack. The officer in charge there voluntarily placed himself under Chivington's command, adding 125 U.S. troops and two army artillery guns to the campaign.

Chivington charged the six hundred sleeping Tsistsistas, Hinono'el, and Kiowa relatives at Sand Creek before the first light of day. People in the camp were awakened by what they thought was a buffalo stampede. Black Kettle ran up a white flag with the American flag at the center of the camp, telling the people they would be safe, but all who huddled under the flags were killed. Black Kettle escaped on horseback with Medicine Woman, one of his four wives, who had been shot nine times. Some 450 others escaped, and only seven were taken captive. Their escape and the mayhem that ensued were later blamed

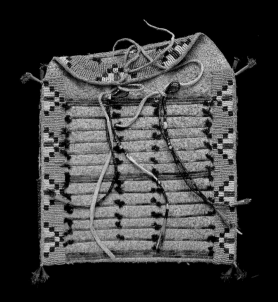

Figure 5
**Quilled and Beaded Hide
Pouch**
Tsistsistas (Cheyenne) Artist
19th Century
E3824

Figure 6
Child's Moccasins
Hinono'el (Arapaho) Artist
19th Century
E1887

on the whiskey that most of the troops drank on their night ride to Sand Creek.

Among the many killed were Cheyenne Chiefs Standing in the Water and War Bonnet—who also had received Lincoln's peace medal gifts at the White House the year before—and Bear Man, Lone Bear (One Eye), Spotted Crow, Two Buttes (Two Thighs), Yellow Shield, Prophet Yellow Wolf, and White Antelope. The unarmed White Antelope, at seventy-five, was too old to run. He faced the Veho and sang his death song—"Nothing Lives Forever, Only Mother Earth Endures"—until he was shot to death. A witness later testified that he saw the old Chief's body "with the privates cut off, and I heard a soldier say he was going to make a tobacco pouch out of them." According to other eyewitnesses, all the dead and dying were scalped, bludgeoned, and carved up, and babies were ripped from the wombs of their mothers.

In all, the troops mowed down and mutilated 110 women and children and fifty-three men. Their scalps, fingers, ears, noses, genitals, unborn babies, and other "war trophies" were paraded through cheering crowds in Denver City on 22 December, which was declared an official holiday for the volunteers' victory at the "Sand Creek Battle." At the Denver Opera House in the middle of a performance, one hundred scalps were strung on a rope across the stage, and the festive holiday audience gave them a standing ovation. The *Rocky Mountain News* reported that the "Bloody Thirdsters" had "covered themselves with glory."

The atrocities of the Sand Creek Massacre sickened many of the officers, soldiers, and scouts, according to their eyewitness accounts in subsequent military and congressional investigations. An 1865 joint Senate-House committee on the conduct of the war described the events this way: "And then the scene of murder and barbarity began—men, women, and children were indiscriminately slaughtered. In a few minutes all the Indians were flying over the plain in terror and confusion. . . . From the sucking babe to the old warrior, all who were overtaken were

deliberately murdered. . . . the soldiers indulged in acts of barbarity of the most revolting character, such, it is to be hoped, as never before disgraced the acts of men claiming to be civilized."

The committee placed blame on Chivington and the officers "who had so sedulously and carefully plotted the massacre" and "who stood by and witnessed these acts without one word of reproof," and the "soldiers who had so faithfully acted out the spirit of their officers." Evans was singled out for appealing to the "cupidity" of the people of Colorado with his proclamations, stating that his testimony before Congress was "characterized by such prevarication and shuffling as has been shown by no witness."

Evans was removed as territorial governor, and Chivington resigned his military commission to avoid a court-martial. No one was ever punished for his part in the Massacre. More than a century later, in April of 1996 during a general conference in Denver, the United Methodist Church formally apologized for Chivington and the atrocities at Sand Creek. Shortly after the Massacre, the church had expelled Chivington, but for the reason that he had married his son's widow. Chivington was further disgraced sometime later, when he was fired as Colorado's Arapahoe County coroner for stealing eight hundred dollars from the pocket of a corpse.

Two works in *Gifts of the Spirit* were made by Cheyennes and Arapahos during the mid-1800s—a Tsistsistas man's or woman's pouch and a Hinono'el child's moccasins (figures 5 and 6). The hide pouch has red quill designs and blue, yellow, and red beaded trim. It was donated by G. A. Peabody and obtained by the museum in 1877. The moccasins are beaded with pink and white designs and red and blue figures. They were collected by J. R. Sutcliffe and accessioned by the museum in 1887. Nothing is recorded about the people who made or wore the pouch or moccasins, or how they were acquired from the makers or wearers. It is unlikely that these highly personal belongings would have been trade items at the time.

Life on the Run

Those who escaped from Sand Creek on horseback fled to the Dog Men camp. The Dog Men rescued the other survivors and took them to their Smoky Hill home, joining the other Cheyennes, Arapahos, Burned Thighs (Brules), and Oglalas there. The formal grieving ceremonies continued for a full cycle of the moon. In January of 1865, they retaliated for the Massacre by raiding the mining camps and cutting off Denver City from food and outside communication. Life on the move quickly became life on the run. With each successive move, the people had less and less to carry on their ponies and backs, and more to carry in their hearts.

In order to find safe haven for the eldest and most seriously wounded, the Dog Men moved Black Kettle and four hundred Massacre survivors south of the Arkansas River to Little Raven's Arapaho camp. Bull Bear, Chief Tall Bear, and the Dog Men and Kit Fox families then moved north with some three thousand Arapahos and Sioux to the Powder River camp of Chiefs Morning Star and Two Moon (Bull Bear's cousin) of the Cheyenne. In the spring, they all moved to the Tongue River, near the Oglala Lakota camp of Chief Red Cloud.

During the summer, U.S. officials from Washington found Black Kettle and Little Raven for "peace talks." By October, they had coerced a treaty, through which more hunting grounds and gold lands were stolen. The treaty purported to extinguish all the Cheyenne and Arapaho reservation lands in Colorado and all the hunting grounds in Kansas. It included a formal apology for the Massacre and awarded reparations for survivors and relatives of the massacred. In the 132 years since that promise, the United States has failed to compensate any victims or descendants.

The Cheyennes and Arapahos who were in the north did not know that their lands had been dealt away on paper. Bull Bear and most of the Tsistsistas were with the Arrow Keeper at the Crazy Woman Fork of the Powder River, where Chief Sitting Bull of the Hunkpapa had called for the Friendly Peoples to gather together for their ceremonies. There, the Tsistsistas conducted the Four Medicine Ceremony and the Societies renewed their Medicine Bundles and other

sacred objects, as the Lakotas, Dakotas, and Hinono'el conducted their separate Sun Dances and other sacred ceremonies. Afterward, the Friendly Peoples had many battles with U.S. soldiers and other trespassers, as the stream of gold diggers increased and more forts, roads, and railroad tracks were built.

Bull Bear, Tall Bull, and other Tsistsistas returned to their winter camp, where they learned of the 1865 "treaty." Recognizing that those who had not signed it would not abide by it, messengers were sent from Fort Larned in the spring of 1867 to ask the Societies' headsmen to meet about a peace accord. Bull Bear, Tall Bull, and others made camp on the Pawnee Creek thirty-five miles from the fort. Sensing treachery, Bull Bear warned the women and children to abandon the camp and return to Smoky Hill, and then called for a two-day break in the talks. When they did not return to the fort, the U.S. soldiers raided the empty camp—burning the 251 Cheyenne and Sioux tipis and nearly a thousand buffalo robes, and collecting what treasures they wanted—and the warfare continued.

In the summer of 1867, a U.S. peace commission was convened at Medicine Lodge Creek in Kansas for treaty-making with the Apache, Arapaho, Cheyenne, Comanche, and Kiowa Nations. Black Kettle remained across the creek from the main camp to enable escape, if needed. When the other Cheyenne Chiefs and Societies' leaders were induced to join the talks, they made camp sixty miles away on the Cimarron River. The Apaches, Comanches, and Kiowas signed on 21 October. Little Raven and the Arapahos would not sign until the Cheyennes did, and Black Kettle would not sign unless the other Cheyenne leaders agreed.

The U.S. commissioners pledged that the new treaty would establish a safe and secure reservation and that the hunting grounds would be protected from "bad men." Bull Bear was the last to be convinced. He and Buffalo Chief were reported as having this understanding: "We will hold that country between the Arkansas and the Platte together. We will not give it up yet, as long as the buffalo and elk are roaming through the country." After Bull Bear signed on 28 October, the others followed, with the last Cheyenne signer being Many Magpies.

The ink was barely dry on the Medicine Lodge Treaty when the U.S. broke it. They tried to stop the hunts at the same time that the people were starving and sick from rancid rations. In the early summer of 1868, Bull Bear and the Dog Men went north with the Arrow Keeper for ceremonies and renewals. On their way back in the late summer, they hunted along the Solomon River above the Arkansas for winter provisions. They did not know that there was a new military campaign to kill off all the buffalo and to round up or kill all the Indians who had "jumped the reservations." This resulted in many clashes throughout the Plains, including a demoralizing one for the Cheyennes, the Battle of Beecher's Island, where a powerful Crooked Lance Warrior, Roman Nose, was killed.

General Philip H. Sheridan, fresh from the Civil War and the winning "total destruction" strategy, was in charge of this latest campaign. Failing to control the Dog Men and other Cheyennes, he declared Black Kettle's peaceful home along the Washita River east of the Antelope Hills a "hostile Indian camp." He dispatched Lieutenant Colonel George Armstrong Custer and the Seventh Cavalry to attack the old Chief's home, shoot or hang the warriors, kill the horses, and capture everyone else. It happened four years after the Sand Creek Massacre, nearly to the day, on 27 November 1868. As before, Black Kettle and his people were camped under the presumed protection of the United States and the 1867 Treaty the Senate had ratified only four months earlier, in July.

The attack at Washita, as at Sand Creek, came just before daybreak. Custer charged in the fog and snow to the sound of his marching band playing "Garry Owen." Black Kettle and his wife tried to escape on horseback, but they were shot off their pony and trampled by the charging troops. Only eleven warriors were among the 103 Human Beings who were killed that day.

After the fifty-three women and children captives were rounded up, Custer then ordered his troops to burn all the tipis, except for the best one, which he kept for himself; to burn all their clothes, buffalo robes, blankets, saddles, weapons, tobacco, and food; and to shoot all the ponies in the corral. Many of the Tsistsistas women and children were raped in the smoke

of the great bonfires to the sound of the slaughter of eight hundred ponies. The women named Custer the Attacker at Dawn, which has been mistranslated by historians as Son of the Morning Star—a name Tsistsistas women would not have given to such a person.

Custer delivered the scalps of Black Kettle and the other dead Tsistsistas to Sheridan at Camp Supply, as "trophies of the Battle of the Washita," reporting proudly, "We destroyed everything of value to the Indians." Custer received a hero's welcome and, as the victory band played, Sheridan congratulated him for "efficient and gallant services." Sheridan later reported a great triumph over the "savage butchers" and "cruel marauders." The 22 December *New York Times* declared "The End of the Indian War and Ring" and editorialized that "The truth is, that Gen. Custer, in defeating and killing Black Kettle, put an end to one of the most troublesome and dangerous characters on the Plains. . . . It was a fortunate stroke which ended his career and put the others to flight."

Over the winter and spring of 1869, those who stayed on the reservation were herded to Camp Supply. Those who left found slaughtered buffalo rotting in their hunting grounds. Tall Bull returned with two hundred Dog Men families, in order to stockpile a large quantity of rations for their long trip north and to encourage their relatives to travel with them for the summer ceremonies. However, they encountered subdued and dazed reservation leaders who blamed the Dog Men for the hardships, called them "troublemakers," and said they would stay at Camp Supply where it was safe.

Tall Bull and the Dog Men families went to the Smoky Hill camp. Sheridan dispatched General Eugene A. Carr and his Fifth Cavalry to hunt them down and kill them. In May, Carr attacked the camp, but the Dog Men Sacrifice Warriors held them off until everyone else escaped to reservation land. In keeping with the Dog Men vows, the brave Warriors stood their ground and fought to the death to protect the people. There were no women or children defiled, killed, or captured that day.

Bull Bear and some Dog Men moved south to find their families; Tall Bull and others contin-

ued north. In July, Carr's troops and Pawnee scouts caught up with Tall Bull and the Dog Men at Summit Springs in Colorado. Many of the Dog Men Warriors were camped on the other side of the Platte River, marking the crossing point through the high waters. Tall Bull and fifty-one others were killed; eighteen women and children were reported captured, along with four hundred ponies and mules. The troops and scouts plundered the camp, burning eighty-four lodges and everything else they did not keep for themselves.

On the reservation, Bull Bear pleaded for the freedom of the women and children captured at Summit Springs. When they were released in March of 1870, two hundred of the Dog Men families moved north for ceremonies, staying the next few winters near Fort Laramie. The winter of 1873 was so harsh and the buffalo so scarce that they moved onto the reservation to draw rations and to hunt buffalo in the south. However, the Veho buffalo hunters were slaughtering the herds in New Mexico and Texas, and Sheridan's reaction was "Let them kill, skin, and sell until the buffalo is exterminated, as it is the only way to bring lasting peace and allow civilization to advance." According to army estimates, 7,500,000 buffalo were killed between 1872 and 1874.

In June of 1874, a Comanche man named Isatai claimed to have a medicine that would take away the power of the Veho buffalo hunters' guns. Chief Quanah Parker of the Kwahadis Comanches planned to attack the hunters at their trading post, Adobe Hills, in New Mexico. He offered a war pipe to the Apaches, Arapahos, and Kiowas, who accepted. Bull Bear and other Cheyenne leaders then smoked the war pipe and rode at the head of the war party with the other Nations' leaders. The buffalo hunters' guns were not rendered useless, and they held their compound, killing fifteen Cheyenne and Comanche warriors. The man with the bad medicine was disgraced, and soon thereafter, Quanah Parker turned to Peyote Medicine.

The Cheyennes, Comanches, and Kiowas then followed the buffalo into the Palo Duro Canyon on the Staked Plain of Texas. Over the summer, as word spread about the good hunting, fishing, and freedom there, many of their families and

Arapahos and Apaches joined them. In September, thousands of bluecoats were dispatched to herd the Indians back to their reservations. They attacked the Indian camps, killing or capturing the people who could not escape, burning all the homes and stored food supplies, and slaughtering all the ponies they could find—one thousand at one time in the Tule Valley.

The grief-stricken, starved, and hunted people held out until the next year, but they had few ponies or weapons, no homes or winter clothes, and no way of even cooking without signaling their whereabouts. The elders, children, nursing mothers, and wounded people were given most of the remaining ponies, in order to slip back onto the reservations, while the leaders and the stronger people made diversionary fights and, finally, surrender marches to the forts.

In March of 1875, the Cheyenne Chiefs surrendered; Stone Calf carried the white flag, followed by Bear Shield, Bull Bear, Eagle Head, Gray Beard, Little Wolf, Many Magpies, and other Tsistsistas. The Kiowas returned to Fort Sill in February, as the Kwahadis did in May. Some thirty Cheyenne men and one Cheyenne woman were among those selected for imprisonment for the Red River War. They were taken in chains to Florida by train and confined at Fort Marion.

At this same time, gold miners were digging all over the Black Hills in violation of the 1868 Fort Laramie Treaty, which the Sioux, Arapahos, and Cheyennes, including Morning Star (Dull Knife), had signed seven months after the Medicine Lodge Treaty. Instead of removing the trespassers, another Treaty Commission was sent from Washington to persuade the Indians to give up the Black Hills, but the "treaty" was refused. One of the Sioux leaders is recorded as telling the commissioners: "The white man is in the Black Hills just like maggots, and I want you to get them out just as quick as you can. The chief of all thieves (Custer) made a road into the Black Hills last summer, and I want the Great Father to pay the damages for what Custer has done."

Tensions and fighting escalated over the next year, finally erupting on 25 June 1876 at Little Bighorn, where the Indians did not lose. Custer and some 225 soldiers and Crow scouts were

killed there. Some fifty Cheyenne, Sioux, and Arapaho men and women were also killed that day. Afterward, strict military rule was enforced against all Indians, and the bluecoats hunted down all who were off the reservation or on horseback.

During the winter, soldiers who were hunting Crazy Horse, the great Oglala hero at Little Bighorn, raided Morning Star's camp. Those who escaped fled to Crazy Horse's home. In the spring of 1877, after months of being stalked and starved, Crazy Horse, Morning Star, and their people surrendered at Fort Robinson in Nebraska. The bluecoats marched nearly one thousand Cheyennes to Fort Reno on the reservation in Indian Territory, where they arrived in August. Crazy Horse was murdered at Fort Robinson in September.

Morning Star and his people found their relatives on the reservation suffering from hunger and sickness. They were dying from malaria that summer and, in the summer of 1878, from measles. In September, Morning Star, his brother Little Wolf, and nearly three hundred Cheyennes escaped and headed north on horseback and on foot. Pursued by the bluecoats, Little Wolf headed for the Tongue River and Morning Star for Red Cloud's home, each with some one hundred and fifty people. In October, Morning Star's people were overtaken by a snowstorm and soldiers, and they were confined at Fort Robinson again.

Morning Star is recorded as having told one of the army officers that they would not go south again. "Tell the Great Father that [we] ask only to end [our] days here in the north where [we] were born. . . . if he tries to send us back we will butcher each other with our own knives." From Washington, Sheridan directed their return to the reservation. In January of 1879, they made a daring night escape. The Dog Men Warriors staked their sashes to the ground, and most were killed, while the others escaped. By morning, sixty-five people, mostly women and children, had been captured. Those who got away were in two groups, thirty-two people in the first and Morning Star and five family members in the second. The first group was hunted down a few days later, and twenty-one were killed.

Morning Star's small group made it to Pine Ridge, where they were imprisoned. Little Wolf's group surrendered and became prisoners at Fort Keogh. Several later said it was there that they became the first Tsistsistas to take up the throat-burning sweet drink. Following federal inquiries in Washington, the Northern Cheyenne Reservation was established on the Tongue River, and the prisoners at Pine Ridge and Forts Keogh and Robinson were permitted to move there. The Northern Cheyennes in the south were held on the reservation in Indian Territory, despite repeated petitions to move north.

Today, after more than a century of being split into two countries, in Montana and Oklahoma, the Tsistsistas still send political and ceremonial runners to each other, maintain family and social relations, care for the traditional sacred places, renew sacred objects, and conduct ceremonies together. Despite the decades of life on the run and every pressure the Veho could exert, the Cheyennes have never abandoned the Tsistsistas ways.

One of the Hunkpapa warriors who distinguished himself at the Battle of Little Bighorn was One Bull, who fought with a Winchester rifle with a red zigzag lightning design on it, which was a gift from his adopted father, Chief Sitting Bull. His fifth great-grandson is Don Tenoso, whose Hunkpapa name is Wambli Hokeshiela, Eagle Boy, and who is widely respected for his intricate and hilarious dolls.

Don Tenoso's gift to this exhibition is a chess set with impeccably made miniature doll pieces, whose point of departure is the Battle of Little Bighorn. His Indian and cavalry pawns have weapons from the battle—bows, arrows, spears, and Winchester rifles—and all the guns are walnut and silver (figure 7).

On one side of the chess set is Custer in the king position, a saloon hall gal as the queen, and military officers in white frock coats that partially conceal their guns as the bishops. One of Custer's castles has a cannon, and the other, an outhouse, has a Bible. "These are the first things they brought us," says Tenoso. Castles on the other side are tipis. Traditionally dressed Dakotas are the queen and king. The knights are horses' heads, wearing beads on the Indian side

Figure 7
Chess Set
Don Tenoso
Hunkpapa Dakota Artist
1996

and bearing the U.S. brand on their faces for the other.

The artist says that the three-foot square deer-hide "board" and the dolls "represent the mobility of the Indians that the U.S. wanted to kill—the Indians could have just rolled up these soft guys in the hide and taken the war game with them."

A Journey to Veho Science and Collections

Nowhere in the official records of any of the investigations or reports regarding the massacres or battles did anyone note as an atrocity the orders they carried out for the Indian Crania Study of the U.S. Army surgeon general—to decapitate Indians, measure the heads, weigh the brains, and ship the skulls to Washington for more "study." The army had long collected Indian heads and scalps from Indian scouts and Veho bounty hunters as proof of kills, but its official practice of collecting Indian heads and bodies for "science" did not begin until 1862, with the founding of the Army Medical Museum and its study of infectious diseases.

In 1868, George A. Otis, curator of the Army Medical Museum, and Joseph Henry, secretary of the Smithsonian Institution, agreed that the museum would receive osteological remains, and the Smithsonian would receive burial and cultural items. They jointly advertised in newspapers and paid civilians for crania and other material for their collections. Their agreement also initiated collections at the American Museum of Natural History in New York, the Field Museum of Natural History in Chicago, and the Peabody Museum at Harvard University in Cambridge, and in Europe at the Physiological Institute in Berlin.

The crania were "harvested" from massacre sites, battlefields, prisons, schools, burial grounds, and even from hours-old graves. The purpose of the beheadings at Sand Creek, Washita, Summit Springs, Fort Robinson, and throughout Indian country was not known by Native Peoples for

more than a century. In the late 1980s, army officers' on-site bills of lading for the "crania from the Massacre at Sand Creek" were found in the Anthropological Archives of the Smithsonian Institution. The army had transferred thousands of skulls to the Smithsonian in 1898 and 1904, after scientific measurements "proved" that the French were less intelligent than Cro-Magnon man, and the science was abandoned as invalid.

Of the Cheyenne victims, fewer than two score of skulls, skeletal parts, and scalps have been returned to date. Some of the remains were turned into jewelry (such as teeth and finger bone necklaces), scalp lock dolls, wall hangings, and other trophies and keepsakes. Many Cheyenne remains, clothes, and other personal items are still in private and public collections and museums worldwide.

Certain officers' accounts, such as that of the beheading of Apache Chief Mangas Colorado (Red Sleeves), point to the cross-racial comparative aspects of the Indian Crania Study and leave open the possibility that some Indian people may have been murdered for their heads. While the army's prisoner in 1863, California Volunteer guards woke Colorado, tortured the seventy-two-year-old Chief with heated bayonets, and eventually shot him. When the "dead body fell to the ground," the officer reported, "I immediately decapitated the head, measured the skull and weighed the brains. . . . while the skull were smaller, the brain were larger than that of Daniel Webster."

One of Red Sleeves's descendants is Bob Haozous, a contributing artist to *Gifts of the Spirit*. He and his father, the late Allan Houser, both Chiricahua Apache sculptors, once traced Red Sleeves's head to Europe—where it had gone into private hands from the collection of a civilian "scientist" in Pennsylvania, but the trail was lost in Germany.

Bob Haozous's sculpture in this exhibit—*The Bishop's Table*—symbolizes the "heavy hand of Western religion on the Apaches." He says that

the "view that we were godless, motivated and justified, in their minds, all their acts against us. They even renamed our sacred Gan/Crown Dancers 'Devil Dancers' and tried to kill the traditional religion in any Apache they couldn't kill outright." His steel-with-bronze-plate table of five feet and five inches is supported on a base of snakes and features cutout nudes with dangling chains guarding a chalice (figure 8).

The Sunrise Ceremony is one of the Apache religious and social ceremonies of passage that was considered pagan and banned by U.S. law. A doll in the exhibition from the museum's collections is wearing a Sunrise Ceremony dress, which is made for each Apache girl upon her physical passage into womanhood. The young woman's extended family prepares a celebration feast for their honored relative. She is blessed by the spiritual leaders, who offer prayers and messages for her, and greeted by a new name by all the gift-bearing well-wishers who then feast and dance.

Nothing is recorded about this particular doll's maker or owner, but it was donated to the museum in 1946 by Mrs. Frederick W. Fitts of the Case Home in Swansea, Massachusetts. An Apache woman, usually a family member, would have made the doll for the honoree as a personification of her. It would have been among the young woman's most cherished and lifelong possessions (figure 9).

Journey to Veho Law, Civilization, and Museums

Public and private collections of Native Peoples' cultural and personal property were formed throughout the world in connection with a long line of official U.S. religious suppression and "Indian civilization" actions. At the beginning of the 1800s, Congress began to authorize appropriations for the "Civilization Fund" to reeducate and deculturalize Indians. Christian denominations were given federal funds and franchises on particular Native Peoples for the purpose of conversion to European ways. This practice continued into this century.

In 1880, 1884, 1894, and 1904, the secretary of the interior published regulations of the Indian office banning all traditional religious activities,

ceremonies, and dancing. In the version of the regulations issued on 1 April 1904, under the heading "Civilization," stiff imprisonment and starvation sentences were imposed for any violation of the "Indian offenses." Each federal Indian agent was directed, as the "chief duty," to "induce his Indians to labor in civilized pursuit." Agents were directed "to impress upon the minds of their Indians the urgent necessity for a strict compliance with these instructions, and warn them that without this protection they are liable to be looked upon and treated as hostile Indians."

Characterization as a "hostile" was tantamount to a death sentence. Periodically, in the latter half of the 1800s and early 1900s, lists of "hostile Indians," "fomenters of dissent," and "ringleaders" were circulated among the army and the Indian Police, and were used as the justification, for example, for the murders of Chief Sitting Bull and his half-brother Chief Big Foot of the Dakota; for the Massacres at Sand Creek, Washita, and Wounded Knee; for the imprisonment of Apaches, Arapahos, Cheyennes, and Kiowas at Fort Marion in Florida; and for Chief Geronimo and his Apache people being held as prisoners of war for more than a quarter-century.

The regulations outlawed the Sun Dance "and all other similar dances and so-called religious ceremonies." Also outlawed were the "usual practices" of a "so-called 'medicine man' [who] operates as a hindrance to the civilization of the tribes," who "resorts to any artifice or device to keep the Indians under his influence," or who "shall use any of the arts of a conjurer to prevent the Indians from abandoning their heathenish rites and customs."

If convicted of these "offenses" or "any other, in the opinion of the court, of an equally antiprogressive nature," a religious leader "shall be confined in the agency guardhouse for a term not less than ten days, or until such time as he shall produce evidence satisfactory to the court, and approved by the agent, that he will forever abandon all practices styled Indian offenses under this rule."

Giveaway, honoring, and any ceremonies involving the exchange or elimination of property

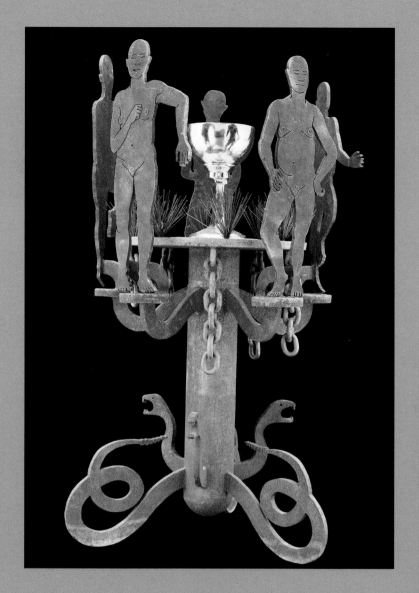

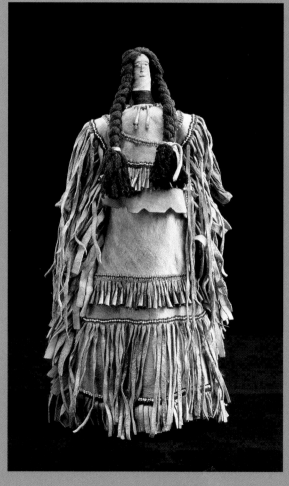

Figure 8
The Bishop's Table
Bob Haozous
Chiricahua Apache Artist
1995

Figure 9
Sunrise Ceremony Doll
Apache Artist
E25991

were banned. The regulations particularly noted that a defense that "the party charged was at the time a 'mourner,' and thereby justified in taking or destroying the property in accordance with the customs or rites of the tribe" was not a "sufficient or satisfactory answer to any of the offenses." Violations of any offenses under the regulations were used to justify confiscation of sacred objects, funerary items, and cultural or personal property.

Agents, soldiers, and their families initially benefited most from property confiscated from the living and removed from the dead. The property was sold and gifted to other collectors or transferred to prominent as well as obscure museums, universities, and other institutional repositories. One example of this is the ledger of a Cheyenne Dog Men Warrior, Little Finger Nail, who was imprisoned at Fort Robinson with Morning Star. The officer in charge at the fort tried to buy the ledger from Little Finger Nail. He declined and thereafter always wore the Dog Men history book strapped to his body under his clothing.

A Sacrifice Warrior during Morning Star's escape from the fort, Little Finger Nail was hit by .45/70 bullets, one of which passed through the ledger and killed him. The ledger was removed from the body by a soldier who gave it to his commander, who, in turn, gave it to his brother. Through sale and gift, it ended up in the American Museum of Natural History, where Little Finger Nail's exquisite drawings are exhibited, complete with bullet hole and dried blood.

Under the regulations, the agents were ordered to "forbid" and "prevent" the "sale of ponies to Indians," and to persuade them to "exchange their ponies for cattle, sheep, swine, and poultry." All "nomadic Indians" were forbidden to "roam away from their reservations" or "trespass upon the public domain," where most sacred lands and burial grounds were located.

The "practice of bands of Indians making or returning visits to other reservations" (where ceremonies for birth, death, and other passages of relatives took place) was "deemed injurious to the Indians, and must not be allowed." Indians could make such visits "as a reward for their good conduct," if they had "earned the extension of certain privileges" by "meritorious con-

duct and attention to labor," if they sought and obtained the consent of the agent and of the Indian office, and if the visit would "in no event be likely to prove disadvantageous to the Indian Service."

Indian Affairs commissioners' circulars implementing the regulations were issued and enforced until the mid-1930s. One in 1921 reiterated the prohibitions and penalties regarding religious ceremonies and "any dance which involves . . . the reckless giving away of property . . . frequent or prolonged periods of celebration . . . in fact any disorderly or plainly excessive performance that promotes superstitious cruelty, licentiousness, idleness, danger to health, and shiftless indifference to family welfare."

Another in 1923 allowed dances to occur during seven months of the year, "limited to one in each month in the daylight hours of one day in the midweek, and at one center in each district." It prohibited anyone under fifty from being present and ordered that "a careful propaganda be undertaken to educate public opinion against the dance."

In 1934, a commissioners' circular warned employees of the Indian Service "against interfering with the religious liberties guaranteed by the Federal Constitution." The regulations were revoked, in part, in 1935, after more than a half-century of vigorous enforcement. However, many of the same practices continued through the interior department's cash-and-poverty politics and through Native American self-enforcement, force of habit, and historic inhibition.

After the New Deal administrations in the mid-1930s, U.S. Indian policy reverted to that of assimilation and dislocation, and the numbers of traditional Native religious practitioners and religions themselves, as well as sacred lands and sacred objects, rapidly diminished over the next two decades and up to the present.

During the time that traditional tribal religions were outlawed, the use of Peyote Medicine was embraced throughout Indian country. Its use is not within the tribal tradition of any living Native Peoples in North America, and was generated by the Comanches, most notably the widely admired Quanah Parker, in the late 1800s. Peyote was adopted by many Apaches, Arapahos, Chey-

ennes, and Kiowas in the Palo Duro Canyon camps and was readily accepted by those with Mescal Ceremony traditions. The Peyote Ceremonies often were allowed by Indian agents, under the theory that the pan-Indian ceremonies, like Christianity, would hasten the end of the outlawed tribal religions.

At the turn of the century, when the U.S. Indian population was only 250,000, it was thought that the traditional religions also were all but extinct. While many did die, most religious activity simply was conducted underground. Much traditional religious information is held in strict secrecy today, some because of religious tenets, but mostly because of the prolonged assault when openness meant confinement, confiscation, starvation, injury, or death. As the Native American Church added Christian layers to the Peyote Ceremony, the Church members' use of the sacrament was promoted and legalized.

Two works in *Gifts of the Spirit* depict Peyote Ceremony items used by practitioners today. Lutz Whitebird's contribution is a beaded and sculpted Peyote Rattle of a kind used in many Peyote Ceremonies of the Native American Church (figure 10). Whitebird is Cheyenne from Oklahoma, which has the largest Native population of any state and where nearly one-sixth of the Indian people are Church members.

Jack Malotte's fine line drawing of a large Peyote Fan against a mountainous horizon depicts the importance of another ceremonial item used by Native American Church members (figure 11). Malotte is a citizen of the Western Shoshone Nation and lives and works in his traditional territory in Nevada, where many of the Native people are practitioners of the Peyote Ceremony.

Three works by Tsistsistas men and women in the late 1800s and early 1900s—a quilled hair ornament, a painted Dog Men Shield, and a painted honoring drum—were donated to the museum in 1946 by Colonel George L. Smith, who collected them at the Cheyenne Reservation in 1909 (figures 12, 13, and 14).

Smith did not provide information regarding the way the ornament and Shield were obtained from the makers, wearers, or holders, or anything about them. The hair ornament could have been made by a man or a woman and worn by a man for ceremonial occasions or by either for the outlawed Mescal Ceremony, which Cheyenne men and women held separately. It has quilled and beaded designs on buckskin for the back of the head, with white horsehair, brass, and tradebead streamers hanging down from the sides of the face. The same style hair ornament also is worn today for social events.

The buffalo-hide Shield is made from a parfleche with geometrical designs on the back, which a Tsistsistas woman would have painted. The front features representational designs of a Man-Bird and Lizard Medicine, which the Tsistsistas man would have painted, and two red-tailed hawk feathers and one eagle feather, awarded for coup counts. It is a Dog Men Shield for praying, for fighting, and for hunting. It is an exclusively personal item that stands for and protects the Warrior. If it were captured or lost, the Warrior would assume the end of his life was near. The Warrior could gift it to a trusted person, but a Shield usually was buried with the holder. The Shields were confiscated under the "Civilization" regulations.

The honoring drum was made by John Stands in Timber, a Tsistsistas Kit Fox Warrior. He was born in 1884 and lived on the Northern Cheyenne Reservation in Montana until his passing in 1967, the year his book *Cheyenne Memories* was published. His mother was Buffalo Cow and her father, Lame White Man, was killed in the Battle of Little Bighorn. His honoring drum was "collected" in the year of his first marriage and the first of his two wedding giveaway ceremonies, both of which were outlawed by the federal rules. It is not known if the drum was a giveaway item, and there is no recorded information about its acquisition from the maker or owner.

The drum depicts a hunting story that the donor told this way: "The man at the deer is John Stands-In-Timber who shot the deer, put down his gun and was about to cut the deer's throat. The deer, only wounded, recovered and attacked John. The other man is John's son who killed the deer." The hero of the honoring drum, however, could not have been John Stands in Timber's son in 1909 (when the drum was donated to the museum) or before. The maker of the drum and his first wife married in 1904 and

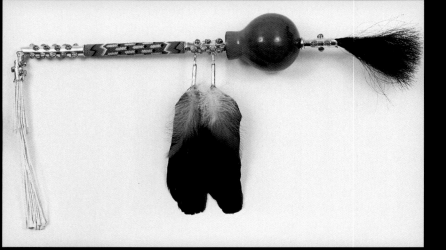

Figure 10
Peyote Rattle
Lutz Whitebird
Tsistsistas (Cheyenne) Artist
1994

Figure 11
Peyote Fan
Jack Malotte
Western Shoshone Artist
1994

Figure 12
Hair Ornament
Tsistsistas (Cheyenne) Artist
Late 19th Century
E26016

Figure 13
Shield
Tsistsistas (Cheyenne) Dog
Men Society Artist
19th Century
E26065

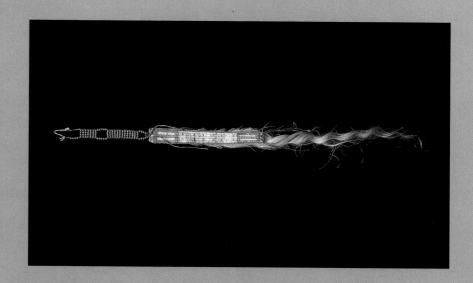

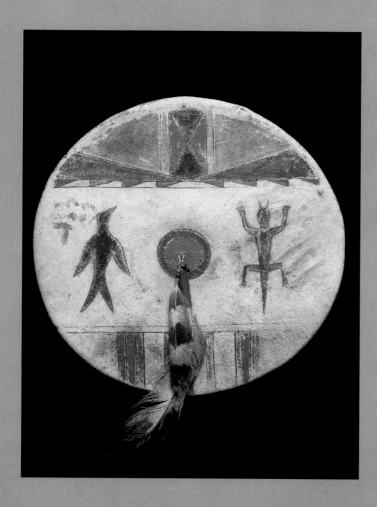

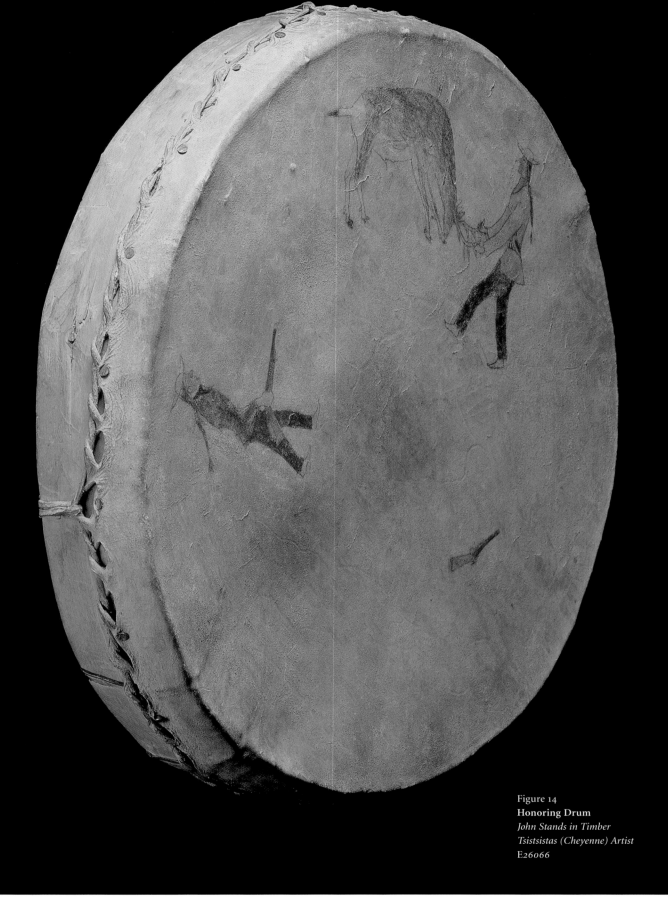

Figure 14
Honoring Drum
John Stands in Timber
Tsistsistas (Cheyenne) Artist
E26066

had only one child, a boy who died at age two in an influenza epidemic. His wife died in 1915, and he did not remarry and begin having children again until 1919.

It is likely that John Stands in Timber made the drum while at the Haskell Indian Institute in Lawrence, Kansas, in the years immediately before his first wedding ceremony. The hero of the drum maker's hunting story probably was his brother, who had been a student at Haskell and died of tuberculosis at home before starting his senior year in high school at the Fort Shaw Indian School.

A Journey to Veho Education

The federal Indian educational system sprang from treaty provisions promising schoolhouses and teachers for the Indians to learn the "arts of civilization." These were understood by the Indian treaty signers as possibly useful tools and skills, rather than the replacement of tribal languages, cultures, and traditions that were later imposed.

By the time of the first "Civilization" rules in 1880, the U.S. was on a clear course of mandating Christian-only/English-only education of Indian children. They made it a criminal act for any "so-called 'medicine man' [to] adopt any means to prevent the attendance of children at the agency schools."

The first federal Indian boarding school was the Carlisle Indian Industrial School in Carlisle, Pennsylvania, which had been the site of the U.S. Army's first cavalry school, and then a prison. Children of famous Indians and strong families were taken to Carlisle between 1879 and 1918 to assure the continued cooperation of their parents and extended families. It became the prototype for the federal Indian boarding school system that continued into the mid-1900s.

Captain Richard H. Pratt was Carlisle's founder. He had been been the officer in charge at Fort Marion in Florida, where the prisoners from the Red River War in Palo Duro Canyon were jailed, along with Geronimo and other Apache prisoners of war. The Fort Marion prisoners' ledger-book drawings, and the artists themselves, were exhibited by Pratt in nearby towns.

There were eleven Tsistsistas warriors who were

among the prisoners/artists: their average age was twenty-four; only two were over thirty; and the youngest was eighteen. Seven were imprisoned for the crime of being "ringleaders": Big Nose, Buffalo Meat, Howling Wolf, Little Chief, Making Medicine, Shovelhead, and Squint Eyes. Soaring Eagle and Spider were imprisoned for murder, while Chief Killer was held for murder and kidnapping, and Bear's Heart as an accomplice to murder.

The prisoners/artists and their artwork were photographed and widely viewed with the newly invented stereopticon, which provided a three-dimensional effect of the drawings and photographs of the artists. The artists, their work, and the exciting technology became a cause célèbre in the art world and in the social reform movement, the core of which were the reconstructionists who had turned to deconstructing Indians. Pratt became the golden boy of the movement, and his charges were touted as successful products of his civilization theory: "Kill the Savage, Kill the Indian, Save the Man."

At Carlisle, Pratt employed a similar theory of year-round "civilization" with no family contact, a prison regimen, military-style uniforms, corporal punishment, exposure to the "arts of civilization" and "outings"—free or low-paying labor—with local Pennsylvania families. His philosophy was simple: "To civilize the Indian, put him in the midst of civilization. To keep him civilized, keep him there." Bull Bear's youngest daughter, whose "agency name" was Elsie Davis, was kept there. She died in 1898 of unrecorded causes and was buried in the Carlisle Cemetery, which is now a tourist attraction.

In this exhibition, Steven Deo's photocollage *The Indoctrination* shows his own family members and their classmates as they were visually and emotionally transformed from Indian boys with long hair and traditional clothes to boys wrenched from their families to be "civilized" in their new home, a federal Indian boarding school (pages 162 and 184). Deo is Yucci and Muscogee. He lives and works in Oklahoma, is a Stomp Dancer at the Duck Creek Stomp Grounds, and a graduate of the Institute of American Indian Arts (IAIA) in Santa Fe, which is one of the few good schools in the federal boarding school system.

Richard Ray Whitman also is Yucci, a Stomp Dancer, and an IAIA alumnus. He is a member of the Otter Clan and a citizen of the Muscogee (Creek) Nation, and lives and works in the visual, written, and performing arts in Oklahoma. The Yucci Nation is distinct but culturally and legally related to the Muscogees, and is seeking its own federal recognition at this time. His serigraph in this exhibition (Do Indian Artists Go to Santa Fe when They Die?) relates to the IAIA, which has launched an extraordinary number of Native artists since its inception in the 1960s, when Whitman was a student there, and to a widespread impression that Native art is only produced in the Southwest (pages 94–96).

The IAIA's record of success is evidenced by the number of graduates whose work graces this exhibition. Among the other *Gifts of the Spirit* artists who studied there are Marcus Amerman (Choctaw), Delmar Boni (San Carlos Apache), Barry Coffin (Potowatami and Muscogee), Laura Fragua (Jemez Pueblo), Conrad House (Navajo and Oneida), Tom Huff (Seneca/Cayuga), Tony Jojola (Isleta Pueblo), Martin Red Bear (Oglala and Sicangu Lakota), Diego Romero (Cochiti Pueblo), Mateo Romero (Cochiti Pueblo) and Denise Wallace (Chugach). In addition, Jean LaMarr (Paiute/Pit River) was a professor of printmaking at IAIA and taught the current generation of Native printmakers there.

Their work does not represent a single school of art, even though they went to the same institution, and shows an exceptional range of styles, subjects, media, techniques, and experiences. Examples include Tony Jojola's blown-glass sculpture (Night Keeper), Martin Red Bear's acrylic-painted deer hide, Conrad House's Turtle Clan textile, Mateo Romero's painting of dysfunctionalism in this era (Broken Circle), Barry Coffin's clay sculpture with a rubber chicken (Wally Koshare Meets Rambo), and Diego Romero's ceramic pot of ancient and modern icons (The Drinker).

Two other artists whose works are represented in *Gifts of the Spirit* are also graduates of the IAIA, and each was president of the student government there: David P. Bradley (who is White Earth Ojibwe and Mdewakaton Dakota from Minnesota) was there in the late 1970s, and Lutz Whitebird was there during the mid-1980s. Bradley is the only artist to have taken the top honors in both sculpting and painting at the Santa Fe Indian Market, the largest annual juried art fair for Native artists, which celebrated its seventy-fifth anniversary this year.

David Bradley's gifts to this exhibition are a fine marble sculpture of a crouching man trying to protect himself (Indian Affected by Anti-Indian Backlash) and a mixed-media collage painting (The Shores of Gitchi Gami Revisited) (pages 209 and 221). The painting is composed in four horizontal layers, the top presenting a familiar image of two Indians hunting ducks from a canoe on a placid northern Minnesota lake. The next layer is of the underwater Panther Spirits. Below it is a layer of writing in the Ojibwe and English languages ("Land o' Bucks," for example) over a wild rice serigraph. The bottom layer is an Ojibwe floral design of painted beads on black velvet, with cowrie shells beneath it.

Gifts of the Spirit of Women

Native women made most of the work exhibited in *Gifts of the Spirit.* Unfortunately, the names of the women artists who made the older works were not recorded. One work in the exhibition that specifically honors Tsistsistas women also is offered in celebration of all the Native women artists whose work is part of *Gifts of the Spirit.* Frank Sheridan's painting is on the original paper used by the Indian prisoners/artists at Fort Marion. One of the Cheyenne artists slipped a blank ledger to one of his relatives, a woman in Sheridan's family, and the pages were handed down to him.

Anita Fields is an Osage and Muscogee artist who lives and works in Oklahoma. She sculpts in clay and does ribbonwork. Her gift to this exhibition is a ceramic piece that specifically deals with gifts, Turtle Woman's Purse #2, (pages 160–61 and 177). The purse represents one her aunt received as a wedding gift when she married a man from the Omaha Tribe. Fields said she "made the purse, too, with my own grandmother's bag in mind, and the one she gave to me when I was a girl, a miniature beaded purse with a mirror and all those little things we keep simply because they are precious."

Valjean Hessing's painting *Telling a Naughty Story* is another gentle gift (pages 160 and 175). Her three old women laughing are not only impeccably painted, but her subject matter is most unusual in art by Native women or men. First, she depicts Native women who are old and not in ceremonial pose. Second, she shows Native women laughing. Third, she shows old Indian women having a good time over something bawdy. The scene itself is one that Hessing would have seen often among her Choctaw relatives and other tribal women in her Oklahoma home. Hessing has produced an exceptional body of work over the past several decades.

Jean LaMarr's multimedia installation is the artist's reaction to conventional stereotypes about Native women. The title *Minniehaha Lives!* responds to Longfellow's poetic and romanticized character, the legend of which perpetuated the Indian maiden fantasy image (pages 211 and 232). LaMarr is part of a strong Paiute and Pit River family from the Susanville Rancheria in northern California, and one of the most influential Native artists working today.

Another artist from Susanville is Judith A. Lowry, who is Mountain Maidu and Hamowi Pit River. She is known for her technical expertise as a painter and for her insights regarding societal and commercial imaging of Native women. Her contribution to the exhibition is *American Tobacco Girl*, a painting in the style of a logo or cover for a tin of nickel cigars (pages 211 and 226). It portrays an Indian princess, a Cher look-alike with major hair and a serious headdress. The tobacco girl sports an off-the-shoulder, flag-draped outfit, and holds a long-stemmed pipe, complete with wispy yellow hair; the figure is imposed over a tipi camp and waterfall background and a foreground of the *Niña, Pinta,* and *Santa Maria.*

The hilarious ceramic piece by Laura Fragua, *Just Because You Put Feathers in Your Hair Don't Make You an Indian*, comments on stereotyping and cultural appropriation regarding Indian people generally (pages 209 and 217). An extraordinary sculpture by Teresa Marshall (Micmac), *Peace, Order, and Good Government*, with its beaded safe, rifle, and hightops, comments on our time generally (pages 104 and 127). Linda

Haukaas (Sicangu Lakota) and Shelley Niro (Mohawk) personify themselves and the spirit of Native women in their respective works, *The Women's Dance at Okreek* and *Flying Woman #8* (pages 163 and 181 and pages 187 and 197).

Other contemporary works by Susan Stewart (Crow and Blackfoot) and Denise Wallace, while not presenting overt social statements, simply are their reflections on Native women as artists. It is worthy of note that none of the contemporary works by women in the exhibition is in the form of dolls, "traditional" beadwork, or pottery. These are done by men in this exhibition; examples would be the dolls by Tom Haukaas (Sicangu Lakota), the beaded bandolier bag by Jerry Ingram (Choctaw and Cherokee), and the clay pot by Lonnie Vigil (Nambe Pueblo).

Gifts of a Family Journey

I am Tsistsistas and Hodulgee Muscogee, a citizen of the Cheyenne and Arapaho Tribes of Oklahoma and a product of the collective wisdom and strength of the Cheyenne and Muscogee Peoples.

Susie Eades Douglas is my mother. She is the great-granddaughter of Chief Bull Bear (Buffalo Bear), who led the Cheyenne resistance for so long, and a great-grandniece of Chief Starving Bear (Lean Bear), who died relying on the words of a Veho leader. She is the granddaughter of Thunder Bird, Bull Bear's youngest son, who also was a headsman of the Dog Men Society.

Thunder Bird was born in 1867 at the Dog Men camp during the Council of the Medicine Lodge Treaty, which his father signed to establish a safe home, the Cheyenne and Arapaho Reservation in Indian Territory. His mother was Buffalo Wallow, who died when he was ten years old in 1877; Bull Bear's other Cheyenne wife, Pipe Woman, died the following year. Bull Bear lived until 1906.

Thunder Bird was given the "agency name" of Richard Davis. He and his sister, Elsie Davis, were made hostage students at the Carlisle Indian Industrial School, where she died of unknown causes. They were part of the effort to make their father and his strong family "good Indians" on the reservation. Thunder Bird later worked at Carlisle as an interpreter.

In 1889, Thunder Bird and Nannie Aspenall Sargent, a Pawnee woman, had their first child, my mother's mother, who was given the agency name of Richenda Aspenall Davis. She was born during a storm at the Green Bank Farm House in Chester County, Pennsylvania, where her mother worked as a domestic, and was enrolled as a citizen of the Cheyenne and Arapaho Tribes. She was educated at Carlisle and raised as Tsistsistas on Thunder Bird's Cheyenne land along Boggy Creek in Washita County, Oklahoma.

During the summer of 1904, Thunder Bird, Bull Bear, Chief Bushyhead, and some twenty other Cheyenne men, women, and children lived in their summer camp of painted tipis on the grounds of the St. Louis world's fair. They were human exhibits in the fair's "anthropology reservation," where visitors observed their daily routines and arts demonstrations.

A Smithsonian scientist, W. J. McGee, designed the exhibition of two thousand of the world's "primitives" to illustrate human evolution. McGee said that the "physical types chosen were those least removed from the subhuman." For their official world's fair photographs, Thunder Bird, Bull Bear, and other Cheyennes wore yellow flicker feathers on their shoulders and carried Flicker Medicine to signify that they were practitioners of the Mescal and Peyote Ceremonies, religious practices whose banning was punctuated by the reissuance of the federal "Civilization" regulations that same year.

Thunder Bird also traveled to Europe with other "exhibitions" and Wild West shows. He also lived and worked in Hollywood, where he was in many cowboy-and-Indian movies and in stage shows. John Stands in Timber has written about his own crew work in 1930 in the made-on-location movie *The Oregon Trail* in which Thunder Bird was an actor. Thunder Bird's wife died in California in the mid-1920s, after contracting pneumonia on her journey from Oklahoma to join her husband. Thunder Bird passed on in the mid-1950s.

While students at Carlisle, my grandmother and her sister Mary went to New York City for the parade marking the end of World War I. Mary's fiancé was marching in it with his best friend, Joseph Cleveland Eades, who was born in 1889,

and whose grandmother was Susan Wolf, a Cherokee woman. Richenda and Joseph married soon after meeting, moved to Oklahoma, and had six children. My mother, their second child, was born in Pawnee, Oklahoma, in 1921. They moved to El Reno, Oklahoma, within the exterior boundaries of the Cheyenne and Arapaho Reservation, where my grandparents lived out their days.

In 1939, my mother met her future husband, Freeland Douglas, when they were students at Chilocco Indian School in Chilocco, Oklahoma. My mother remembers that her education was punctuated there and at the Haskell Institute with the importance of being a "good Indian." Beginning at Euchee Indian School in grade school, my father was beaten regularly for speaking his language, running away, and generally being a "bad Indian."

My father recalls that the white bounty hunters would be paid five dollars for every runaway Indian boy they captured and returned to the federal Indian boarding schools. During reunions of the Euchee Indian School graduates, the former students, now in their seventies, laugh about surviving the boarding school system. When they tally up the bounties, my father is credited as one of the top moneymakers for the bounty hunters of his time.

My father was born in Okemah, Oklahoma, in 1922, to Bessie Mikey Haines. He is a Hodulgee (Wind Clan) citizen of the Muscogee Nation, of the Nuyaka Tribal Town and Stomp Grounds of the Coosa (White-Hearted/Peace-Hearted) People. People of the Muscogee Nation are called Creeks and one of the "Five Civilized Tribes" in U.S. history and law.

At the beginning of time, the Muscogees came out of the underground caves, and the world was dark and covered with fog. The first people to emerge, to clear away the fog, and to see the light were the Wind Clan people. The other clans have names and duties associated with the Bear, Bird, Deer, Fox, Opossum, Raccoon, Skunk, and other children of Mother Earth. This emergence was at the time of the Giant Monsters, who grew too large for the world and died away. The Muscogees still do an ancient dance imitating their movements, as well as the Stomp Dances, Green

Corn Dances, the women's Red Stick Dance, and other ceremonial and social dances.

For millennia, the Muscogee Nation stayed in its country, throughout what is now the southeastern United States. They developed a tribal town and society system that was used by all the Nations who were part of the Muscogee Confederacy. Disputes were settled by playing games, such as stickball, often involving hundreds of people on each side. Stickball, still conducted for religious and social purposes, is a more difficult precursor of lacrosse.

The Muscogees allowed the Scot stonemasons, whose clan leaders had been killed by the British in the Battle of Culloden in 1745, to become a part of the tribal towns, because their clan structures were nearly identical. The Muscogees also provided safe haven for certain runaway slaves, also for reasons of tribal commonalities.

The Muscogee Nation had the same experience with treaties that all Native American Peoples have had: each one was broken. My Muscogee uncle Phillip Deere, a Stomp Dance leader, used to say, "When the United States of America promised that the land would be ours from bank to bank, we meant the bank of the river, while they meant the Bank of America."

President Andrew Jackson, who started his Indian-killing career as head of the Tennessee Volunteers, had the Muscogees, Cherokees, Chickasaws, Choctaws, and Seminoles (the "Civilized Tribes") forced-marched to eastern Indian Territory. More than twenty thousand Muscogees alone died during the death marches. When the army's Indian agents prepared the records of the survivors, many Muscogees and others from the Trails of Tears took the name Hajo, which was written Harjo, as a personal protest. Hajo is the Muscogee Warrior Society. It means "Magic in Battle."

Despite this sorry history, Muscogees, like most other Native American Peoples, still honor their treaties of peace and friendship, and have been patriotic defenders of the United States in every war of this century. The first Native American to receive the Congressional Medal of Honor in World War II was a Muscogee, Ernest Childers of C and A Companies of the Thunderbird Division.

My father was a survivor of the federal Indian school system and a hero of World War II in C Company of the Thunderbird Division. When he returned from Europe, he and my mother married in 1944, and celebrated their fifty-second anniversary this year. I was born in 1945 at the El Reno Sanitorium, which had been established primarily for Indians with tuberculosis, and was enrolled as a citizen of the Cheyenne and Arapaho Tribes.

Among my parents' other grandchildren are my own two grown children, Adiane Shown Harjo and Duke Ray Harjo II, whose father, Frank Ray Harjo (Wotko Muscogee), was born in 1947 in Wewoka, Oklahoma, and died in 1982 at the age of thirty-five.

A Healing Journey

Bently Spang's gift to this exhibition is *The Healing,* which he says is "about cultural healing and personal healing, and represents the place of art in my life—restoring, stabilizing, healing." Spang, whose Tsistsistas name is Na Nisit Hum, Lion, is from one of the largest families on the Northern Cheyenne Reservation. His father's people are Kit Fox Society members; his grandmother's father was Wolf Chief (Nathan Limberhand), a medicine man; the name Spang is from a French man with a German name who married into his father's family five generations ago. His mother's people are Cheyenne, Oglala, and Little Shell Band, Chippewa/Cree.

His installation features a cocoon figure in the center—"which stands for the transformation of the person or culture"—and is surrounded by the elements for "achieving the healing." The shield forms on either side—*One of the Two Selves*—are self-portraits representing duality, with traditional Cheyenne symbols and materials on one side (the Four, cedar) and mixed contemporary (cast aluminum) and natural materials on the other.

The sculptural element on the left, *Tool #1* is a Staff, which stands for life. *Tool #2* on the right is "a traditional bag that is carried because it has something important in it." He uses the cedar "to honor the real simple things that have power, but are taken for granted." Spang says the piece represents, too, "the power of captured energy trapped in symbols."

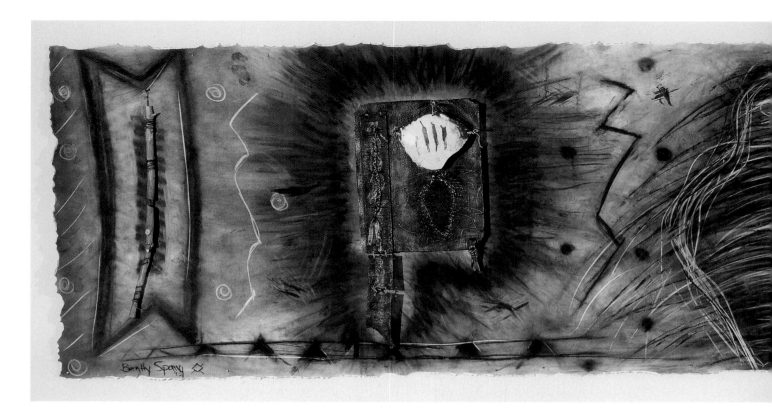

Figure 15
The Healing
Bently Spang
Tsistsistas
(Cheyenne) Artist
1994

The Healing speaks to me through the generations, in the ever-present Is and Is Coming way of the Tsistsistas language. Much of my writing, from poetry to the material that becomes federal Indian law, is about the hard work of settling the spirits and writing history right.

Native Peoples in this quarter of Mother Earth have lived with generational anguish and distress. It is only in this time that we are able to understand how our days were turned to nights and to begin to deal with the reasons that it happened. It is only in this decade, for example, that the Sioux Nation has been able to conduct the Wiping of the Tears Ceremony for the Wounded Knee Massacre of 1890 and that the Cheyenne Nation has been able to lay to rest some of our massacred relatives from Sand Creek and Fort Robinson. This is part of the healing work that determines what Is and Is Coming.

Like the artists in *Gifts of the Spirit,* I am one of the fortunate people who is able do something for the good. In 1967, I was part of an important gathering at Bear Butte. There, it was concluded that we must carry out our duties in whatever way we can to protect the holy places and to bring our people and sacred beings home. One Tsistsistas man said that we could not become whole, within or without, as a person or as a nation, unless they complete our circle. After that gathering, I wrote the first draft of legislation to return sacred objects and sacred lands.

I had no idea how to write legislation, and did not know I would ever live and work on Capitol Hill. However, within seven years, I was in Washington and, within four years after that, we achieved approval of the American Indian Religious Freedom Act of 1978. It articulated the new policy of the United States to preserve and protect Native American religions, sacred sites, sacred objects, and cultural practices.

In just over ten years after that, we had secured the first of the repatriation laws, the historic agreement with the Smithsonian for the return of Native American human remains, sacred objects, and cultural property, as part of the National Museum of the American Indian Act of 1989. The next year, we revolutionized part of the museum world with enactment of the Native American Graves Protection and Repatriation Act of 1990. This year, we gained the Executive Order on Indian Sacred Sites, restating the U.S. policy of protecting the integrity of sacred sites on federal lands and American Indian traditional religious activities there.

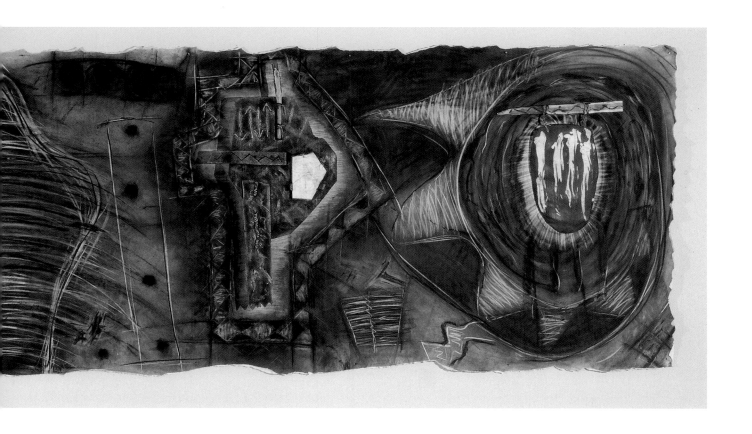

In 1990, Dan Monroe, then slated to become head of the American Association of Museums, was across the negotiating table from us. He saw that a broad repatriation law would be positive in the museum community and in Indian country. I never viewed Dan Monroe as an adversary, but as a history-making ally. We also discussed working on an exhibition of works by living Native artists. Once he had joined the Peabody Essex Museum, with its remarkable collections, the idea of an exhibition took on new depth.

Gifts of the Spirit in the Beautiful Land represents completion of a personal and cultural cycle. This is part of what my Cheyenne brothers Hachivi Edgar Heap of Birds and Bently Spang visually articulate in *Neuf* and *The Healing,* and I am grateful for their images and for those of all the artists. The strong-hearted women and men of *Gifts of the Spirit* give every reason for optimism in the strength of the Native Nations, and what Is and Is Coming has rock-solid wholeness.

Aho.

Legacy of the Creative Spirit *Change and Innovation as Traditions in Native American Art*

The Creative Spirit in All Things *The Creative Process • Beauty in Everyday Objects*

Connections to the Spirit of Nature *Inspirations from the Natural World • Transforming the Materials of Nature*

Sharing the Spirit *Art That Helps Bind the Community, Clan, and Family*

The Spirit of Innovation *The Stimulus of New Materials and Ways of Thinking*

Reflections on the Spirit *Affirming the Spiritual • Art as Social Commentary and Humor*

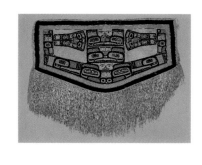

"When the dances are over, the sight, sound, and motion come to an end, but the rhythm remains and can be witnessed in the cycle of the seasons and the rites of passage. My work is of the old transformed into a contemporary vision."

Harry Fonseca, Nisenan Maidu Artist

Quillwork Cradle
Dakota Artist
Early 19th Century

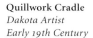

This cradle is a composition in both sight and sound. When carried about, rows of variously tuned chimes would have enveloped the baby in gentle music. Visually, it is a masterpiece of design and quillwork technique; the effect of the stark figures against a brilliant white background would have been intensified out-of-doors in daylight. Wood, leather, dyed quills, and metal.
Gift of Stephen Phillips, 1949. E27984

Chilkat Blanket
Tlingit Artist
Early 19th Century

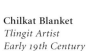

This Chilkat-style blanket, intended to be worn cape-like over the back and shoulders, combines a radically innovative design approach with extraordinary technical virtuosity. Earlier examples, of which there are very few, are characterized by geometric grids; this is the oldest known example with a representational composition, here dominated by a pair of "coppers," a symbol of wealth in the Northwest. The fineness and precision of the weaving reveal the hand of a master textile artist. Mountain goat yarn, plant fiber, and dyes.
Gift of Captain Robert B. Forbes, 1832. E3648

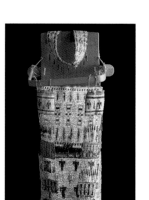

Do Indian Artists Go to Santa Fe when They Die?
Richard Ray Whitman
Yuchi Artist
1989

"It's hard to feel winds when you're sitting in some welfare office.
But I am not a case.
It's hard to see the mountains when you're sitting in some employment office;
I am not a number."
Serigraph.
Loaned by the Institute of American Indian Arts.

The Headache Pot
Clancy Gray
Osage Artist
1995

Clancy Gray works in various media, including painting, silverwork, and sculpture. Here, in a ceramic piece, he has created a humorous personification of frustration. Ceramic.
Loaned by the Bartlesville, Oklahoma, Community Center.

Pouch with Tassels
Pawtucket Artist
17th Century

The dyed quill embroidery of this work, consisting of double curves and geometric motifs on opposite sides, has faded from the original palette of bright orange, yellow, white, and blue/green. The graceful tassels, with metal chimes and elongated pull tabs with cutouts, combine with these lively colors and forms to create a kinetic and musical sculpture when worn. Dyed deerskin, fur, dyed porcupine quills, and metal.
Gift of Edward S. Moseley, 1950. E28561

Black Stone Bear
Pawtucket Artist
Ca. 16th Century

The technique of "pecking" one stone against another, creating small dimples that merge to form contours, was widely used to create functional stone tools such as ax blades and fishing weights. It is used here with brilliant economy to "release" a pensive bear from a water-rounded stone. Igneous rock.
Gift of Beara Eaton, 1898. E50296

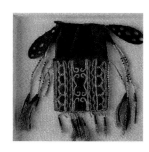

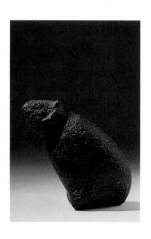

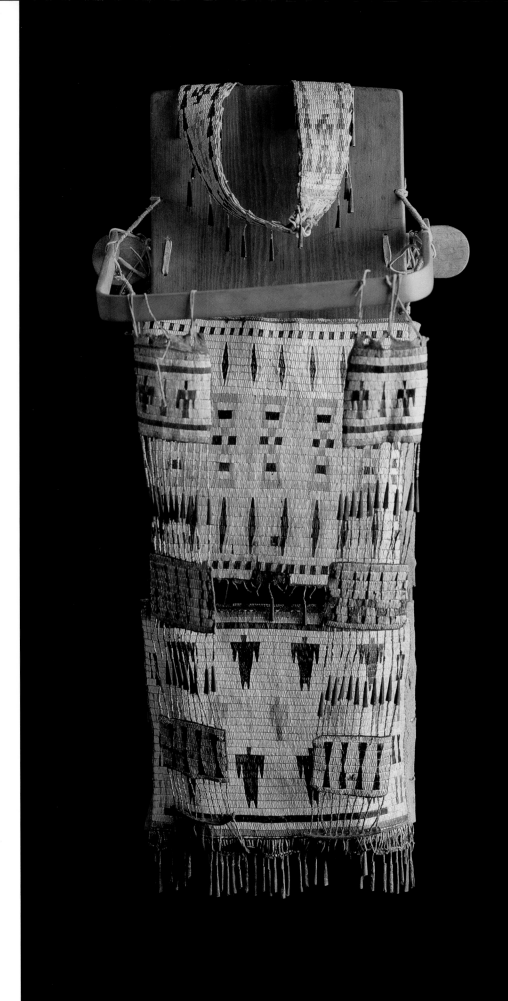

Quillwork Cradle
Dakota Artist

The Headache Pot
Clancy Gray

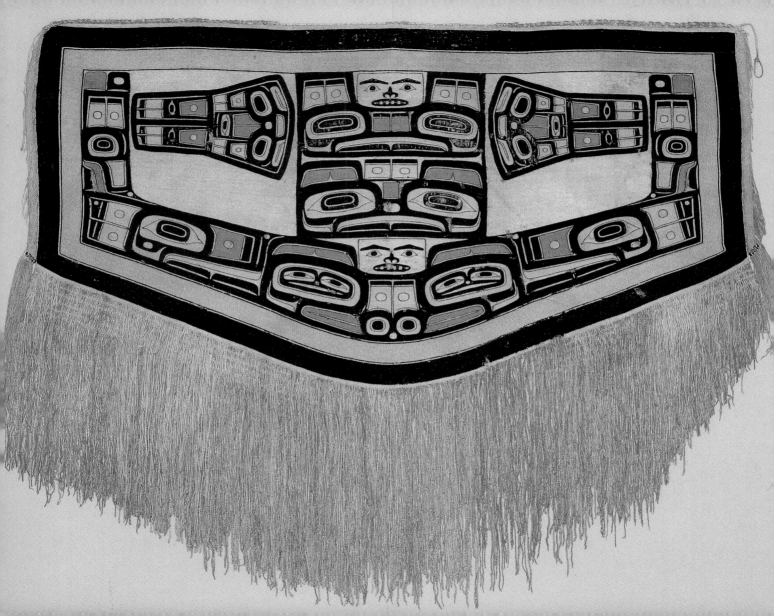

"I like to think that what I am doing expands on the work of artists of our documented culture. They were awesome artists—all their work had a sense of design, scale, and shape like sculpture. That's all I'm doing, continuing those same ideas, that tradition. . . . Just as people before me explained their world, I try to understand and bring purpose to mine."

Brian Tripp, Karok Artist

Pouch in Leather and Quills
Great Lakes Artist
Early 19th Century

The relaxed geometry of the triangles imparts a sense of horizontal movement to the dyed quillwork panels of this pouch. The strength of the design withstands the large catalogue number added in the 19th century. Leather, quills, and dyes. Donated before 1821. E3687

Bingo War Bonnet
Richard Glazer-Danay
Caughnawaga Mohawk
Artist
1995

"One should not take this business of art all too seriously. I often wonder why humorous art is not accorded the legitimacy that so-called 'high art' is." Hardhat and acrylic paint. Loaned by the artist.

Bowl in Burled Wood
Northeastern Artist
19th Century

The rich and turbulent grain of the wood is beautifully enhanced by the simple design and confident carving of the bowl. Wood. Gift of Mr. and Mrs. Willard C. Cousins, 1960. E36435

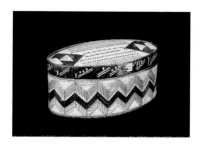

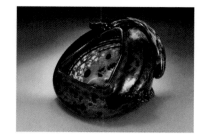

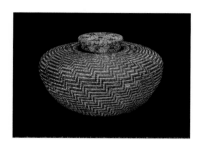

Oval Box
Micmac Artist
19th Century

The continuous side panel
of this oval box is quill-
embroidered with a bold
chevron design that is easily
readable at a distance, as
when stored on a shelf. The
cover panel is more intri-
cately conceived, sustaining
close-up visual interest
when the box is handled
and opened. The contrasting
approaches to the two sur-
faces, unified by the dark
top band, emphasize the
shape and mass of the box.
Birch bark, quills, and dyes.
Gift of John Robinson, 1906.
E9063

Basket with Lid
Chumash Artist
19th Century

In this work, beautifully
executed geometric patterns
alternately read to the eye
as parallel steps or spirals
of both wide and narrow
bands. Plant fiber.
Gift of Alvin Johnson, 1950.
E28771

Night Keeper
Tony Jojola
Isleta Pueblo Artist
1991

For Isleta Pueblo potters,
and glass sculptor Tony Jo-
jola, fire is a dramatic and
defining ingredient. Em-
ploying an array of high-
temperature techniques,
Jojola uses the "fire" itself to
sculpt and mold his works.
The *Night Keeper,* a blue ser-
pent, has been created from
colored glass threads, fused
to the surface of the molten
vessel with a torch. Glass.
Loaned by the Institute of
American Indian Arts.

The True West
Alex Janvier
Dene Artist
1975

Born in 1935 at the Cold
Lake Reserve in northeast-
ern Alberta, Alex Janvier is
the son of the last hereditary
chief of his people. Janvier
was removed as a child to a
residential school, where he
began to express himself
through art. Today, his work
is characterized by abstract
maps of his insights into
nature, individual identity,
and political conflict. In
The True West, Janvier
explores the imagery and
mythic associations of the
Canadian West. Acrylic
paint on canvas.
Loaned by the Indian Art
Centre.

101

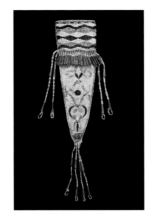

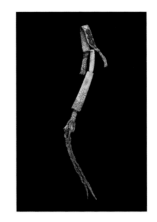

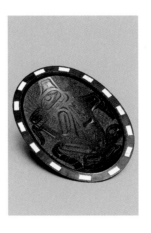

Inlaid Ceramic
John Gonzales
San Ildefonso Pueblo Artist
1995

The impeccably carved
feathers create a strong
inward movement, forcing
the eye to witness the
dramatic lightning-spitting
underwater serpent.
Ceramic with several
turquoise inlays.
Loaned by John Caltagirone.

Knife Sheath
Lakota Artist
Late 18th–Early 19th Century

The creation of convincing
floral and curvilinear de-
signs in quillwork is techni-
cally challenging. Here, its
masterful execution is an
important element of this
graphically powerful com-
position. Leather, quills,
and dyes.
Gift of Mrs. Story, 1845.
E3676

Neuf Series
(one in a series of four)
Hachivi Edgar Heap of Birds
Tsistsistas (Cheyenne) Artist
1991

Acrylic paint on canvas.
Loaned by the artist.

Horse Whip
Lakota Artist
Mid-19th Century

The bright colors of the
wrist strap and fringe gath-
ering are well preserved,
retaining the intended con-
trast to the incised gray-
white handle. Bone, leather,
quills, and dyes.
Donated in 1855. E3672

Sea Monster
Tom Price
Haida Artist
1888

Tom Price is one of a small
number of "signature" art-
ists of the late 19th-century
Northwest. Price was a sil-
versmith as well as a sculp-
tor. Here he treats the lus-
trous black argillite stone in
much the same way as silver,
creating a sense of depth for
the central figure by muting
the background with cross-
hatching. Argillite and ivory.
Museum purchase, 1954.
E31728

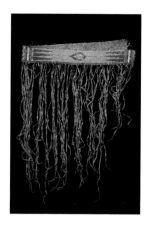

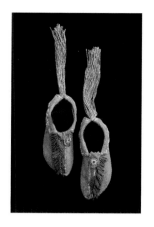

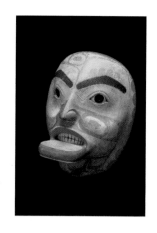

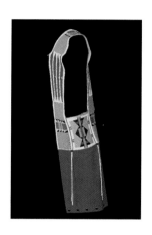

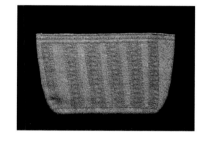

Shirt Strip in Purple and Yellow
Plains Artist
Early 20th Century

One of a pair of fringed ornamental strips, intended for the shoulders of a man's leather shirt, this work preserves the bold original colors of quills prepared with commercial dyes.
Leather and dyed quills.
Monks Collection, received 1944. E24448

Bandolier Bag
Jerry Ingram
Choctaw/Cherokee Artist
Ca. 1985

"I'm trying to bring back images of what it was like in the old days. I've always been fascinated by the Northern Plains Indians, although I'm not of that tribal group . . . but I try anyway to capture the mystique, the colorfulness, the essence." Wool, leather, and glass beads.
Loaned by the artist.

Shoes in Yellow and Red
Comanche Artist
Late 19th–Early 20th Century

The bright colors and trailing fringe of these dance shoes are the embodiment of movement. Leather, glass beads, and dyes.
Gift of the estate of Lawrence W. Jenkins, 1962. E37678

Wallet
Puget Sound Artist
Ca. 1830

Many Native American works from the 19th century are muted and worn with age; this pristine wallet, among the oldest Puget Sound baskets known, was collected when relatively new and retains the intended crispness of its bold design. Plant fiber.
Gift of Captain Robert Bennett Forbes, 1832. E3624

Djilakons
Haida Artist
Early 19th Century

The subject of this portrait mask is inferred to be Djilakons, the ancestress of the eagle moiety in Haida cosmology. The mask was carved by a master artist of the early 19th century and is one of a group of works, including a doll elsewhere in this exhibit, by the same hand. Wood and paint.
Gift of Captain Daniel Cross, 1827. E3483

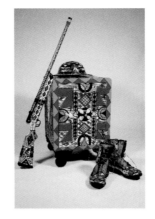

Indian Affected by Anti-Indian Backlash
David P. Bradley
Ojibwe Artist
1978

"I am a mixed-blood Ojibwe, a Minnesota Chippewa, and also have a lesser amount of Sioux heritage. One of my relatives was included in the tragic, public mass execution of Sioux Indians in Mankato, Minnesota, in 1863 during the Lincoln administration. . . . Indians are, by definition, political beings. We are nations who have been under siege for five hundred years." Alabaster.
Loaned by the Institute of American Indian Arts.

Boots
Hinono'el (Arapaho) Artist
Late 19th Century

The striking beadwork panels and vertical rows of polished buttons are designed to be revealed below a woman's ankle-length skirt. Leather, glass beads, and metal buttons.
Gift of Mrs. Phillip W. Bourne, 1942. E23835

Peace, Order, and Good Government
Teresa MacPhee Marshall
Micmac Artist
1993

"I'll probably spend the rest of my life unlearning . . . history lessons, getting past the fiction in order to get closer to a realistic understanding and appreciation of our heritage. . . . I am hopeful that my work serves as a catalyst for considering an alternative perspective to the noble savage image that haunts us." Steel, leather, wood, iron, and paint.
Loaned by the artist.

Neuf Series
(one in a series of four)
Hachivi Edgar Heap of Birds
Tsistsistas (Cheyenne) Artist
1991

"Over many years of walking and watching in the out-of-doors, the images of movement, color, pulse, and celebration have become an evolving visual language. These . . . works seek to project the understanding that the world, as witnessed from the sage, cedar, and red canyon, is a lively and replenishing place." Acrylic paint on canvas.
Loaned by the artist.

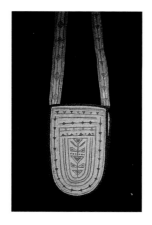

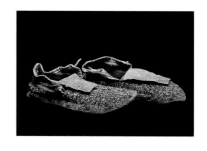

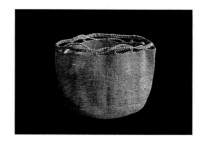

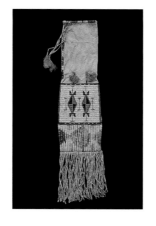

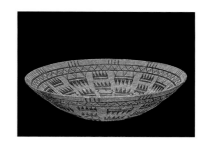

Cap with Glass Beads
Mohawk Artist
Late 19th Century

Thin beadwork sprays serve to lighten the dense floral motifs. Cloth and glass beads.
Gift of Mr. and Mrs. Willard C. Cousins, 1958. E34655

Basket
Inuit Artist
Early 19th Century

Tiny interwoven bits of colored wool provide a subtle adornment, while discreetly calling attention to the finely executed weave. Plant fiber and wool threads.
Gift of Captain Johnson Briggs, 1803. E3620

Shoulder Bag
Naskapi Artist
Early 20th Century

The applied black border of the cover flap enhances the comparative whiteness of the caribou hide, which provides a striking canvas for the energetic red and blue lines of the painting. Caribou hide, paint, and cloth.
Museum purchase, 1950. E28844

Pipe Case
Lakota Artist
Late 19th Century

Carefully crafted beadwork designs contrast with bolder forms created by wrapping rawhide strips with brightly colored quills. Leather, glass beads, quills, feathers, and metal.
Gift of Willard C. Cousins, 1946. E25832

Multicolored Moccasins
Plains Artist
Late 19th Century

The apparently random pattern of multicolored beads conceals a design consisting of diagonally paired black squares and subtle zones of differently mixed colors. Leather and glass beads.
Gift of the Emhart Corporation, 1977. E66864

Basket
Chumash Artist
19th Century

Tiers of upwardly directed forms are interrupted and balanced by ranks of opposing shapes. These lines of apparent movement are confined within the basket by an outer band of double lines and triangles. Plant fiber.
Exchange, Edward Rushford, 1946. E25318

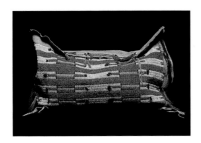

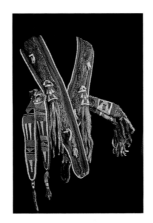

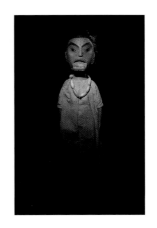

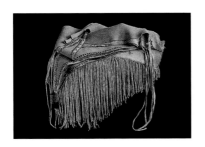

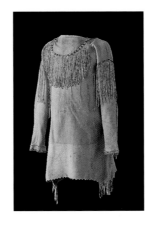

Bag with Red Tufts
Lakota Artist
Ca. 1900

By terminating the beaded red and yellow bands with cloth tufts, the artist has purposely "teased" the design away from the flat surface of the bag, creating the illusion of multiple planes of color. Leather, glass beads, horsehair, and cloth. Gift of Amy Bassett, 1934. E21294

Leggings
Kiowa Artist
Early 20th Century

Both wearer and audience share in the experience of the luxurious leather and ample fringe of these dance garments. Leather and glass beads.
Gift of Ruth G. Cotton in memory of Henry I. Cotton, 1984. E73401

Quiver and Bow Case
Crow Artist
Mid-19th Century

Bright beadwork and extensive panels of red wool and otter fur are sumptuously combined in this quiver/bow case. Intended for formal occasions, this wraparound sculpture transforms and empowers the wearer. Fur, cloth, and glass beads. Museum purchase, 1884. E1918

Fringed Shirt
Kiowa Artist
Early 20th Century

This was worn with the leggings (E73401) also on this page. Leather and glass beads.
Gift of Ruth G. Cotton in memory of Henry I. Cotton, 1984. E73402

Djilakons Doll
Haida Artist
Early 19th Century

This doll and a portrait mask elsewhere in the exhibit are believed to have been produced by a single artist in the first decades of the 19th century. The works appear to be a series of explorations of the iconography of Djilakons, a highly important Haida cultural ancestor. Wood, hair, cloth, paint, ivory, and shell. Andover Newton Theological School Collection, received 1976. E53452

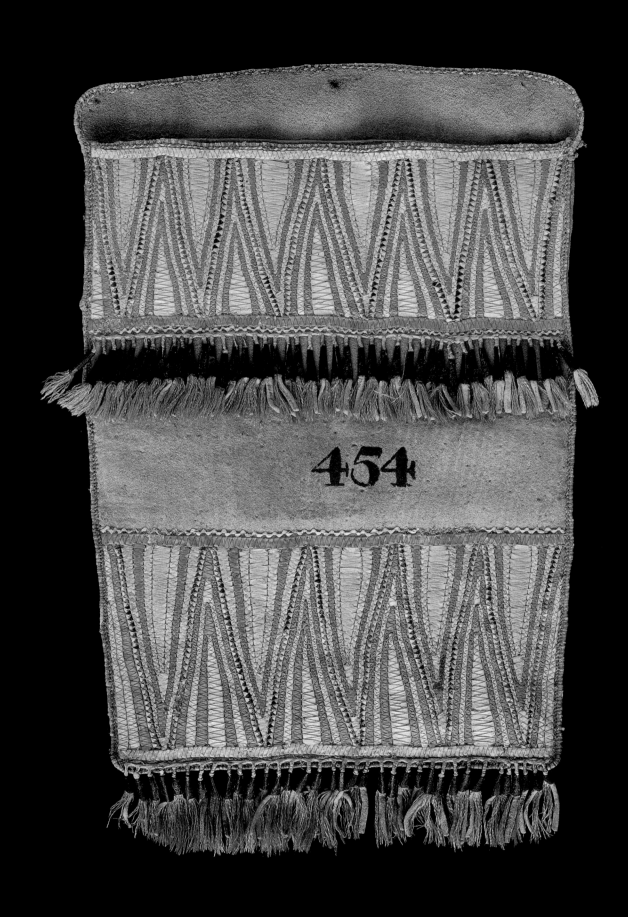

Pouch in Leather and Quills
Great Lakes Artist

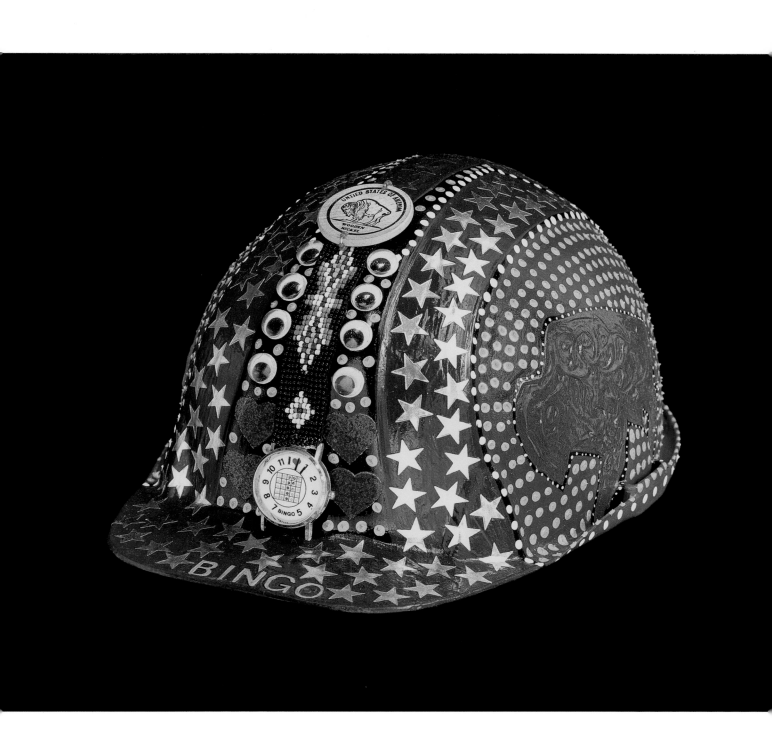

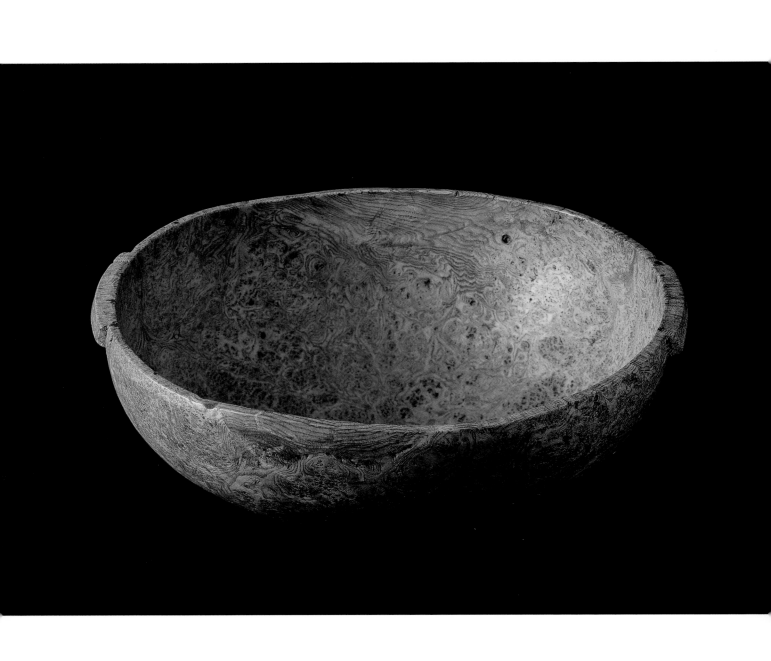

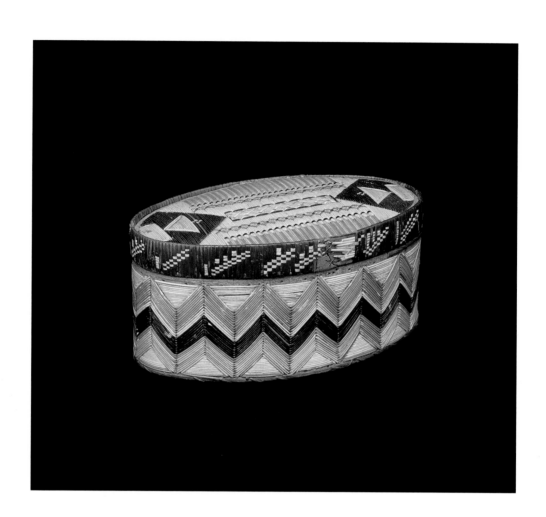

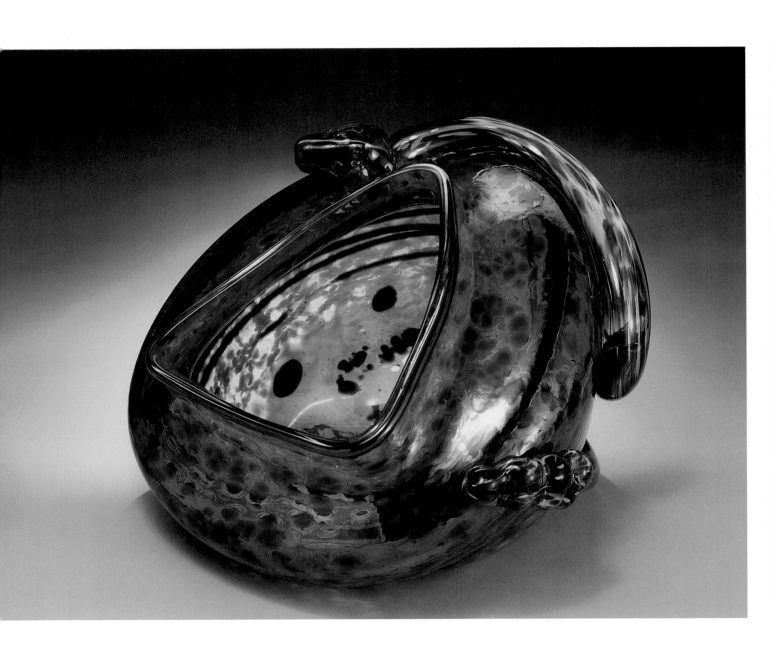

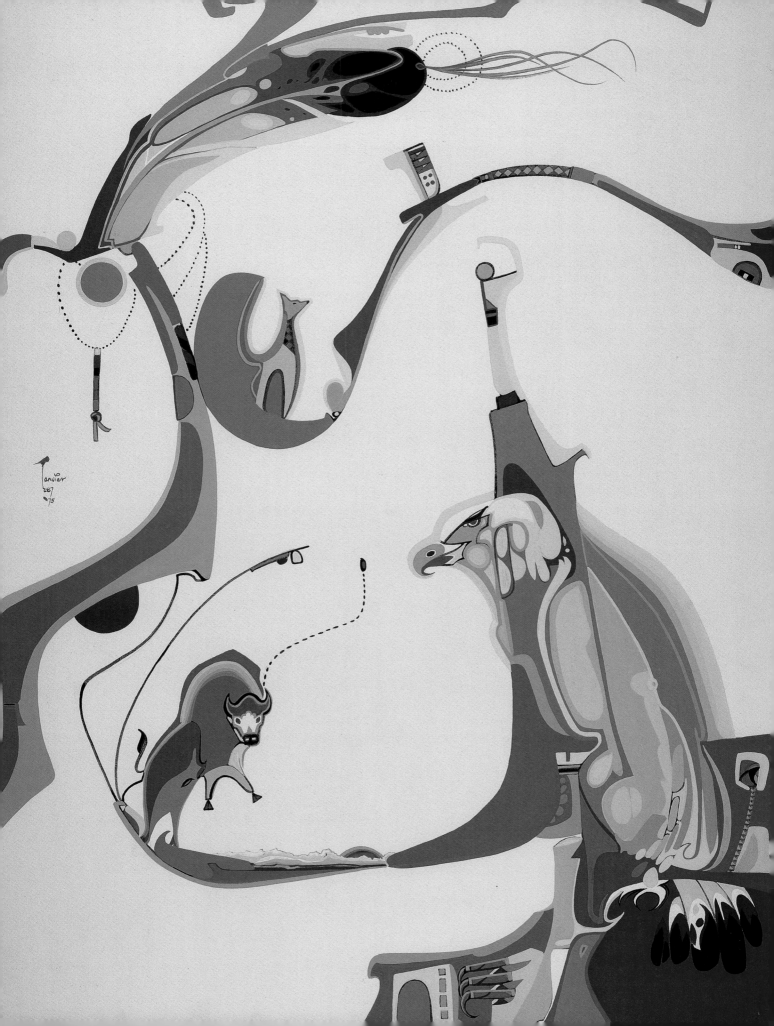

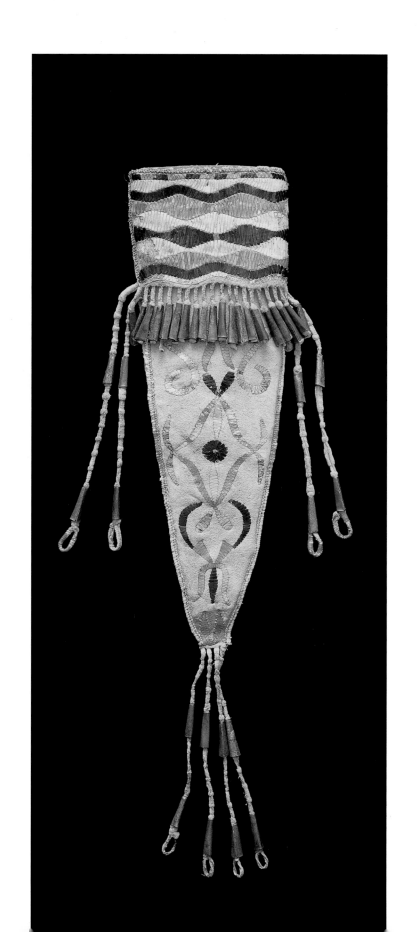

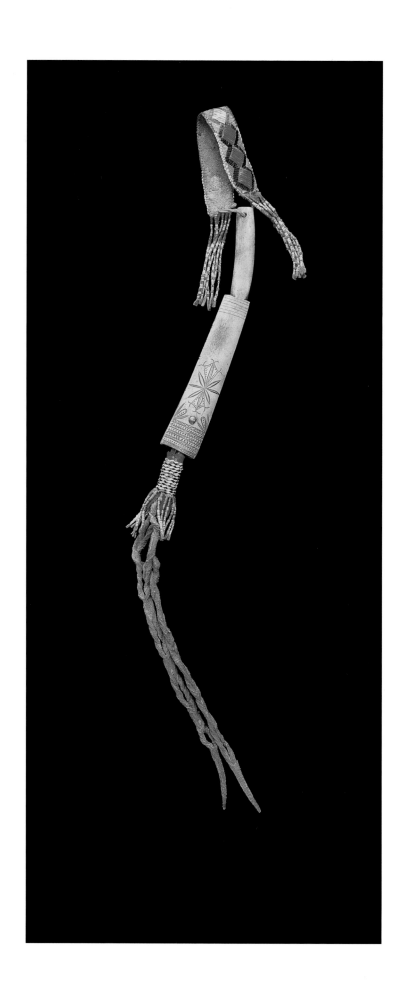

Horse Whip
Lakota Artist

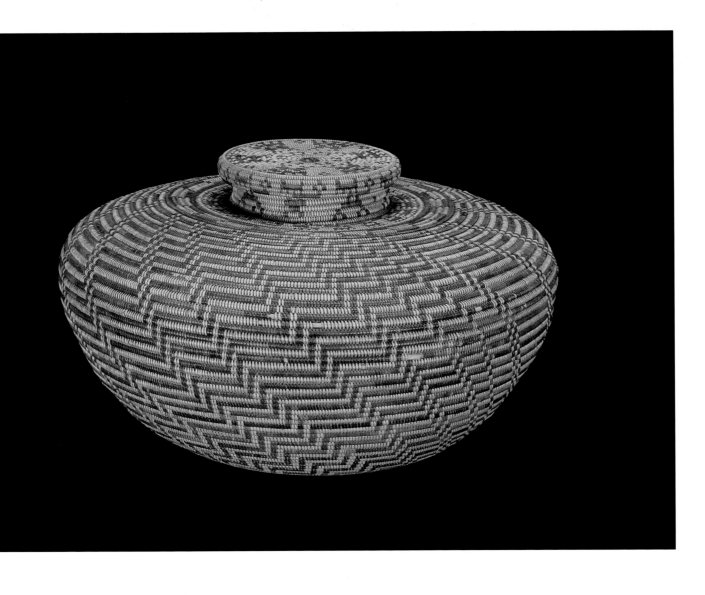

116 **Basket with Lid**
Chumash Artist

Inlaid Ceramic
John Gonzales
San Ildefonso Pueblo Artist

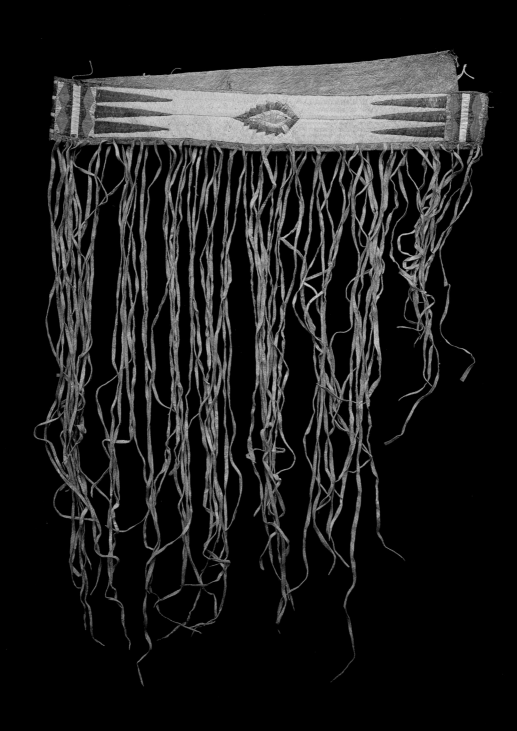

Shirt Strip in Purple and Yellow
Plains Artist

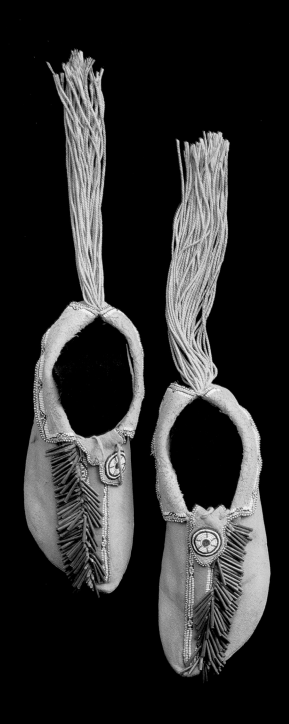

Shoes in Yellow and Red
Comanche Artist

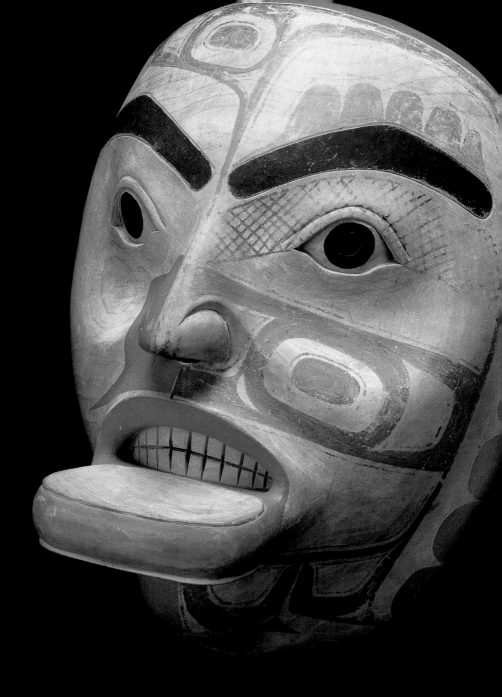

Djilakons
Haida Artist

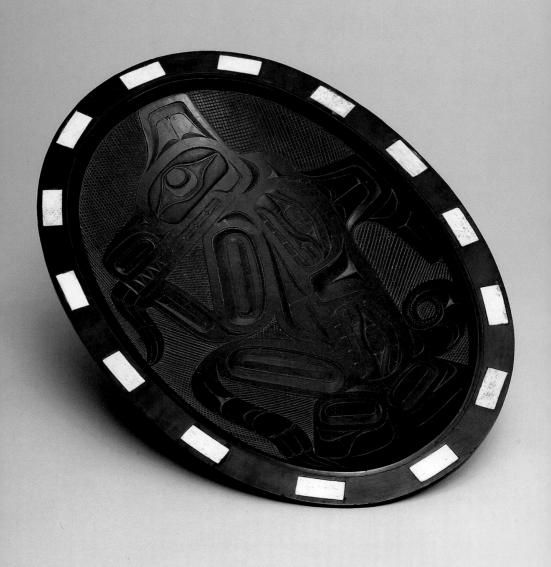

Bandolier Bag
Jerry Ingram
Choctaw/Cherokee Artist

Wallet
Puget Sound Artist

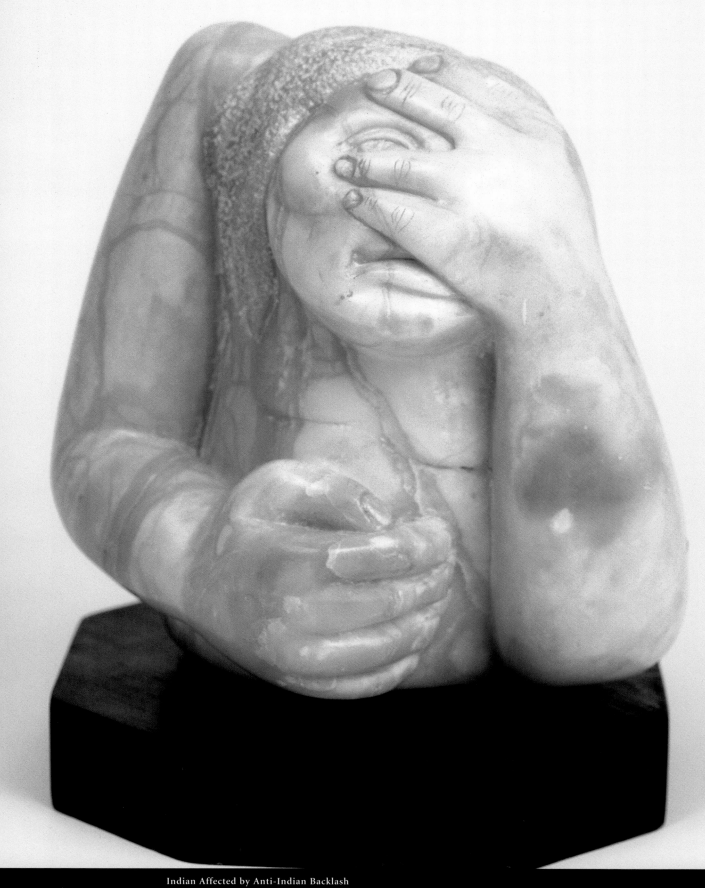

Indian Affected by Anti-Indian Backlash
David P. Bradley

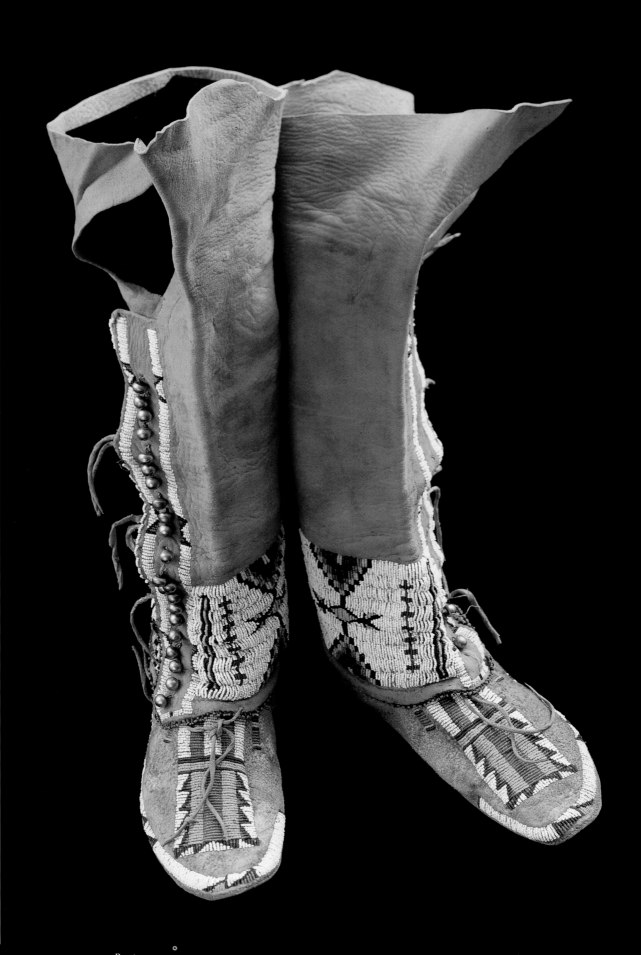

Boots
Hinono'ei (Arapaho) Artist

"My father's use, respect, and knowledge of wood became my own great and primary direction. My mother's work with color, beads, and ribbons also found their place in my work. I discovered what I wanted to do: use those natural forms and materials reflecting where I grew up. . . . My major concern now is not design, but how I can assemble various elements to say what I really want to say."

Truman Lowe, Winnebago Artist

"In this search for my own reality, I seek the power of the rock, the magic of the water, the religion of the tree, the color of the wind, and the enigma of the horizon."

George Morrison, Grand Portage Chippewa Artist

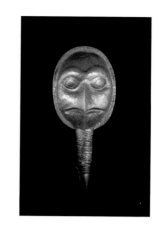

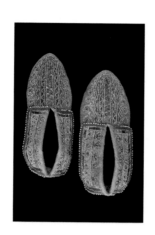

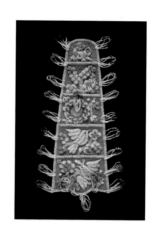

Bird Flute
Dakota Artist
Early–Mid-19th Century

This strongly animated piece, with its brass eye and open beak, seems to "breathe," even before it is played. Wood, paint, and brass. Gift of the Andover Newton Theological School, 1946. E25415

Spirit of the Future
Marvin Oliver
Quinault/Isleta Pueblo Artist
1996

"My works are formulated by merging the spirit of past traditions with those of the present . . . to create new horizons for the future." Bronze. Loaned by the artist.

Water Spirit #3
Truman Lowe
Winnebago Artist
1995

"The reeds and willow wands are like the plants, weeds, and rice that grow out of a marsh's or a stream's banks. If I have a signature, it is the willows on the water's edge." Wood. Loaned by the artist.

Moccasins with Blue and Red
Iroquois Artist
Late 18th–Early 19th Century

The electric contrast between the predominant reds and blues of these moccasins is further exaggerated by the borders of spirals and bright green ribbon. Leather, quills, and dyes. Donated before 1947. E26326

Rattle
Tlingit Artist
19th Century

Copper and wood. Gift of the estate of Isabel Anderson, 1949. E28234

Wall Pocket in Purple
Mohawk Artist
Late 19th Century

In this work, voluptuous clusters of clear glass beads achieve the appearance of cut glass set against a rich purple background. Cloth and glass beads. Gift of M. L. Dewey, 1922. E18499

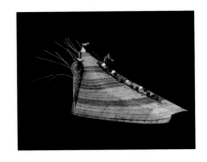

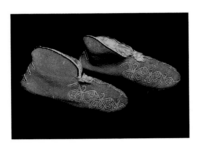

Shield
Dog Men Warrior
Tsistsistas (Cheyenne) Artist
19th Century

The painting on this shield, which provided its owner with both physical and spiritual protection, presents a Man-Bird and Lizard Medicine within a geometric composition that suggests movement toward and/or from a distant horizon. Leather, feathers, and paint. Gift of George L. Smith, 1946. E26065

Moccasins
Muscogee Artist
19th Century

The contrasting outline of the basic motif, consisting of a figure with six sinuous arms, contributes to the overall effect, which is lively, almost psychedelic. Leather, glass beads, and cloth. Museum purchase, 1954. E31731

Spirit Shield
Susan Stewart
Crow/Blackfoot Artist
1990

"[In] painting, . . . I come closest to a place of peace. . . . I use the medium of painting . . . a real contemporary form, but I'm expressing this feeling about the land. . . . it's like a song going through my mind." Acrylic paint on canvas. Loaned by the artist.

Black Velvet Bag
Kahnawake Mohawk Artist
19th Century

The careful geometry of the flaps, outlined in white and black, maintains a sense of overall lightness despite the fully beaded surface. Velvet, ribbon, and glass beads. Museum purchase, 1954. E31556

Hat with Walrus Whiskers
Aleut Artist
Early 19th Century

This hunter's hat, probably intended more for ceremony than everyday use, is an electric and brightly painted compostion. Wood, walrus whiskers, glass beads, ivory, and paint. Gift of Captain William Osgood, 1829. E3486

Beaded Bag
Muscogee Artist
Early 19th Century

The negative space created by the black background serves to unify the complex palette and overlapping motifs of this shoulder bag. Cloth and glass beads. Donated before 1900. E7437

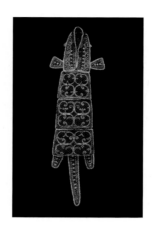

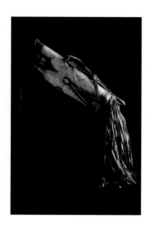

Salmon Woman
John Jay Hoover
Aleut Artist
1993

"Salmon Women were put
at the head of streams to
entice the salmon to return
each year to spawn. . . . I
have interpreted this myth
many times in many ways
as I am a salmon fisherman
myself. . . . The red beads
are the eggs, and the white
beads represent the male
sperm." Wood, paint, and
glass beads.
Loaned by the artist.

Pipe with Quill Streamer
Ojibwe Artist
1767

The head of an otter is bril-
liantly encompassed in the
flaring rim of this catlinite
pipe, inscribed and dated
1767. Catlinite, leather, and
quills.
Gift of Mr. and Mrs. Edward
S. Moseley, 1981. E68211

Turtle Clan Blanket
Conrad House
Navajo/Oneida Artist
1996

"Art is an outlet for the ex-
pression and communica-
tion of ideas, desires, and
fantasies that are pertinent
to me. . . . Nature has been
a primary force and concern
in my creations. . . . Creat-
ing is cultivating a way of
life—growing, learning, un-
derstanding, and translat-
ing." Cloth.
Loaned by the artist.

Winking Mask
Inuit Artist
Late 19th Century

The controlled use of nega-
tive space and the accentua-
tion of a half-closed eye
impart life to this fox mask.
Wood and paint.
Gift of Ellen A. Stone, 1908.
E11580

Mink Skin Bag
Micmac Artist
19th Century

The bright blue curvilinear
designs, set against contrast-
ing red wool, create a strong
sense of movement in this
bag intended for religious
objects. Mink skin, cloth,
and glass beads.
Gift of the estate of Charles
F. Williams, 1907. E9823

Sacred Object Container
Plains Artist
19th Century

An essentially cylindrical
container is here trans-
formed by flame-red and
yellow paint and flowing
fringe into a vibrant and
compelling work. Rawhide
and paint.
Gift of the Pennsylvania
State Historical Commis-
sion, 1949. E28313

Souvenir of Alaska
Inuit Artist
Late 19th Century

Executed with great humor,
this work is surmounted by
a parade of cavorting ani-
mals and a man. Ivory.
Gift of Charles G. Weld,
1908. E10529

Painted Hide
Martin Red Bear
Oglala and Sicangu Lakota
Artist
1991

Deer hide and acrylic paint.
Loaned by the artist.

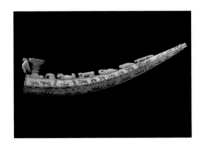

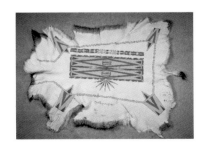

Crimson Ridge. Path to the Sky. Red Rock Variation: Lake Superior Landscape
George Morrison
Grand Portage Chippewa
Artist
1995

Acrylic paint on canvas. Loaned by the artist.

Pouch with Water Panthers
Ojibwa Artist
Late 18th–Early 19th Century

The world, to the Ojibwa peoples of the Great Lakes, floated on a vast body of water ruled by powerful panther-like spirits. Here, the artist provides a window on this underworld. Leather, quills, and dyes.
Andover Newton Theological School Collection, received 1976. E53449

Box
Montagnais Artist
19th Century

Confident workmanship, beautiful form, and perfectly proportioned surface decoration converge in this outstanding box. Birch bark. Museum purchase, 1954. E31705

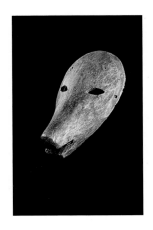

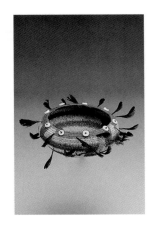

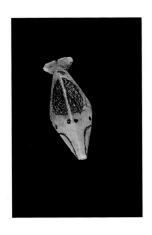

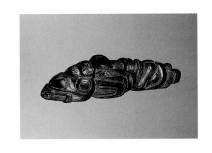

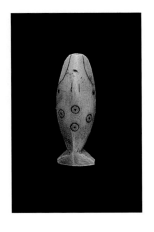

Bear Mask
Inuit Artist
Late 19th Century

Wood and paint.
Gift of Arthur W. Whitcher,
1919. E*17782*

Tiny Whale
Inuit Artist
19th Century

Many works by Inuit artists
are miniature distillations
of the vast Arctic world;
here, a toggle has become a
playful portrait of a whale,
with downturned smile and
inlaid eyes. Ivory and
baleen.
Gift of the Bostonian Soci-
ety, 1957. E*33839*

Copper Knife
Tlingit Artist
19th Century

The smoked-wood bear's
head of this knife has been
animated by the use of
light-catching abalone inlays
for the eyes and teeth, while
the line of the blade is en-
hanced by incised designs.
Copper, wood, leather, and
abalone.
Gift of the estate of Isabel
Anderson, 1949. E*28190*

Transformation Pipe
Haida Artist
Early 19th Century

The artist has maintained a
balanced overall form,
despite the energy of the
component vignettes and
transformations. Argillite.
Gift of John Hammond,
1821. E*3493*

Feather Basket
Pomo Artist
19th Century

Plant fiber, feathers, and
glass beads.
Gift of Lawrence W. Jenkins,
1957. E*37928*

Whale Toggle
Inuit Artist
19th Century

See the companion of this
work (E*33839*) elsewhere
on this page. Ivory.
Gift of the Bostonian Socie-
ty, 1957. E*33840*

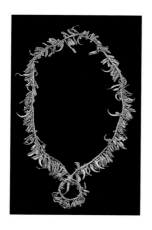

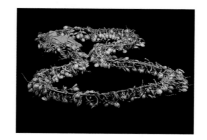

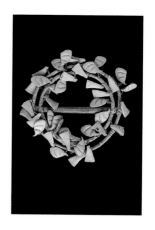

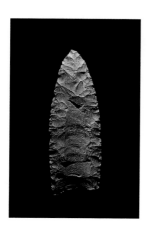

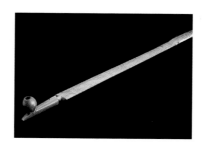

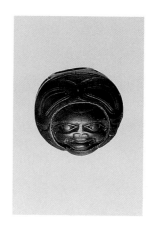

Necklace
Plains Artist
19th Century

Composed of eagle talons, young grizzly bear claws, and dewclaws from a deer, this work is a potent visual and musical narrative on power and prowess in nature. Leather, eagle talons, deer hooves, and bear claws. Gift of the Savage Collection, 1890. E3717

Red Spearhead
Native American Artist
Ca. 10,500 Years Ago

A style prevalent in North America some eleven millennia ago, sculpted by extremely demanding flint knapping techniques. The final step, in which a central channel was created, was the most difficult and dramatic, as it could easily ruin the entire work. Siltstone. Gift of William Eldridge, 1992.

Plumstone Dance Bandolier
Oglala Lakota Artist
19th Century

This work of plumstones, carefully graded by size and sound, must be handled and heard to be fully appreciated. Plumstones and leather. Gift of the Fenstemakers Collection, 1949. E28311

Pipe
Lakota Artist
Early 19th Century

Catlinite, wood, quills, and horsehair.
Gift of John Marsh, 1826. E3690

Puffin Beaks Rattle
Haida Artist
19th Century

The lightweight puffin beaks, combined with the sinew attachments, give this rattle a spring-like energy and a pleasing hollow sound. Puffin beaks, wood, and sinew. Smithsonian Institution Collection, received 1884. E3490

Creation Pipe
Haida Artist
Early 19th Century

In the Haida world, humankind emerged from within an open clam. In this interpretation, a face-first birth is depicted on the sides of this clam-shaped pipe. Argillite. Gift of J. P. Williams, 1829. E3497

135

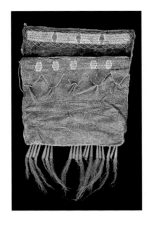

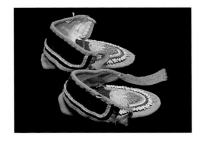

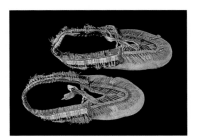

Dark Is the Field. Towards the Night. Red Rock Variation: Lake Superior Landscape
George Morrison
Grand Portage Chippewa
Artist
1995

"I seek the power of the rock, the magic of the water, the religion of the tree, the color of the wind, and the enigma of the horizon."
Acrylic paint on canvas.
Loaned by the artist.

Pouch with Thunderbird
Great Lakes Artist
Late 18th–Early 19th Century

A large central figure of a Thunderbird, messenger of the Spirit and the giver of rain, dominates the smaller figures of birds and fish. Leather, quills, metal, and dyes.
Gift of Captain Douglass, 1822. E6637

Moccasins for a Child
Mohawk Artist
19th Century

In decorating these charming moccasins, the artist has not attempted to miniaturize a full-scale beaded pattern, but rather used only a portion of a larger composition, emphasizing their small size. Leather, glass beads, and cloth.
Gift of Lawrence W. Jenkins, 1957. E34062

Moccasins with Orange and Blue Fringe
Huron Artist
Late 18th–Early 19th Century

The dense orange and blue fringe integrates with the delicate floral designs executed in dyed moose hair embroidery. Leather, moose hair, quills, and dyes.
Donated before 1867. E3708

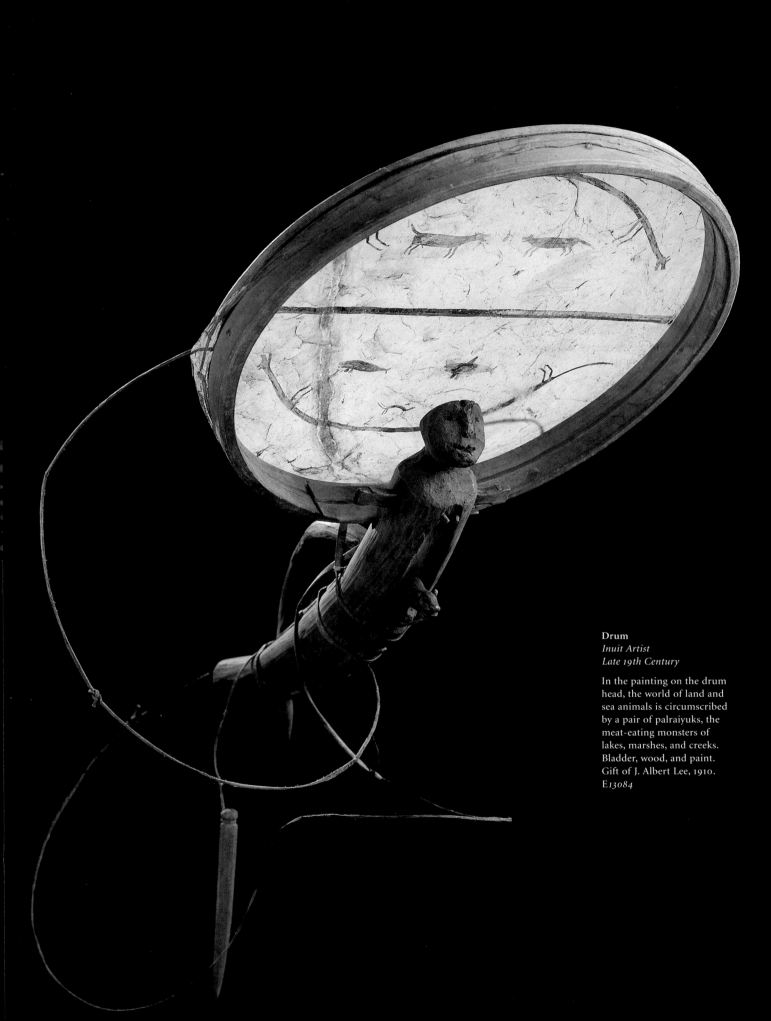

Drum
Inuit Artist
Late 19th Century

In the painting on the drum head, the world of land and sea animals is circumscribed by a pair of palraiyuks, the meat-eating monsters of lakes, marshes, and creeks. Bladder, wood, and paint. Gift of J. Albert Lee, 1910. E13084

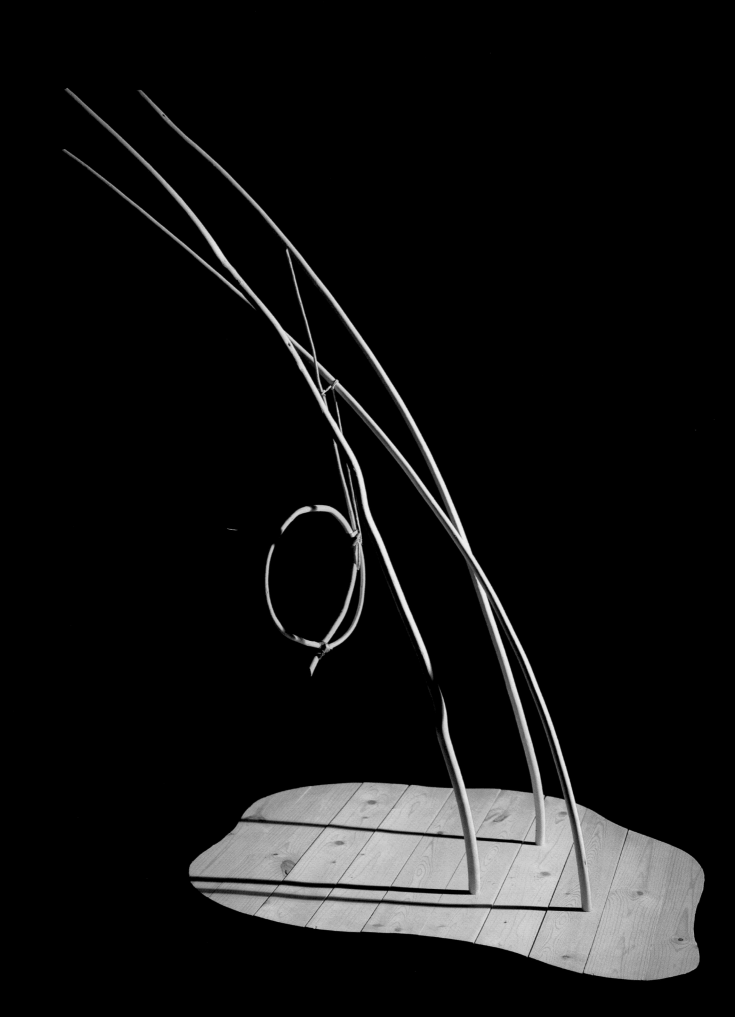

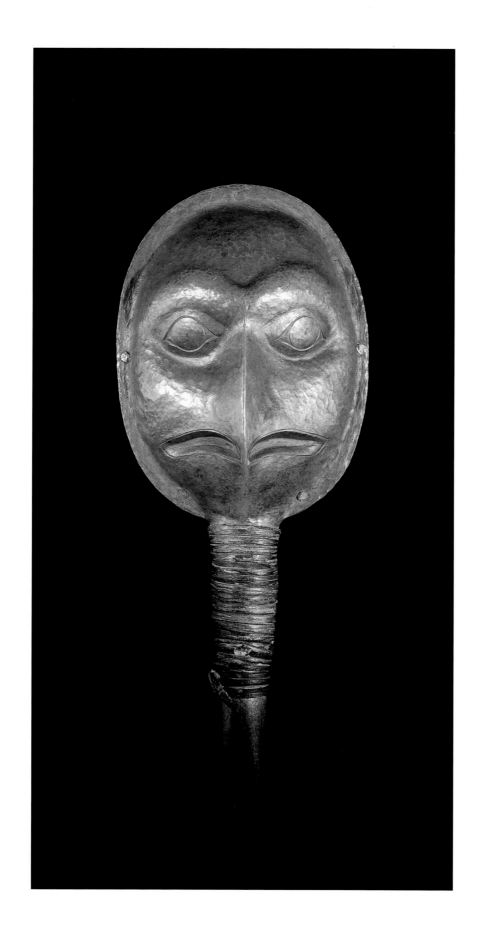

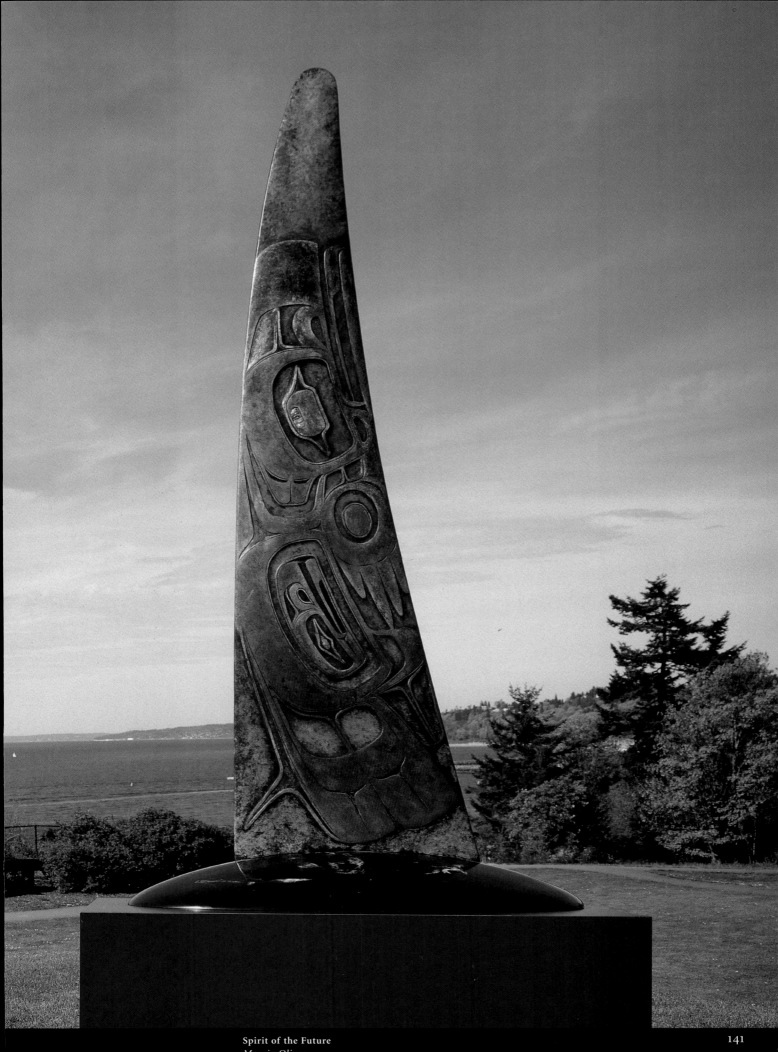

Spirit of the Future
Marvin Oliver
Quinault/Isleta Pueblo Artist

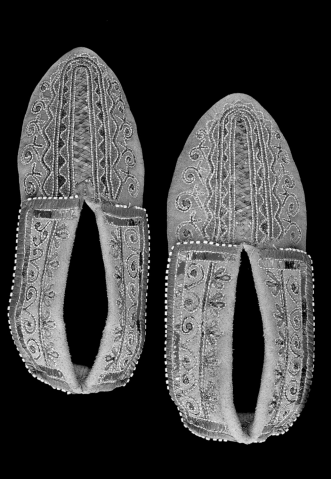

Moccasins with Blue and Red
Iroquois Artist

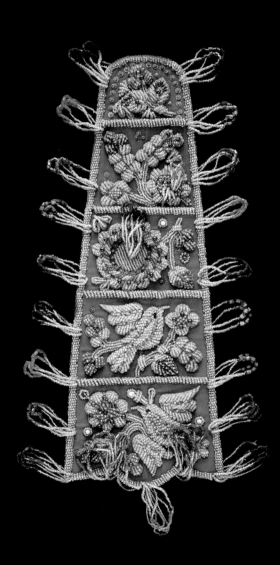

Wall Pocket in Purple
Mohawk Artist

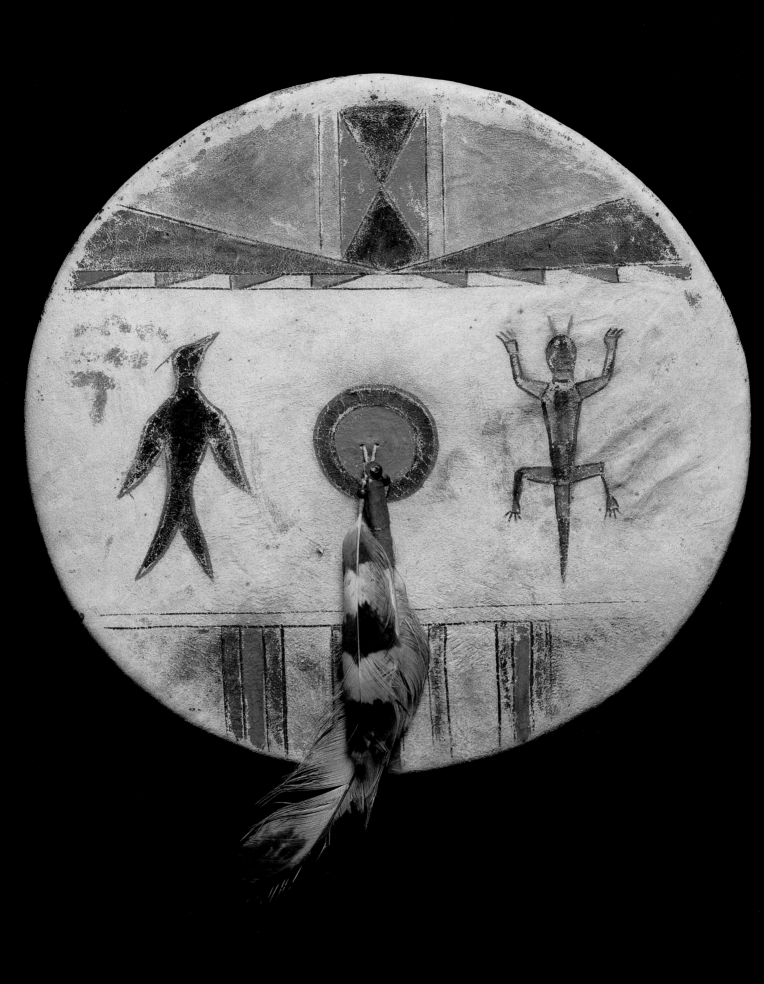

Shield
Dog Men Warrior Tsistsistas
(Cheyenne) Artist

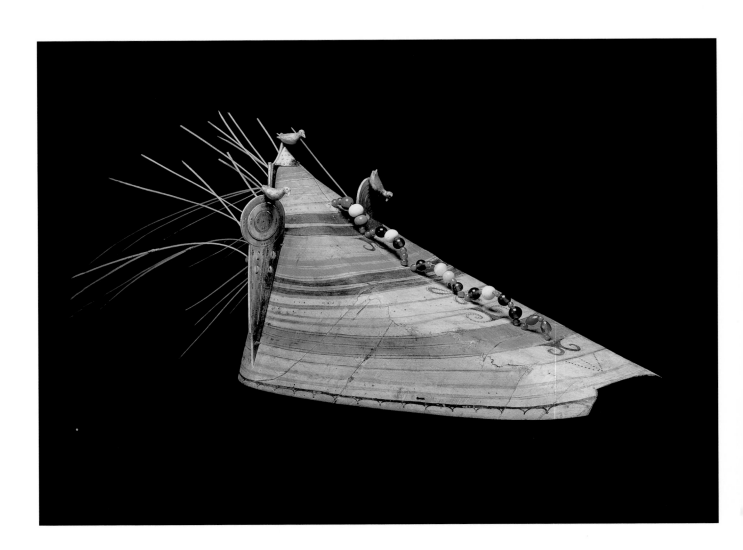

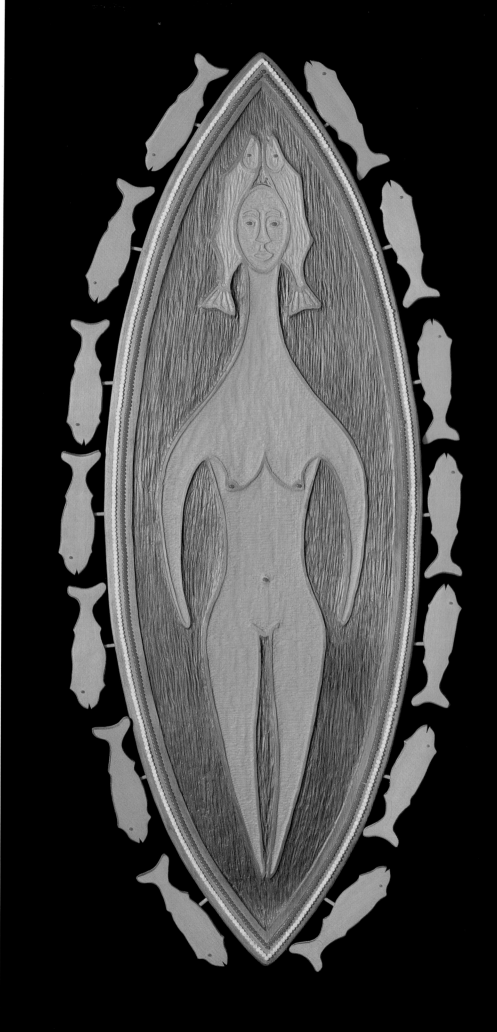

Salmon Woman
John Jay Hoover
Aleut Artist

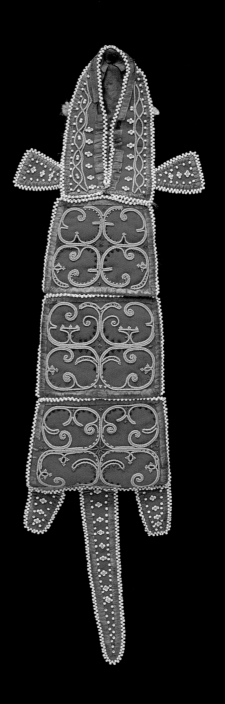

Mink Skin Bag
Micmac Artist

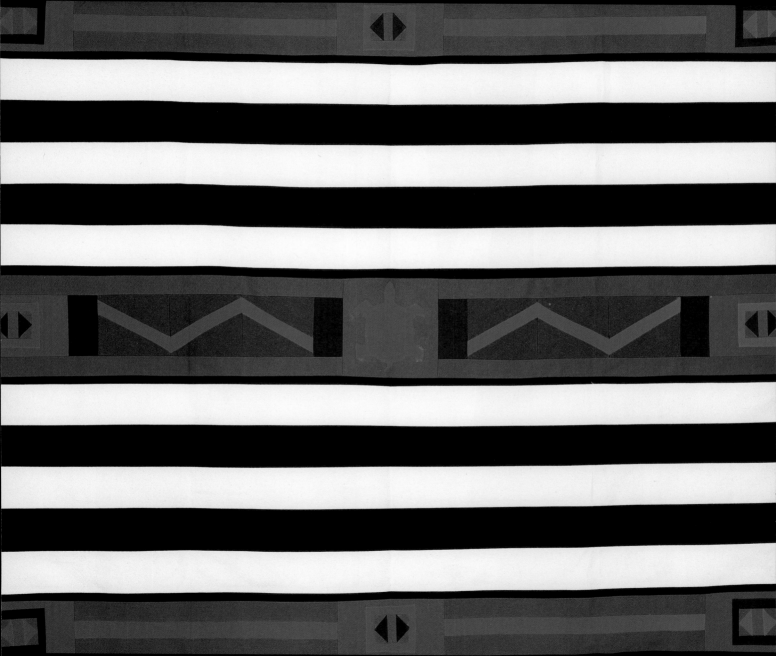

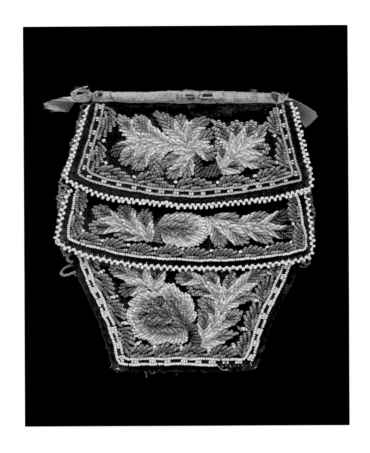

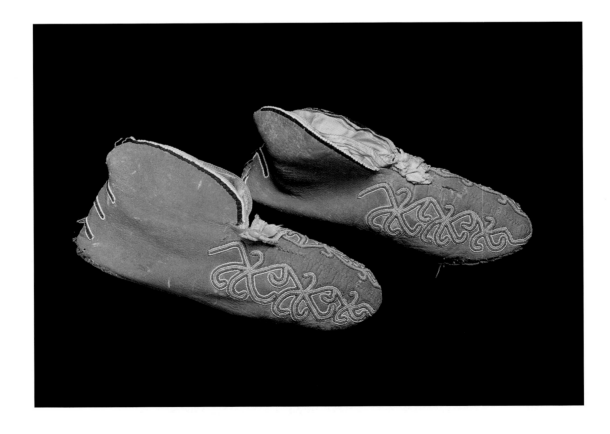

Black Velvet Bag
Kahnawake Mohawk Artist

Moccasins
Muscogee Artist

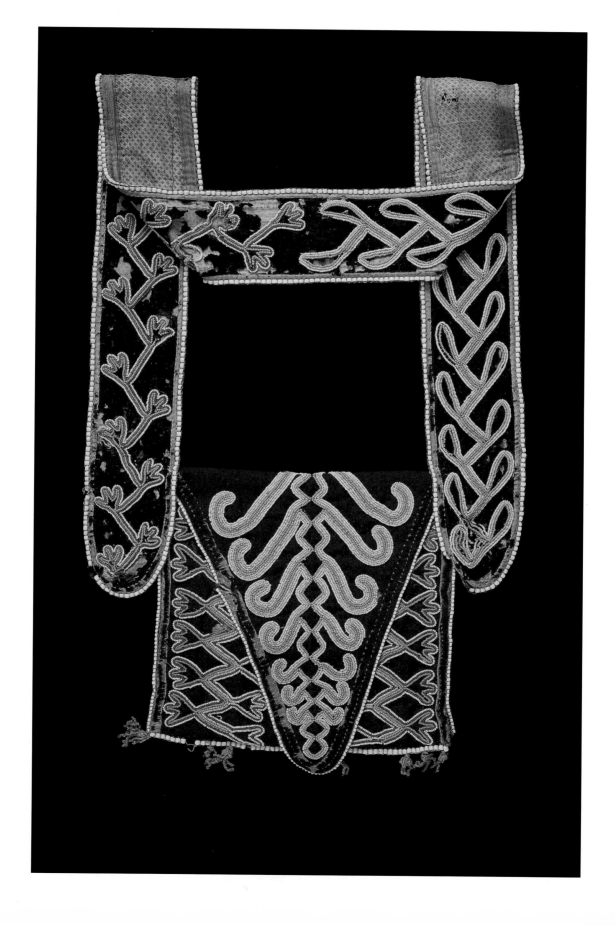

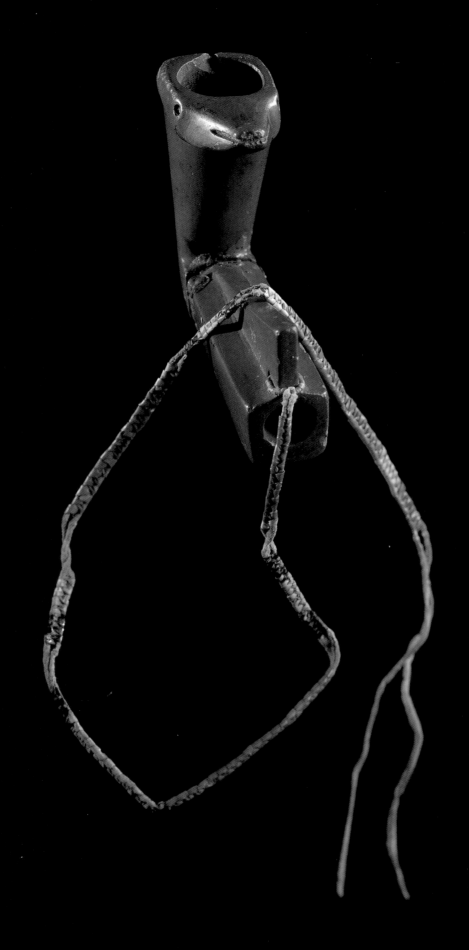

Pipe with Quill Streamer
Ojibwe Artist

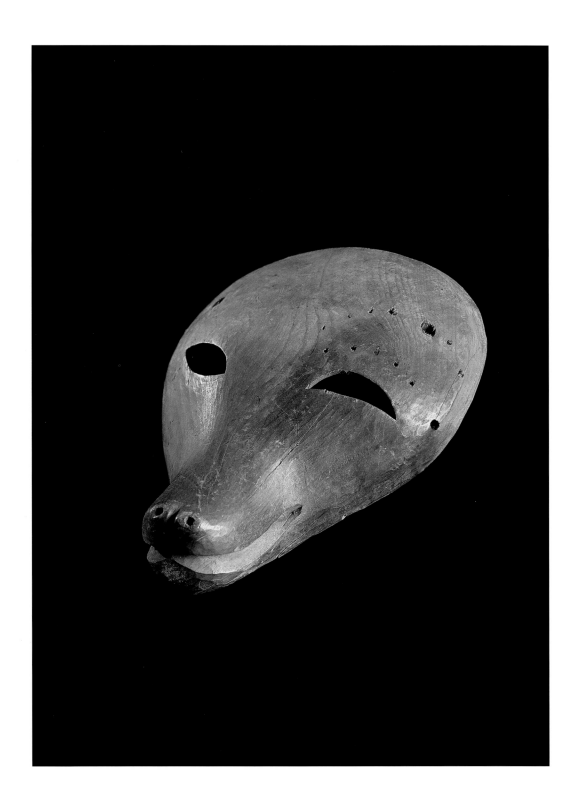

Winking Mask
Inuit Artist

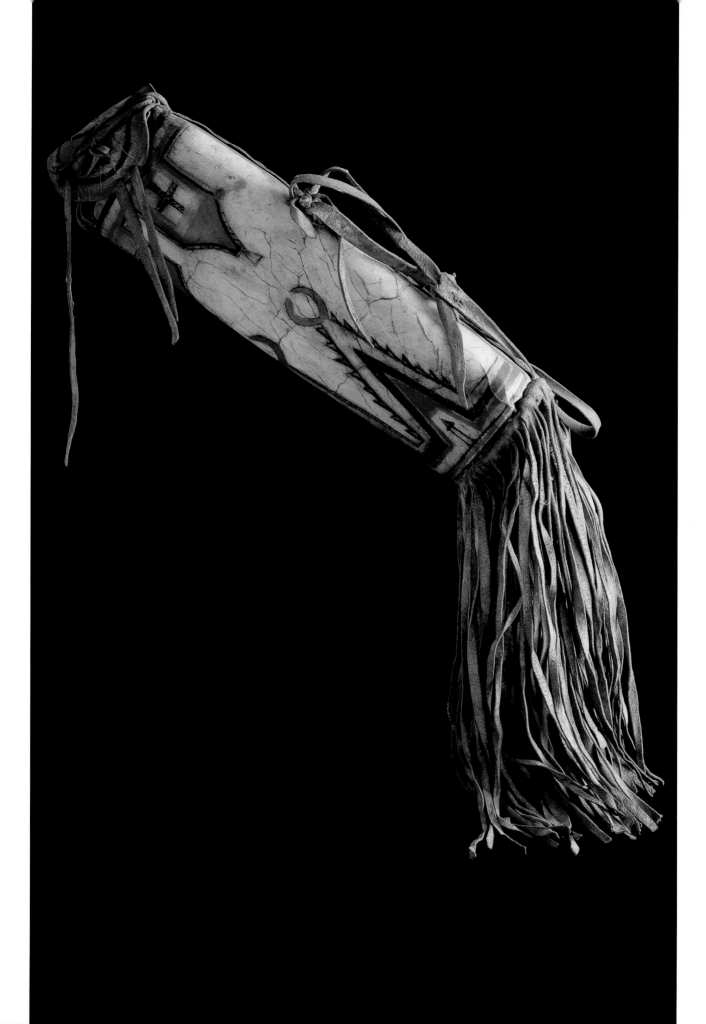

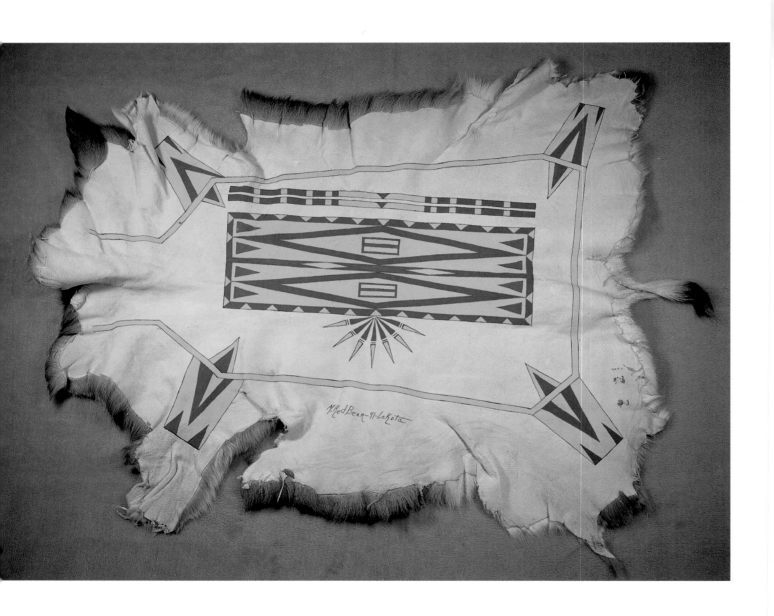

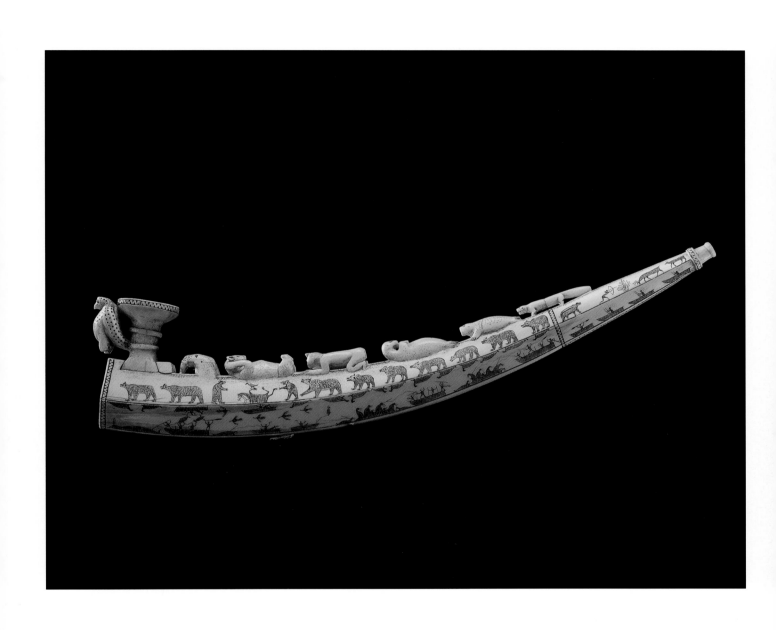

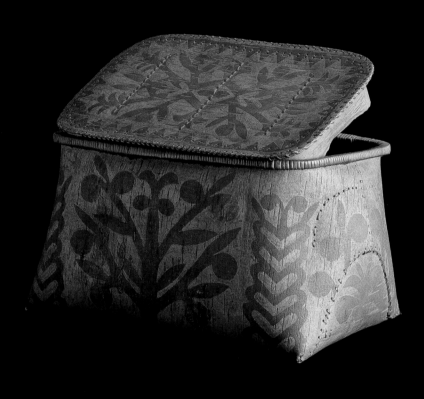

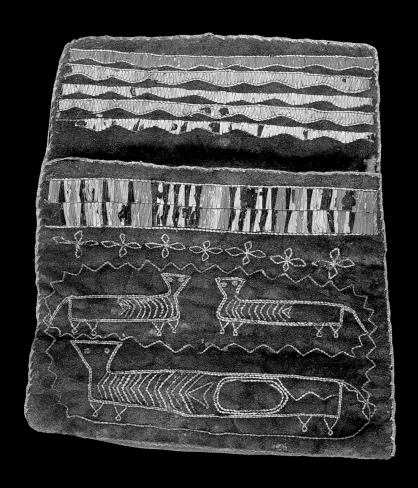

Pouch with Water Panthers
Ojibwa Artist

"The dresses . . . convey how Native people showed remarkable resourcefulness and adaptability towards their environment. The clothing Indian women created showed great pride, dignity, and hope in a culture facing insurmountable odds."

Anita Fields, Osage/Muscogee Artist

Turtle Woman's Purse #2
Anita Fields
Osage/Muscogee Artist
1995

"I made the purse . . . with my own grandmother's bag in mind, and the one she gave to me when I was a girl, a miniature beaded purse with a mirror and all those little things we keep simply because they are precious." Clay, metal, and glass.
Loaned by the artist.

Cradleboard
Ojibwa Artist
19th Century

This work is a tour de force of materials, techniques, and colors and is a true celebration of an infant. The protective bumper, in particular, is an extraordinary execution of dyed quill embroidery. Wood, fabric, dyed quills, glass beads, and shells.
Gift of the Andover Newton Theological School, 1946.
E25409

Telling a Naughty Story
Valjean McCarty Hessing
Choctaw Artist
1981

Here a group of elderly women share a humorous moment. Watercolors on paper.
Loaned by the Harjo Family Collection.

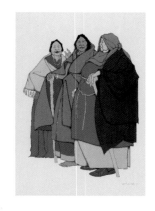

"The American Indian has tenaciously held on to his arts. . . . He is, therefore, the eyes, ears, and voice of his own age. More than that, he has left his personal record, which to a culture without a written language, is the partial repository or encyclopedia of its oral tradition."

Arthur Amiotte, Oglala Lakota Artist

Gray Stone Pipe
Micmac Artist
19th Century

Few beyond the smoker of this pipe would appreciate the artistry and crisp floral engraving of the bowl. Siltstone, pewter, and wood.
Gift of the Pennsylvania Historical Society, 1949.
E28466

Burden Strap
Iroquois Artist
18th Century

The brilliant colors and interlocking pattern suggest movement in both directions along the band, part of a device for carrying bundles. This central portion would have been worn across the forehead. Leather, dyed moose hair, and glass beads.
Gift of Mr. and Mrs. Edward S. Moseley, 1980.
E68210

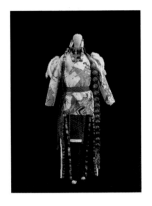 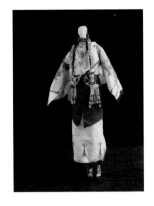 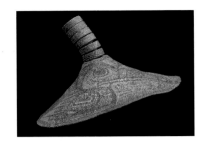

Doll
Tom Haukaas
Sicangu Lakota Artist
1996

The artist is a practicing
psychiatrist and the brother
of Linda Haukaas. Fabric,
leather, paint, and hair.
Loaned by the artist.

Doll
Tom Haukaas
Sicangu Lakota Artist
1996

Fabric, leather, paint, and
hair.
Loaned by the artist.

The Indoctrination
Steven Deo
Yuchi/Muscogee Artist
1995

From 1879 to 1918, numbers
of Native American children
were taken from their homes
and sent to a boarding
school in Carlisle, Pennsyl-
vania, where they underwent
a severe regimen designed
to "civilize" them. The artist
has created a poignant com-
mentary on this episode
based upon a Carlisle class
photograph depicting mem-
bers of his own family.
Photographic collage, wood,
and cloth.
Loaned by the artist.

Raven Crest Hat
Tlingit Artist
Early 19th Century

Owned by the head of a clan,
this basketry hat is painted
with a heraldic raven. A true
masterpiece of Native
American art, it bears its
own pedigree in the form of
stacked rings, which relate to
a long history of ceremonial
display. Fiber and paint.
Gift of Captain Bradshaw,
1832. E3647

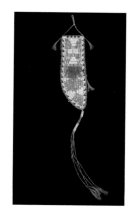

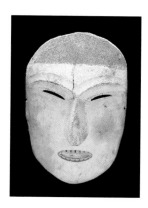

The Women's Dance at Okreek
Linda Haukaas
Sicangu Lakota Artist
1995

"Pictography is Lakota picture writing. We convey events and historical accounts with figures while color serves to highten the senses. . . . I am constantly experimenting with my picture writing, style, color, and story. Many of my drawings fill in the details of life in the 1880s." Watercolors on paper. Loaned anonymously.

Knife Sheath
Sicangu Lakota Artist
19th Century

Leather, quills, dyes, and glass beads.
Gift of Willard C. Cousins, 1946. E25831

Mask in Black and White
Inuit Artist
19th Century

Wood and paint.
Smithsonian Institution Collection, received 1884.
E3489

Taking Care of What Is Mine
Brian Tripp
Karok Artist
1992

"Through my body flows the blood of singers and dancers, makers of dance regalia, carvers, basketmakers, hunters, and fishermen. I know I am these people, and I have done all these things before many, many years ago." Mixed media. Loaned by the Oakland Museum.

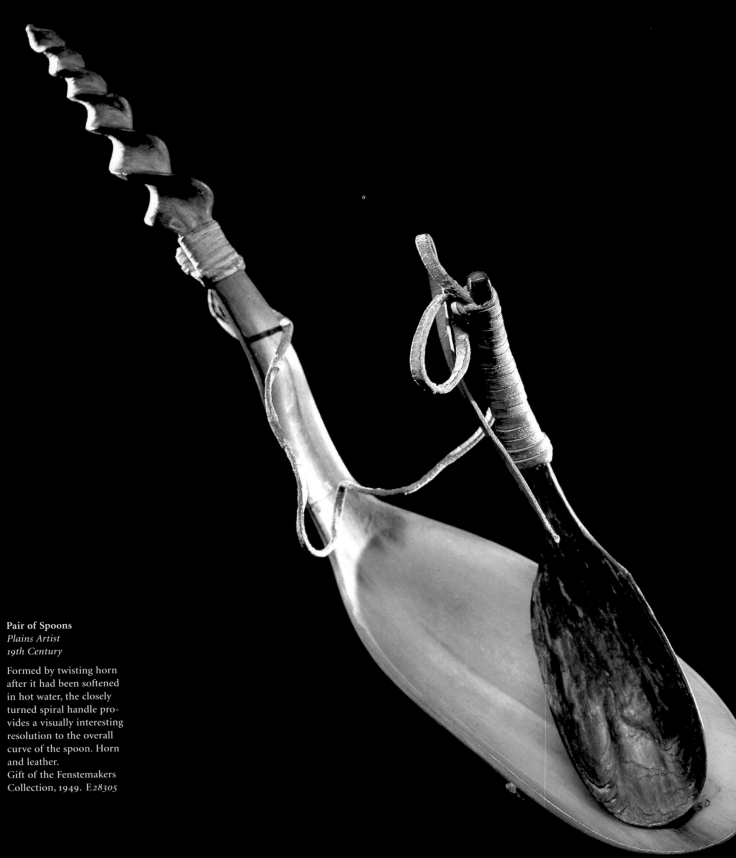

Pair of Spoons
Plains Artist
19th Century

Formed by twisting horn
after it had been softened
in hot water, the closely
turned spiral handle pro-
vides a visually interesting
resolution to the overall
curve of the spoon. Horn
and leather.
Gift of the Fenstemakers
Collection, 1949. E28305

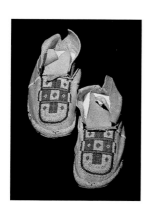

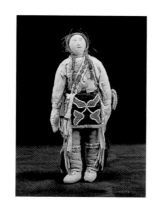

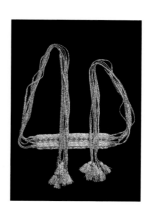

Doll
Lakota Artist
20th Century

Leather, fabric, and glass
beads.
Museum purchase, 1960.
E29388

Moccasins
Tsistsistas (Cheyenne) Artist
19th Century

Leather and glass beads.
Gift of Willoughby I. Stuart,
Harborne W. Stuart, Mrs. E.
S. Pratt, and Mrs. J. Randolf
Coolidge, 1970. E44873

Moccasins
Tsistsistas (Cheyenne) Artist
Late 19th Century

Leather and glass beads.
Gift of George L. Smith,
1950. E26051

Doll
Winnebago Artist
20th Century

With its full complement of
accessories and carefully
modeled features, this doll
conveys individual and cul-
tural pride. Fabric and glass
beads.
Museum purchase, 1960.
E29395

Cap
Hupa Artist
Late 19th Century

The apparent movement of
the staggered parallelograms
is reinforced by the alternat-
ing direction of the thin
bisecting lines. Fiber.
Gift of Sister Mary Edith,
1956. E33634

Sash
Southeastern Artist
Early 19th Century

Wool and glass beads.
Gift of Millicent M. Nichols,
1953. E30723

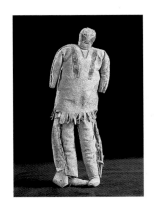
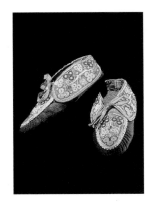
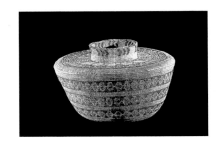

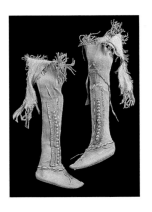

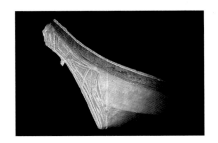

Doll with Painted Face
Tsistsistas (Cheyenne) Artist
19th Century

Minimally provided with physical features, the painted face and clothing details impart a strong sense of cultural affirmation.
Leather and paint.
Gift of Willard C. Cousins, 1948. E27629

Boots with Fringe
Southern Plains Artist
19th Century

The line of bright metal buttons, beaded bidirectional arrows, and close-fitting cut of these women's boots create a strong vertical energy. Leather, glass beads, and metal buttons.
Gift of George C. Stone, 1937. E22650

Moccasins
Malecite Artist
Late 19th–Early 20th Century

Leather, fabric, and glass beads.
Gift of the estate of Lawrence W. Jenkins, 1962. E38860

Strap for a Shoulder Bag
Choctaw Artist
Early 19th Century

The basic double scroll design has been augmented by a highly energetic pattern of white beads. Wool and glass beads.
Gift of the Andover Newton Theological School, 1946. E25410

Basket
Yokuts Artist
19th Century

Fiber.
Gift of Alvin P. Johnson, 1950. E28787

Canoe Model
Nootka Artist
19th Century

Wood and paint.
Donated before 1867. E7349

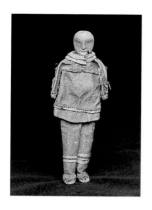
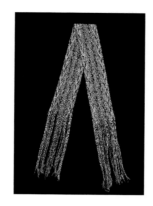
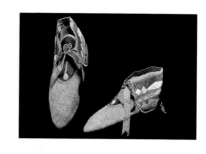

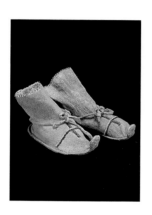

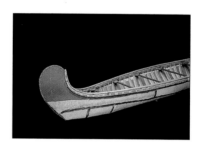

Doll with Ivory Face
Inuit Artist
Late 19th–Early 20th Century

The energetic treatment of the eyebrows imparts to this doll greater presence than its size warrants. Ivory and sealskin.
Gift of J. Albert Lee, 1910. E13116

Moccasins
Apache Artist
20th Century

Leather and glass beads.
Gift of the Emhart Corporation, 1977. E66863

Sash
Iroquois Artist
18th–19th Century

The artist has taken full advantage of the brightly colored trade yarns in creating this eye-dazzling composition of arrows. Wool and glass beads.
Gift of Helen K. Russell, 1910. E13649

Hair Ornament
Tsistsistas (Cheyenne) Artist
Late 19th Century

Bright brass beads, brilliantly colored beadwork, and a long shank of blond horsehair create a striking ornament to wear in the hair. Leather, quills, brass beads, and horsehair.
Gift of George L. Smith, 1950. E26016

Child's Moccasins
Cree Artist
19th Century

Leather, glass beads, and fabric.
Gift of Henry G. Payson, 1967. E44354

Painted Canoe Model
Ojibwe Artist
Early 19th Century

The strong black lines created by the pitched seams integrate with the rich green paint above the waterline to create an interesting sculptural form. Birch bark, wood, and paint.
Gift of Enos Cutler, 1825. E3759

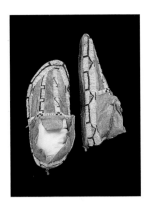

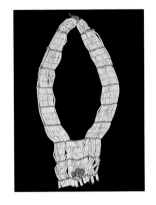

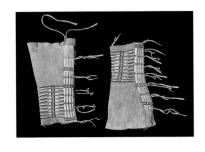

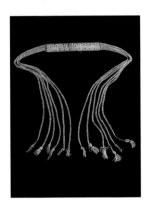

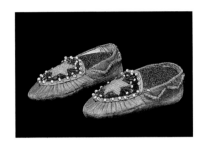

Moccasins
Hinono'el (Arapaho) Artist
Late 19th Century

Each of the beaded bands
utilizes a different motif.
Leather and glass beads.
Gift of George L. Smith,
1950. E26046

Sash
Southeastern Artist
Early 19th Century

The colored concentric out-
lines of the central pattern,
combined with a beadwork
technique that results in a
raised relief, give this work
a remarkable dimensional
appearance. Fabric and glass
beads.
Gift of Charles Heald, 1946.
E25963

Woman's Necklace
Lakota Artist
19th Century

An adaptation in glass beads
of a type of woman's neck-
lace also made from dentalia
shells or polished bone, this
work incorporates bangles
consisting of miniature fry-
ing pans commemorating
a Pan-American fair. Glass
beads, leather, and metal.
Gift of the estate of Law-
rence W. Jenkins, 1962.
E37674

Doll
Inuit Artist
20th Century

Sealskin and wood.
Museum purchase, 1960.
E29444

Leggings
Lakota Artist
Late 19th–Early 20th Century

Leather, dyes, and glass
beads.
Gift of Lawrence W. Jenkins,
1915. E16184

Moccasins for a Child
Kahnawake Mohawk Artist
Late 19th Century

Leather, fabric, and glass
beads.
Donated before 1947.
E26328

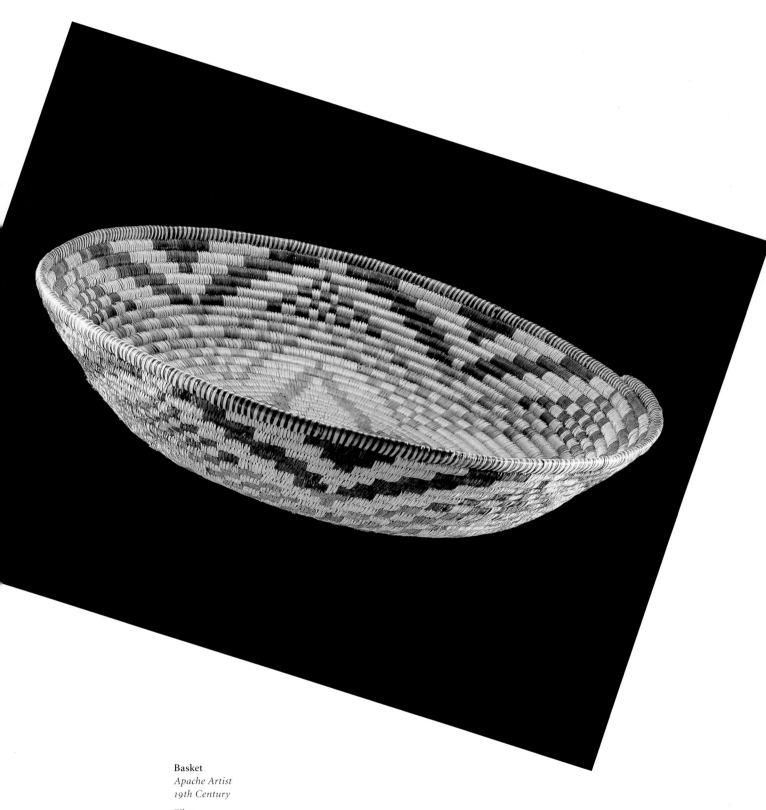

Basket
Apache Artist
19th Century

Fiber.
Donated ca. 1880. E6227

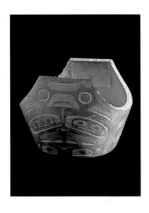

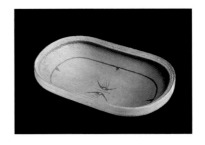

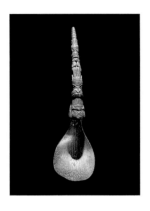

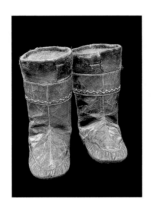

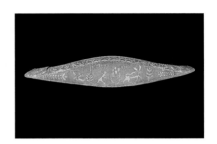

Carved Wooden Bowl
Northwest Coast Artist
19th Century

The carving on this work is
concentrated on the up-
swept ends, creating a move-
ment reinforced by a seal's
teeth inlay along the rim.
Wood, paint, and seal's
teeth.
Gift of Millicent M. Nichols,
1953. E33917

Spoon
Northwest Coast Artist
19th Century

The molded bowl flows
gracefully from a handle
carved with heraldic mo-
tifs. Horn.
Smithsonian Institution
Collection, received 1884.
E3606

Doll
Inuit Artist
20th Century

Sealskin and wood.
Museum purchase, 1960.
E29441

Boots for a Child
Inuit Artist
20th Century

The rich textures of the fin-
ished sealskin and fur liner
are the predominant charac-
teristics of these boots for
a child. Sealskin and fur.
Gift of Mrs. Henri Bour-
neuf, 1973. E49287

Red Bowl
Inuit Artist
Late 19th–Early 20th Century

The beautifully controlled
oval form of this food bowl
contrasts with the sharp
lines of the central bird-like
forms. The resulting out-
ward movement is balanced
by the inward-pointing
spikes and painted border.
Wood and paint.
Gift of J. Albert Lee, 1910.
E13072

Miniature Canoe
Penobscot Artist
1878

Doubtless produced for sale,
this model canoe's bottom
has a charming cartoon in-
volving a hunter, a moose,
and an inept snowshoer.
Birch bark and wood.
Gift of Edward S. Moseley,
1950. E28528

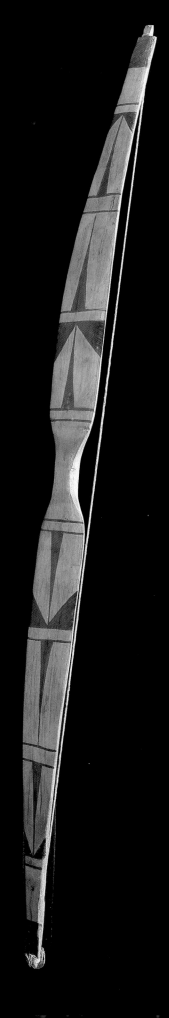

Painted Bow
California Artist
19th Century

Wood, paint, and cord.
Gift of the Maine Historical
Society, 1949. E27986

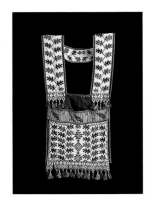

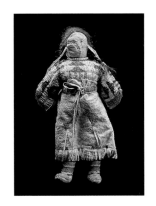

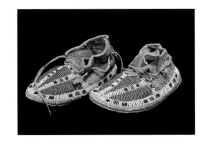

Shoulder Bag
Ojibwe Artist
Late 19th–Early 20th Century

A horizontal band of quieter
colors forms an interesting
contrast with the dominant
pattern of repeating blue
and red oak leaves. Fabric
and glass beads.
Museum purchase, 1949.
E28006

Doll with Braids
Lakota Artist
19th–20th Century

Leather, glass beads, and
hair.
Gift of Mrs. Frederick W.
Fitts, 1946. E25985

Child's Moccasins
Hinono'el (Arapaho) Artist
Late 19th Century

The predominantly orange
and white beadwork, set
against a once-bright green
background of dyed leather,
would have focused atten-
tion on the small steps of
a child. Leather and glass
beads.
Museum purchase, 1887.
E1887

Ivory Earrings
Inuit Artist
19th Century

Ivory.
Smithsonian Institution
Collection, received 1884.
E3511

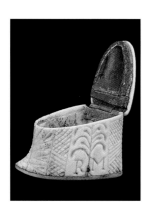

Moccasins
Tsistsistas (Cheyenne) Artist
19th Century

Leather and glass beads.
Gift of the Emhart Corpora-
tion, 1977. E66748

Moose Bone Box
"RM"
Penobscot Artist
18th–19th Century

Probably intended as a
snuffbox, this well-used
container includes a charm-
ing interpretation of the
tree-of-life design. Bone and
metal.
Museum purchase, 1963.

Needle Case
Inuit Artist
Early 20th Century

By pulling the rolled seal-
skin through the seal, a
complement of fine bone
sewing needles is exposed
for use. Ivory and sealskin.
Museum purchase, 1960.
E29510

Moccasins
Southwestern Artist
19th Century

The copper-red color of the
dyed leather provides a
striking background for the
minimal beaded decoration.
Leather, dyes, and glass
beads.
Gift of the Emhart Corpora-
tion, 1977. E72110

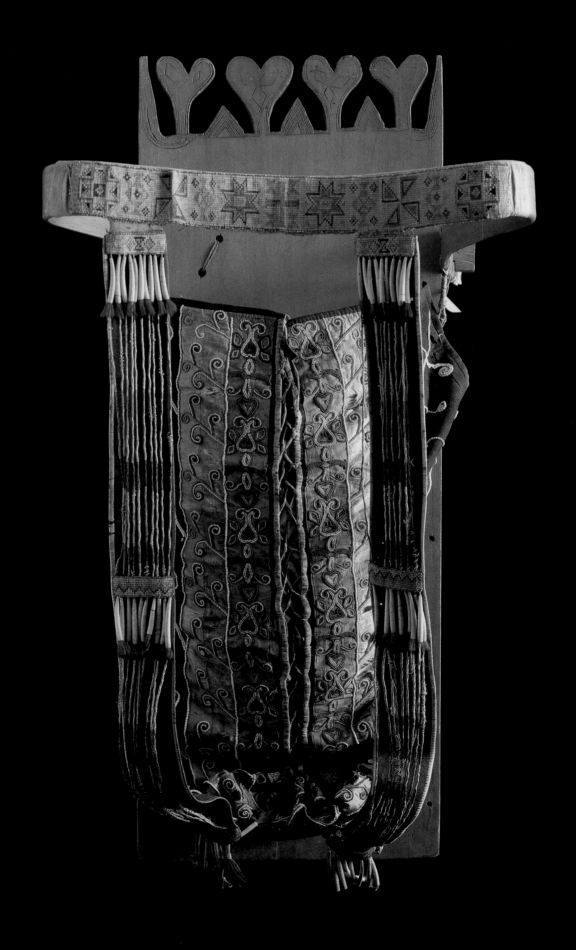

Cradleboard

Gray Stone Pipe
Micmac Artist

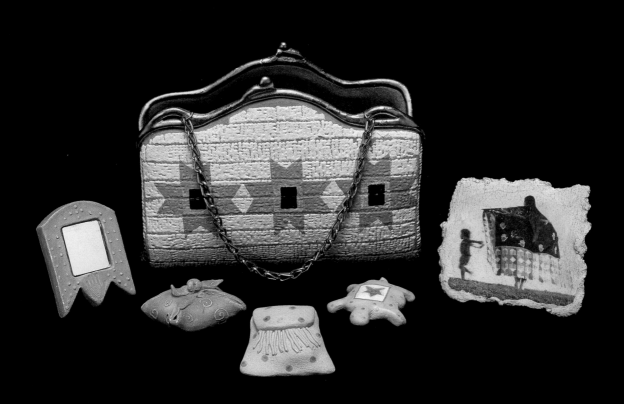

Turtle Woman's Purse #2
Anita Fields
Osage/Muscogee Artist

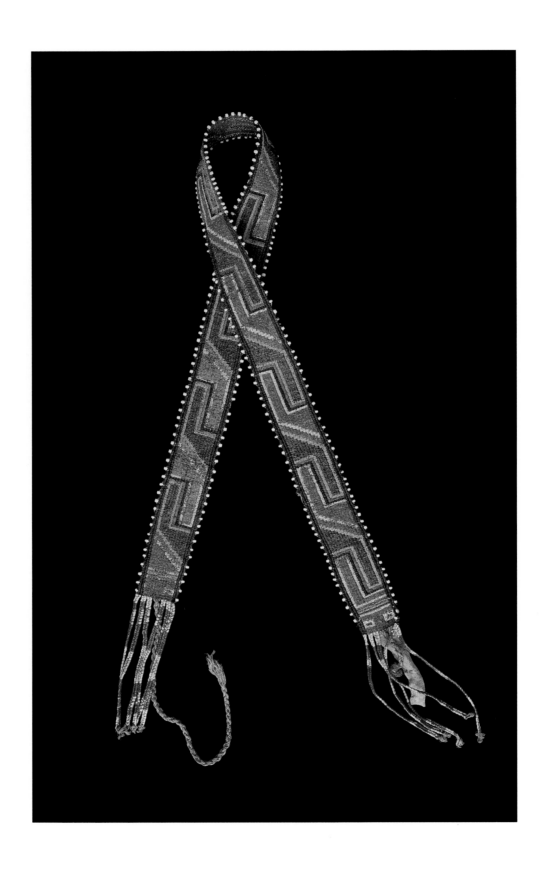

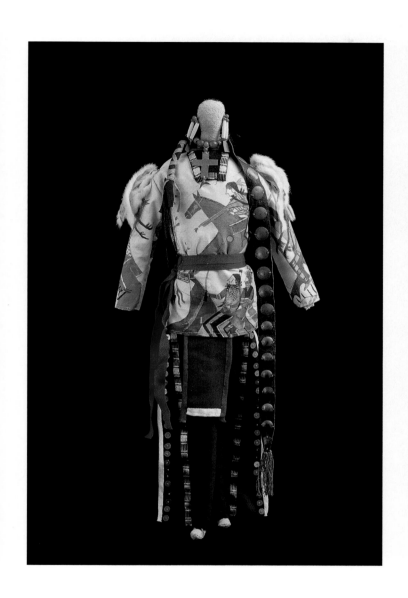
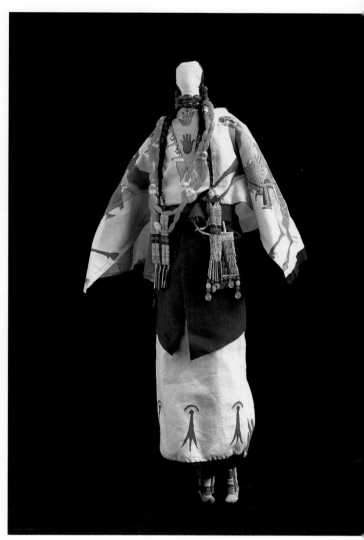

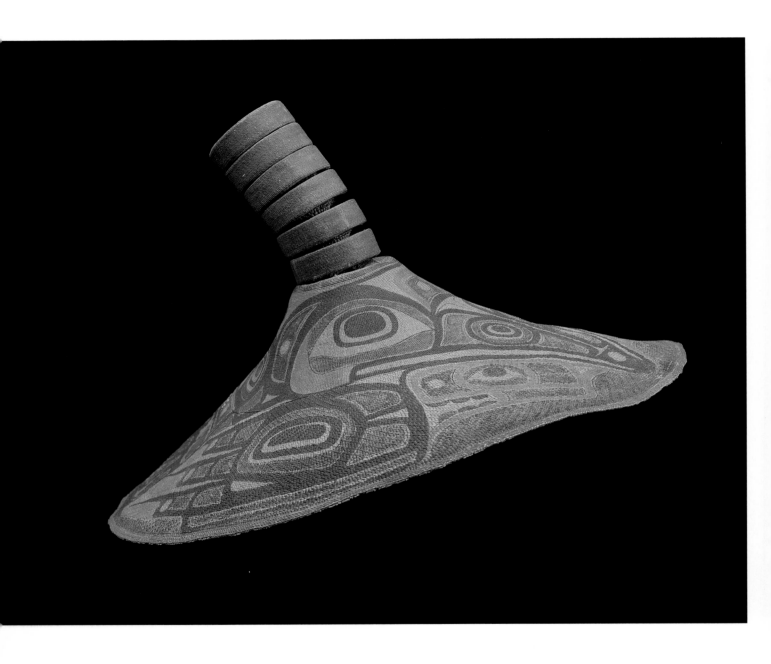

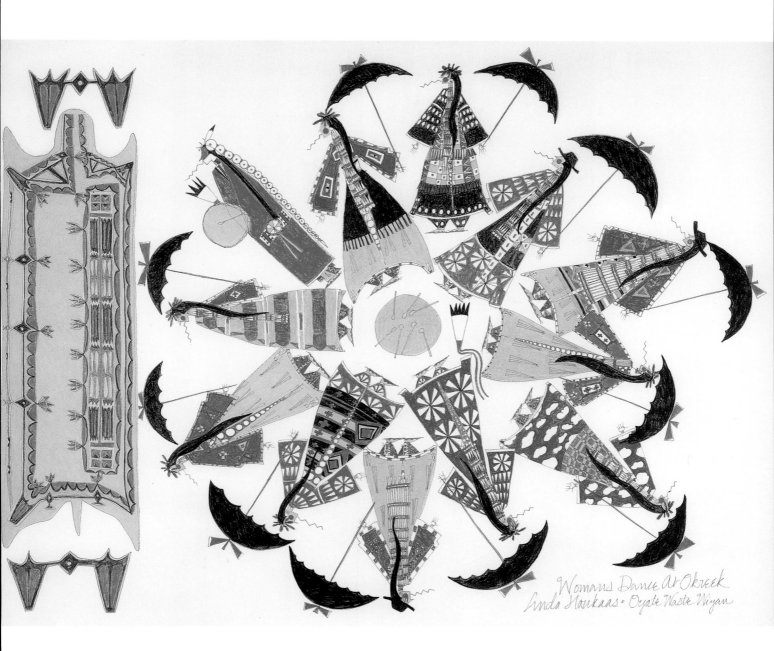

The Women's Dance at Okreek
Linda Haukaas

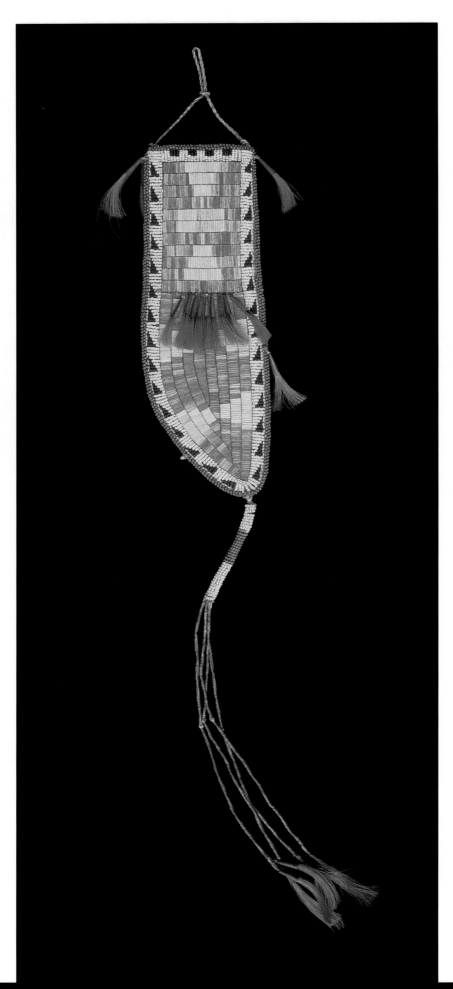

Knife Sheath
Sicangu Lakota Artist

We believe

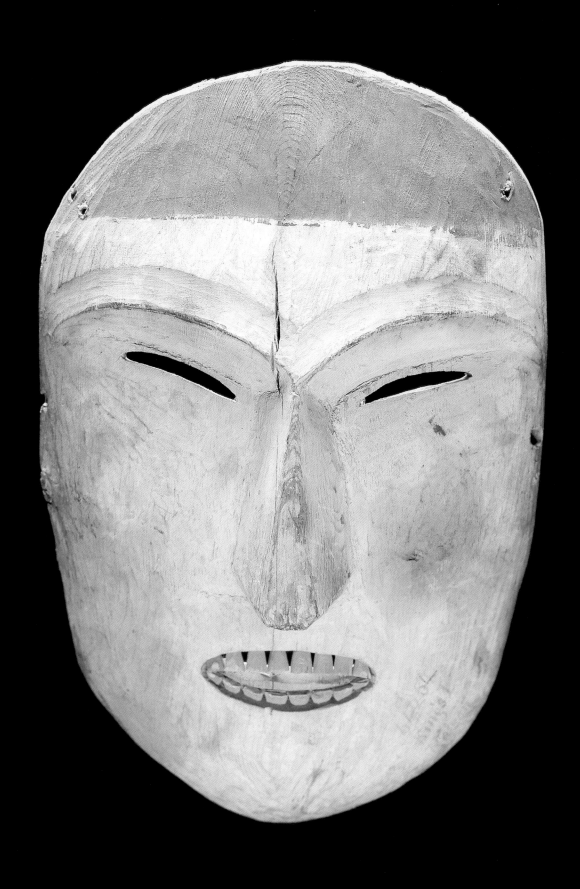

Mask in Black and White
Inuit Artist

"I fell in love with the art form when I first saw it. . . . the heat and liquid glass . . . inspire me. . . . I look at glass as clay you can't touch. My culture gives me such endless inspiration that I know I'll never be able to create all that I have in mind."

Tony Jojola, Isleta Pueblo Artist

Moccasins
Micmac Artist
19th Century

Leather, dyed quills, fabric,
and glass beads.
Donated before 1900. E3707

Portrait of Janet Jackson
Marcus Amerman
Choctaw Artist
1995

Glass beads.
Loaned by the artist.

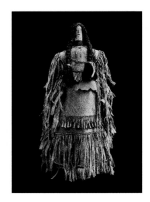

Sunrise Ceremony Doll
Apache Artist
19th Century

This work represents a
young woman in the Sunrise
Ceremony, marking her pas-
sage to womanhood. The
lines of the doll, which cul-
minate in the rich costume
of the occasion, form a visu-
al metaphor for transforma-
tion. Leather, cloth, and
glass beads.
Gift of Mrs. Frederick W.
Fitts, 1946. E25991

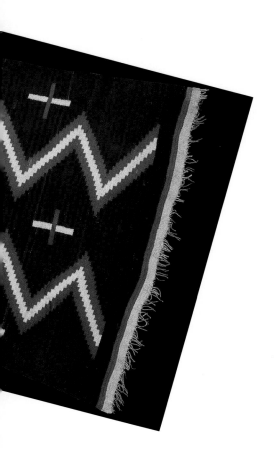

Blanket
Southwestern Artist
Late 19th Century

The southwestern loom has been the focus of active experimentation for Native American artists, and the resulting weavings are a manifestation of individual creativity against a backdrop of cross-cultural influences, the advent of new colors and dyes, and changing patterns of use and demand. Wool.
Gift of Amy G. Bassett, 1934. E21309

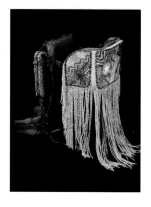

Flying Woman #8
Shelley Niro
Mohawk Artist
1994

Photographic collage.
Loaned by the Canadian Museum of Contemporary Photography.

Saddlebags in Red and Yellow
Apache Artist
19th Century

Leather and cloth.
Gift of Mr. and Mrs. Willard C. Cousins, 1954. E31633

Baby Carrier
Marcus Amerman
Choctaw Artist
1995

Leather, glass beads, prefabricated aluminum, and nylon.
Loaned by the artist.

Pipe
Northwest Coast Artist
19th Century

A fat frog is transformed
into a humorous pipe, the
bowl consisting of a spent
casing from a large-caliber
gun. Wood and brass.
Gift of Walter Newhall,
1908. E11873

Man with Large Headdress
Norval Morrisseau
Ojibwe Artist
Ca. 1965

Painting on paper.
Loaned by the Indian Art
Centre.

Pipe with Inlay
Lakota Artist
19th Century

In this work, a lead inlay
is used to create the nega-
tive space surrounding fine-
ly carved symbolic motifs.
Catlinite and lead.
Gift of William S. Appleton,
1918. E17384

Peyote Rattle
Lutz Whitebird
Tsistsistas (Cheyenne) Artist
1979

Wood, glass beads, feathers,
and hair.
Loaned by the Institute for
American Indian Arts.

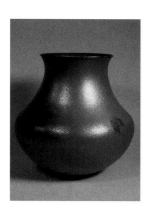

Peyote Fan
Jack Malotte
Western Shoshone Artist
1984

Ink, watercolors, and paper.
Loaned by the Harjo Family
Collection.

Pipe Woman
Frank Sheridan
Tsistsistas (Cheyenne) Artist
1996

Ink, watercolors, and
antique paper.
Loaned by the artist.

Micaceous Jar
Lonnie Vigil
Nambe Pueblo Artist
1994

Clay.
Loaned by the School of
American Research.

Chess Set
Don Tenoso
Hunkpapa Dakota Artist
1996

Mixed media.
Loaned by the artist.

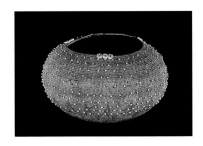

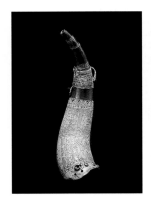

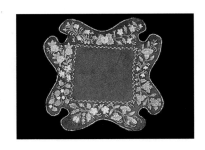

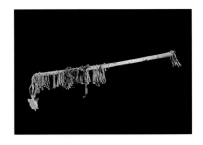

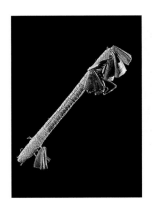

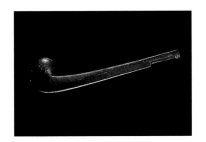

Beaded Basket
Pomo Artist
19th Century

Fiber and glass beads.
Donated before 1960.
E37391

Rattle
Lakota Artist
19th Century

Rawhide, wood, and metal.
Gift of Mabel O. Stimson,
1944. E24349

Powder Horn
Penobscot Artist
18th Century

Through time, Native artists
have creatively integrated
new technologies with exist-
ing aesthetics. While not
usually thought of as a "tra-
ditional" article, this powder
horn is infused with cultural
identity and pride. Horn,
wood, and brass.
Gift of C. W. Hardy, 1947.
E27326

Hoof Rattle
*Tsistsistas (Cheyenne) Elk
Warrior Artist*
19th Century

Wood, cloth, deer hooves,
and metal.
Gift of Albert Fowler, 1951.
E29202

Lamp Mat
Huron or Tuscarora Artist
19th Century

Although the floral sprays
that adorn this lamp mat
were probably inspired by
European patterns, they
are creatively reinterpreted
in dyed moose hair. Cloth,
moose hair, and paper.
Gift of Willis H. Ropes, 1931.
E20836

Ball-Headed Club
Northeastern Artist
18th Century

Wood.
Gift of Stephen Phillips,
1957. E33926

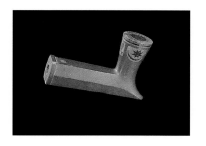

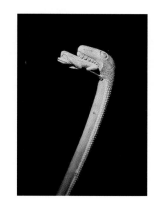

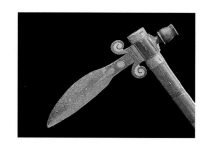

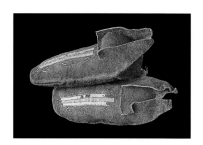

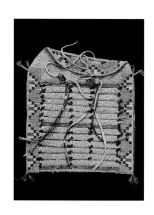

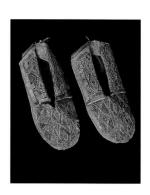

Pipe Bowl
Lakota Artist
19th Century

Catlinite and lead.
Gift of the Pennsylvania
Historical Society, 1949.
E28456

Moccasins
Lakota Artist
Early 19th Century

Leather and dyed quills.
Gift of Captain Douglass,
1822. E3710

Snake Cane
Haida Artist
19th Century

Wood.
Smithsonian Institution
Collection, received 1884.
E3660

**Quilled and Beaded Hide
Pouch**
Tsistsistas (Cheyenne) Artist
19th Century

Leather, dyed quills, and
glass beads.
Gift of George A. Peabody,
1877. E3824

Pipe Hatchet
Tsahagi (Cherokee) Artist
18th Century

This trade hatchet is richly
augmented with inlays of
lead. Wood, iron, and lead.
Gift of the Andover Newton
Theological School, 1946.
E25412

Moccasins
Northeastern Artist
Early 19th Century

The color scheme of the
dyed quill embroidery is
reversed on the cuffs for
added impact. Leather and
dyed quills.
Museum purchase, 1911.
E14566

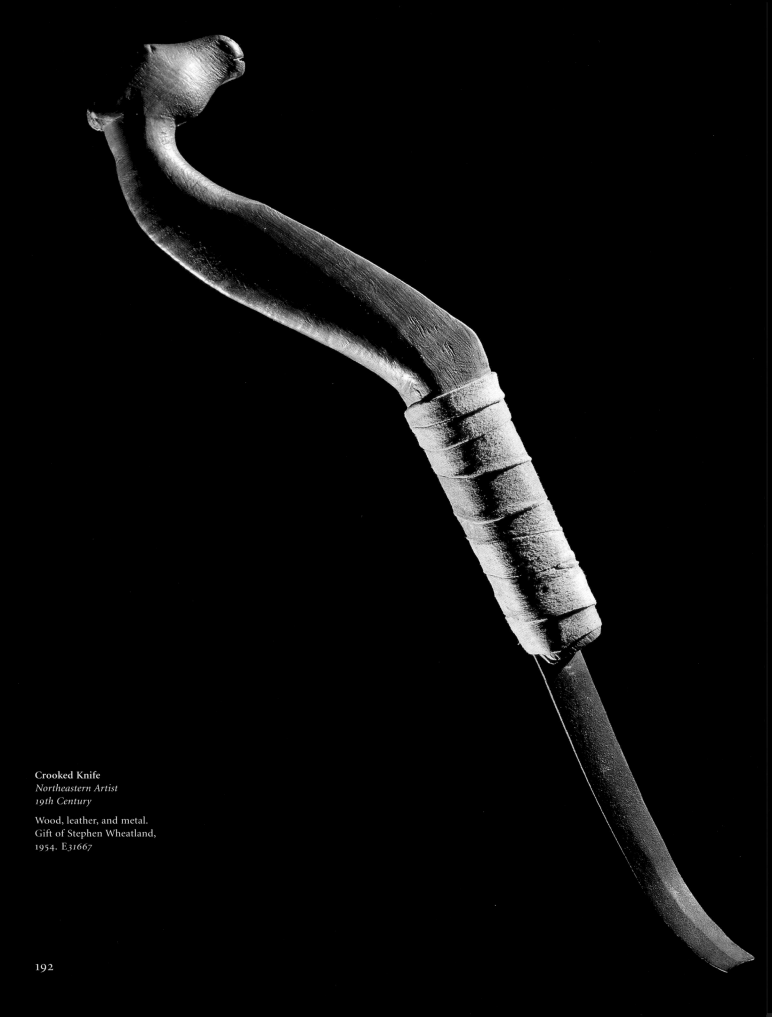

Crooked Knife
Northeastern Artist
19th Century

Wood, leather, and metal.
Gift of Stephen Wheatland,
1954. E31667

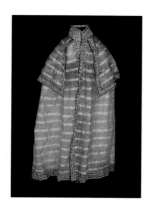 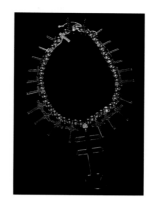

Cape
Aleut Artist
Early 19th Century

The high collar and other details of this garment reflect an attention to contemporary Russian military fashion. Sea lion intestine and dyed sealskin.
Gift of Seth Barker, 1835.
E7344

Necklace
Southwestern Artist
19th Century

Silver and coral.
Gift of Lucy A. Morse before 1960. E37864

Blanket
Navajo Artist
Ca. 1890

Wool.
Gift of Bertha Kenny, 1960.
E37255

Woman's Horse Saddle
Crow Artist
19th Century

The eighteenth-century introduction of horses to the peoples of the Plains transformed ways of life and provided new opportunities for aesthetic expression. Wood, leather, and glass beads.
Gift of Frederick H. Douglas, 1953. E30719

Moccasins
Micmac Artist

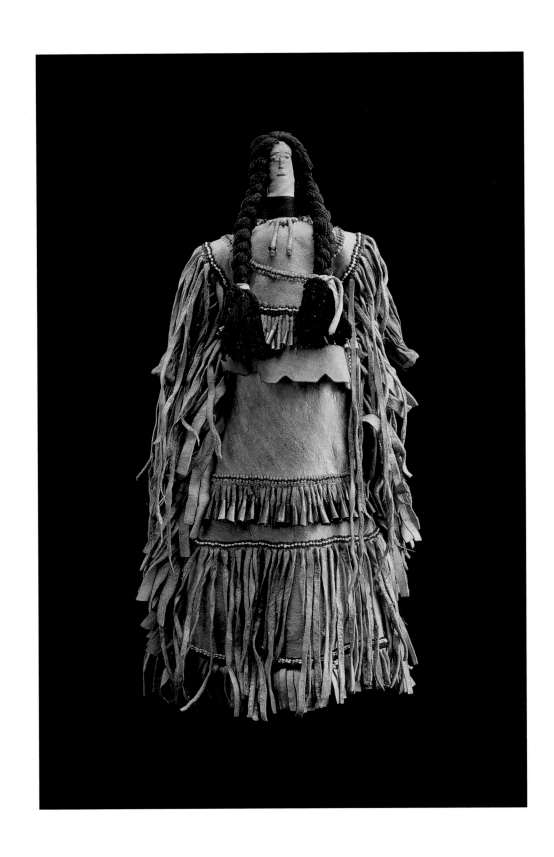

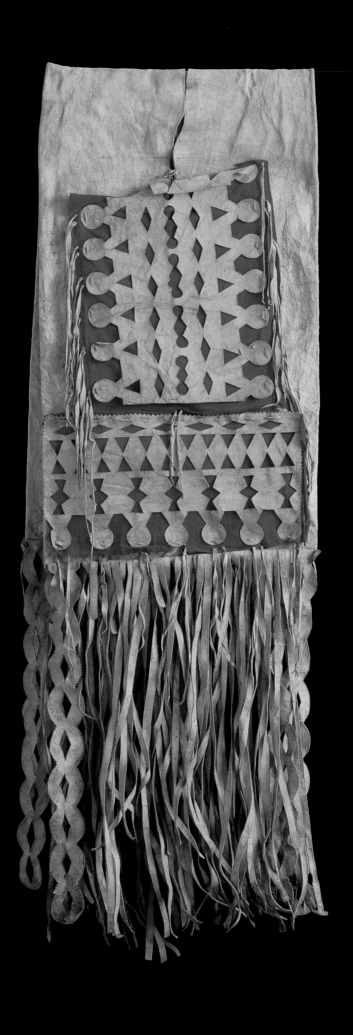

Saddlebags in Red and Yellow
Apache Artist

Baby Carrier
Marcus Amerman
Choctaw Artist

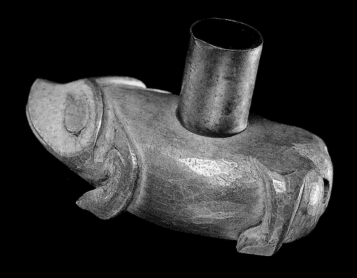

200　　**Pipe**
Northwest Coast Artist

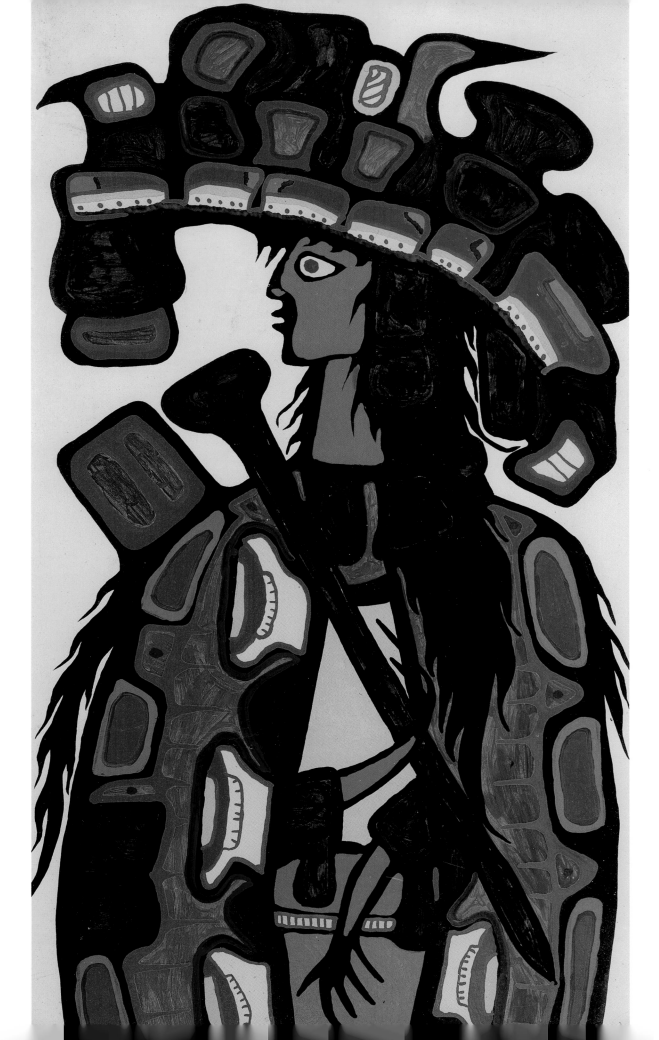

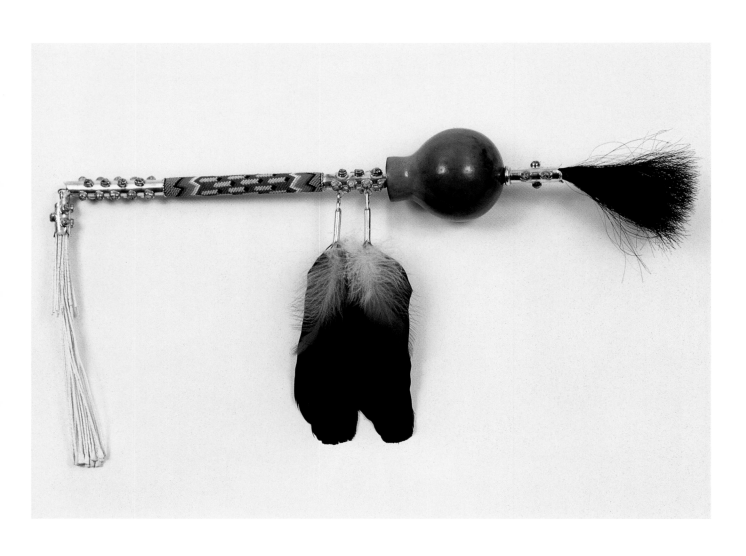

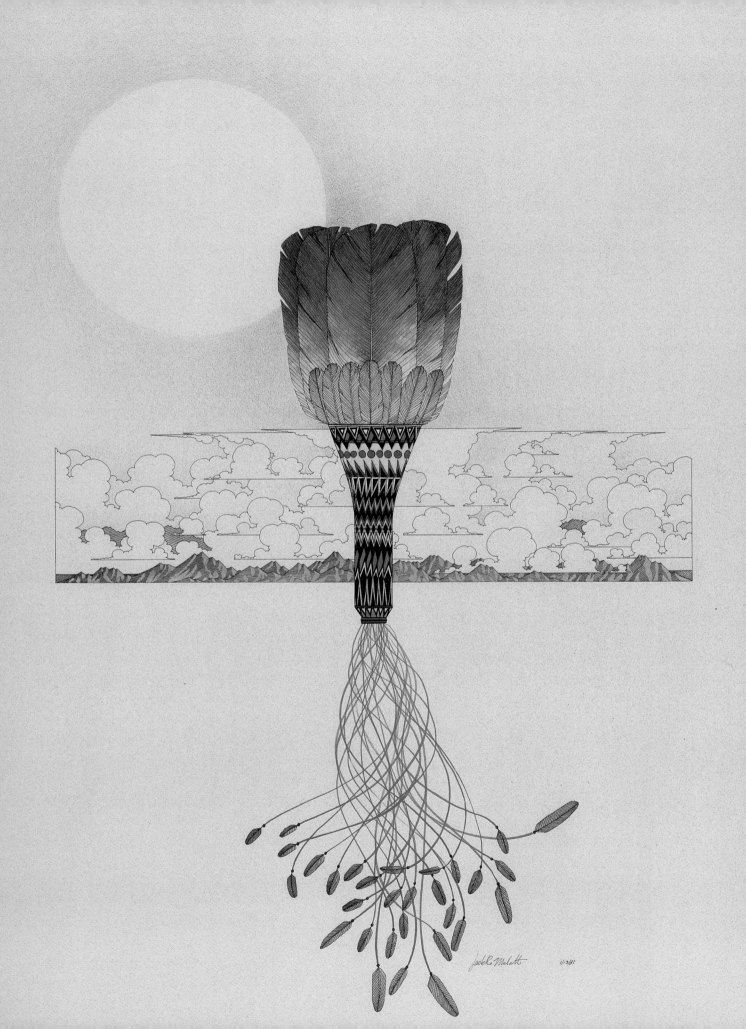

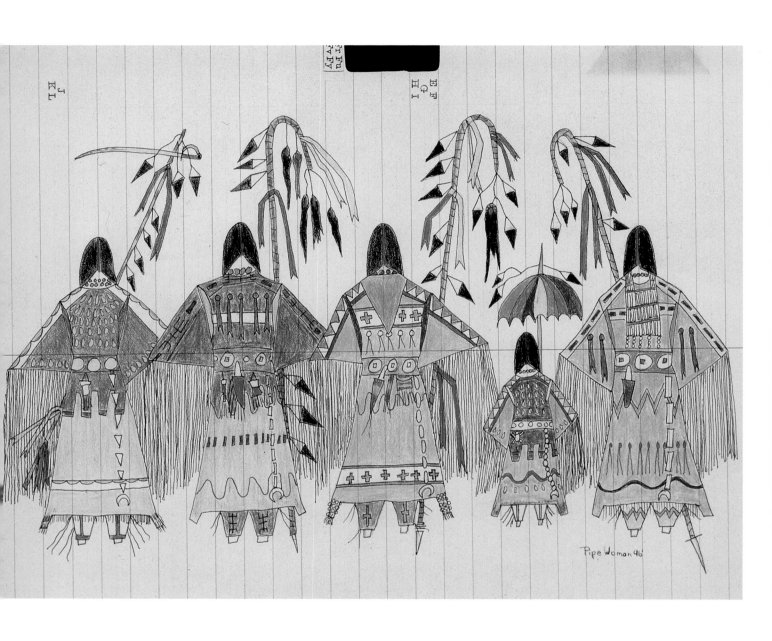

Pipe Woman 96'

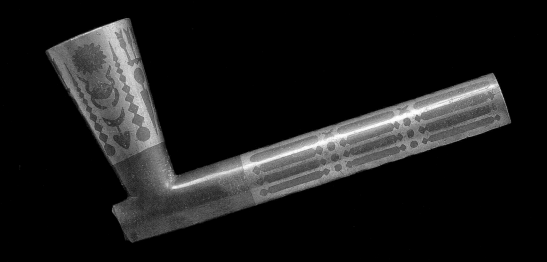

Pipe with Inlay
Lakota Artist

Micaceous Jar
Lonnie Vigil

"I feel sorry for people that lack a sense of humor. . . . They're missing out. I make political statements on how Indians have been treated and the viewers are free to interpret the message however they wish, . . . but the pieces are done with humor and respect."

Barry Coffin, Potowatami/Muscogee Artist

New Horse Power in 1913
Arthur Amiotte
Oglala Lakota Artist
1994

"I purposefully decided to treat Sioux life from . . . 1880 to 1930, a period when cultural change and adaptation were drastically taking place in . . . technology, . . . printed media, . . . language, . . . education, and for Sioux people an entirely different worldview."
Collage.
Loaned by the artist.

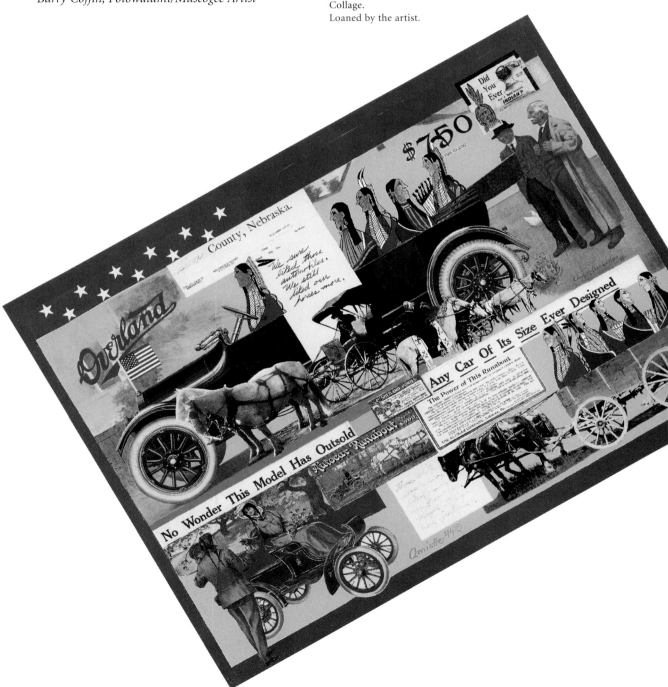

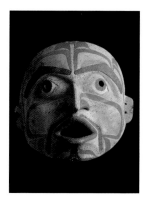

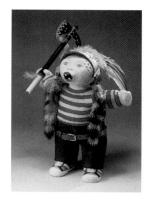

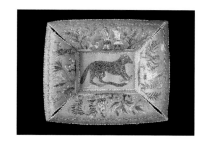

Mask
Bella Bella Artist
19th Century

Wood and paint.
Gift of Edward S. Moseley,
1978. E28575

Honoring Drum
John Stands in Timber
Tsistsistas (Cheyenne) Artist
Ca. 1905

This work commemorates
an incident in which the
artist was attacked by a
wounded deer and then
saved by a bystander, possi-
bly his brother. Wood, raw-
hide, and paint.
Gift of George L. Smith,
1946. E26066

**Just Because You Put
Feathers in Your Hair Don't
Make You an Indian**
Laura Fragua
Jemez Pueblo Artist
1990

"An effective piece of con-
temporary art is evaluated
on its own artistic merits,
not by widely accepted
boundaries of Native Amer-
ican art categories."
Mixed media.
Loaned by the Institute for
American Indian Arts.

**The Shores of Gitchi Gami
Revisited**
David P. Bradley
Ojibwe Artist
1996

"To me, art is war. . . . sell-
ing my art is hunting. . . .
having shows is like stealing
ponies. . . . being chosen to
show in museums . . . rep-
resents, to me, honors won
in battle, such as counting
coup." Mixed media.
Loaned by the artist.

Tray
Huron Artist
Ca. 1840

Trays like this were made,
from an early date, to be
sold to Niagara Falls tour-
ists. Birch bark, dyed moose
hair, and sweetgrass.
Gift of Mr. and Mrs. Charles
D. Carey, 1990. E77743

Basket
Chumash Artist
19th Century

Fiber.
Gift of Alvin P. Johnson,
1950. E28772

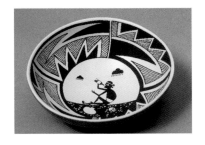
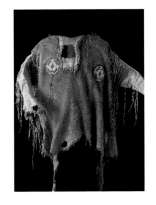

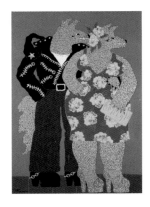

The Drinker
Diego Romero
Cochiti Pueblo Artist
1993
Ceramic.
Loaned by the Denver Art
Museum.

Dream of Ancient Life
Dan V. Lomahaftewa
Hopi/Choctaw Artist
1995
"I was brought up with
katsina dances, ceremonies,
powwows, songs, Hopi vis-
tas, and sunsets. . . . Yes, I
like sunsets. In New York,
they say sunsets are too
sweet. . . . Well, they need
to get out there and see it
in person. How can it not
affect you?" Acrylic paint on
canvas.
Loaned by the artist.

Man's Shirt
Northern Plains Artist
1830–50
This shirt, with its sparing
use of large blue trade beads,
dates from the earliest years
of the 19th century. Leather,
quills, and glass beads.
Gift of the Andover Newton
Theological School, 1946.
E26323

**Rose and Coyote Dressed
for the Heard Opening**
Harry Fonseca
Nisenan Maidu Artist
1981
"I believe my Coyote paint-
ings to be the most contem-
porary statements I have
painted in regard to tradi-
tional beliefs and contem-
porary reality. I have taken
a universal Indian image,
Coyote, and have placed
him in a contemporary set-
ting." Acrylic paint on can-
vas.
Loaned by the Heard
Museum.

Broken Circle
Mateo Romero
Cochiti Pueblo Artist
1994
"In [the] process of self-
identification, the viewers
(both Indian and non-In-
dian), hopefully make this
leap . . . into the idea of . . .
a uniquely Indian voice . . .
divorced from the glittering
construct of the non-Indian
Master Narrative." Acrylic
paint on foamboard.
Loaned by the artist.

Craftsperson Belt
Denise Wallace
Chugach Artist
1992

Silver and gemstones.
Loaned by the Institute for
American Indian Arts.

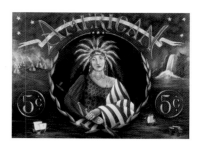

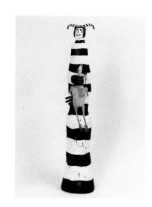

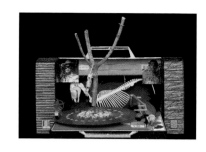

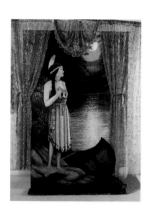

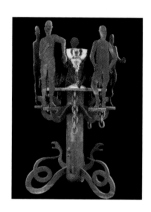

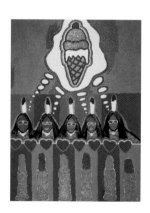

American Tobacco Girl
Judith Lowry
Maidu/Pit River Artist
1994

Acrylic paint and wood.
Loaned by the artist.

Minniehaha Lives!
Jean LaMarr
Paiute/Pit River Artist
1992

"My work communicates to
the non-Indian world. . . .
I feel like I have an interna-
tional language . . . a kind
of nonverbal communica-
tion." Mixed media instal-
lation.
Loaned by the artist.

**Wally Koshare Meets
Rambo**
Barry Coffin
Potowatami/Muscogee Artist
1988

Ceramic and rubber.
Loaned by the Institute for
American Indian Arts.

The Bishop's Table
Bob Haozous
Chiricahua Apache Artist
1989

"If Native Americans were
looking honestly at them-
selves, one would see the
pain reflected in a lot of the
artwork. The problem is that
. . . ninety-nine percent of
Native American art is made
for non-Indian consump-
tion. When all artists are
reduced to being craftsmen
based on an outside stan-
dard, what you have left is
an unhealthy art form."
Steel and bronze.
Loaned by the artist.

**Tonto's Revenge Dance
Party**
Tom Huff
Seneca/Cayuga Artist
Undated

"I am one in a world of two
Old in a world of new
Times have changed
Rearranged
To fit both at once."
Mixed media.
Loaned by the artist.

The Great Native Dream
Delmar Boni
San Carlos Apache Artist
Ca. 1975

"The longer I live, the more
I come full circle to the val-
ues of my elders." Acrylic
paint on canvas.
Loaned by the Institute for
American Indian Arts.

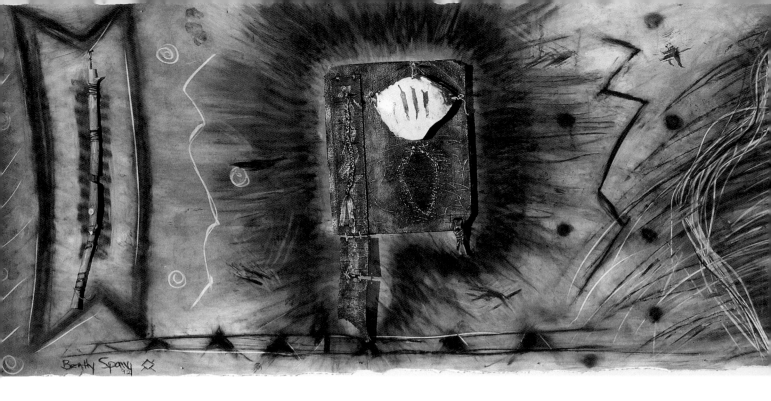

The Healing
Bently Spang
Tsistsistas (Cheyenne) Artist
1994

"The realization that I, as a
contemporary Native per-
son, am creating in much
the same way that my ances-
tors created, combining
indigenous materials outside
the culture to speak about
life at that moment, was
very powerful and very
humbling." Mixed media
installation.
Loaned by the artist.

212

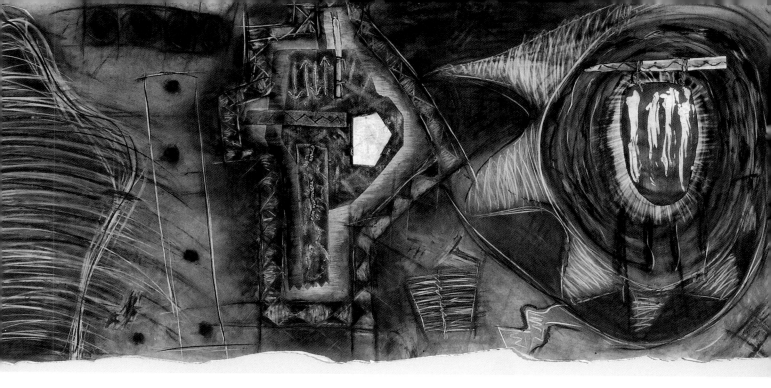

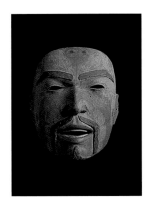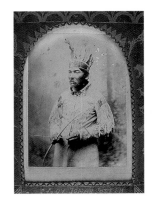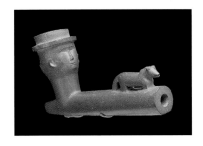

Portrait Mask
Northwest Coast Artist
19th Century

This highly animated mask
depicts an individual in the
act of speaking or singing.
The black mustache and
thick eyebrows focus atten-
tion on the mouth and eyes,
increasing the expectation of
movement. Wood and paint.
Gift of Edward S. Moseley,
1979. E28573

**Frame for Portrait of
Tomah Joseph**
Tomah Joseph
Passamaquoddy Artist
Ca. 1895

Tomah Joseph, a governor
of the Passamaquoddy Na-
tion, was among the first
Native American artists in
the Northeast to sign his
work routinely. Birch bark.
Gift of Nicholas Smith, 1972.
E48627

Portrait Pipe
Running Cloud
Sisseton Lakota Artist
Ca. 1840

This wonderfully executed
pipe is believed to be one of
a body of works by Running
Cloud, identified through
recent scholarship as a mas-
ter pipe carver in the vicini-
ty of Fort Snelling. This and
the other works by Running
Cloud are among the earliest
that can be associated with
a named artist. Catlinite.
Andover Newton Theo-
logical School Collection,
received 1976. E53453

Drill Bow
Inuit Artist
19th Century

Ivory.
Gift of Alexander O. Vietor,
1980. E67117

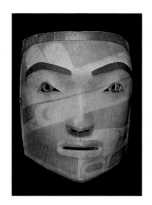

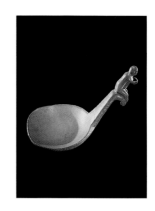

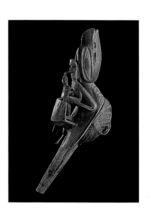

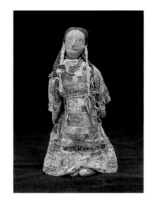

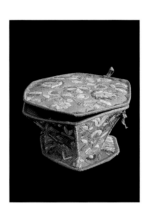

Mask
Northwest Coast Artist
19th Century

Wood and paint.
Gift of Edward S. Moseley,
1979. E28574

Doll
Cherokee Artist
Late 19th Century

Cloth and glass beads.
Gift of Mrs. Frederick W.
Fitts, 1946. E26003

Bark Box
Ojibwa Artist
Ca. 1830

Although now somewhat
misshapen, the form of this
basket is European, perhaps
inspired by the Protestant
missionaries who collected
it. Birch bark, dyed quills,
and ribbon.
Andover Newton Theo-
logical School Collection,
received 1976. E53440

Spoon
Iroquois Artist
19th Century

Wood.
Museum purchase, 1953.
E30727

Raven Rattle
Northwest Coast Artist
19th Century

Wood and paint.
Museum purchase, 1932.
E21054

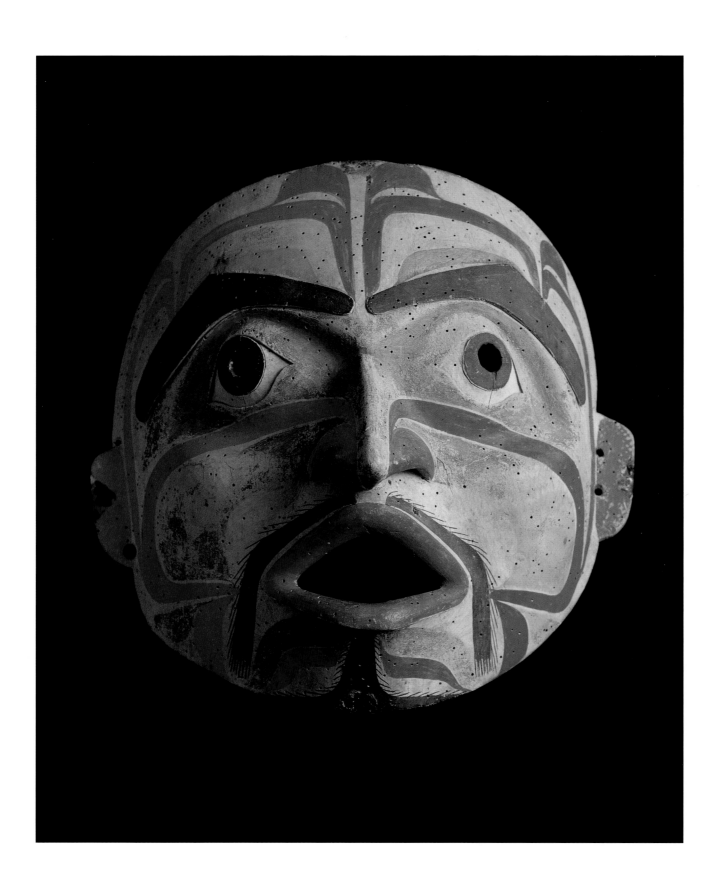

Mask
Bella Bella Artist

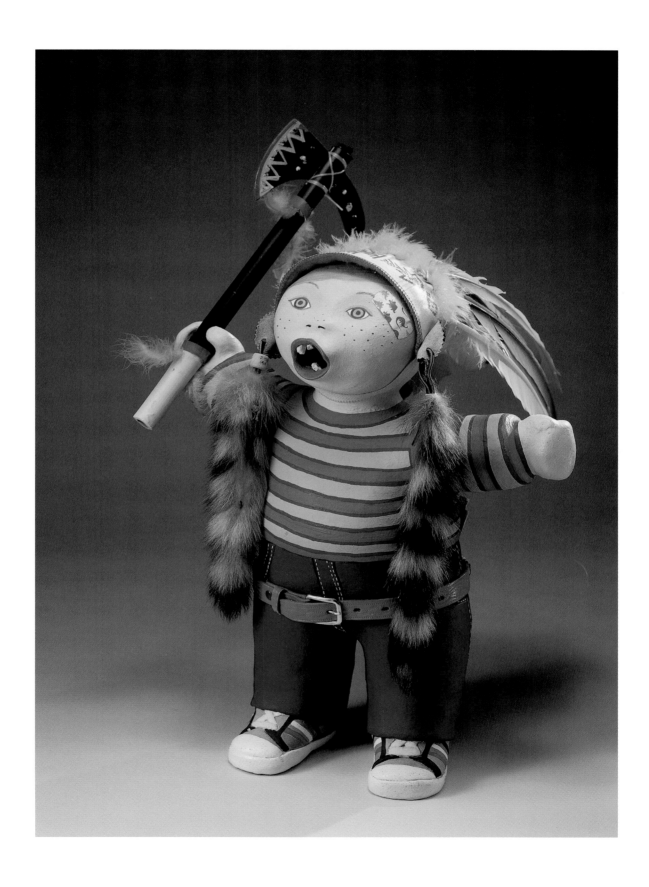

Just Because You Put Feathers in Your Hair Don't Make You an Indian
Laura Fragua

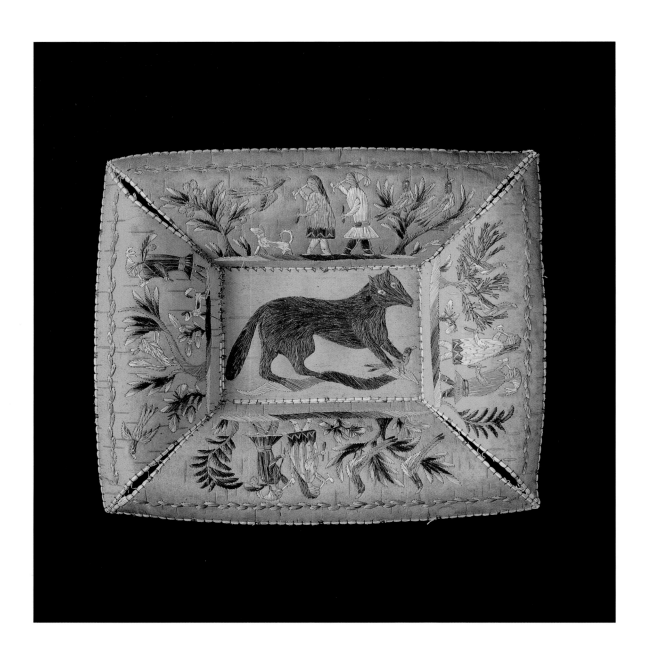

Tray
Huron Artist

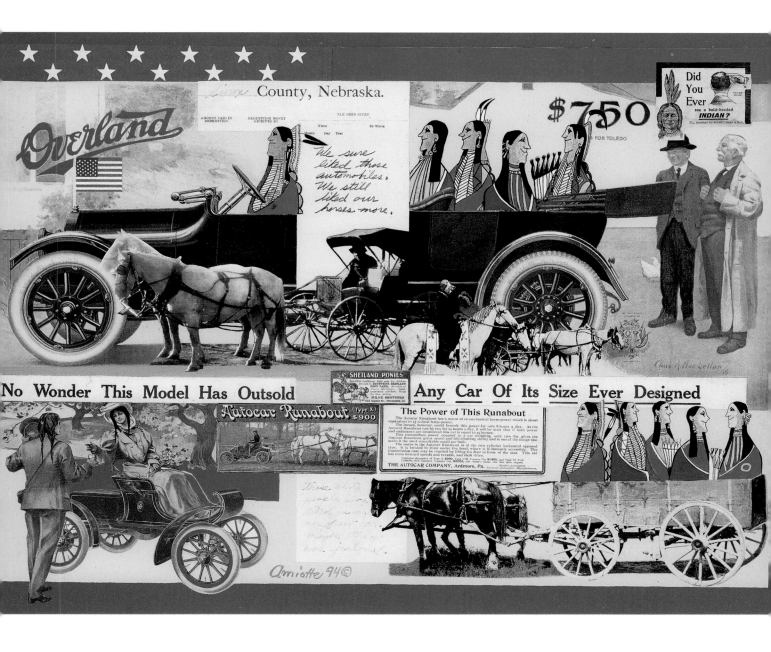

Honoring Drum
John Stands in Timber
Tsistsistas (Cheyenne) Artist

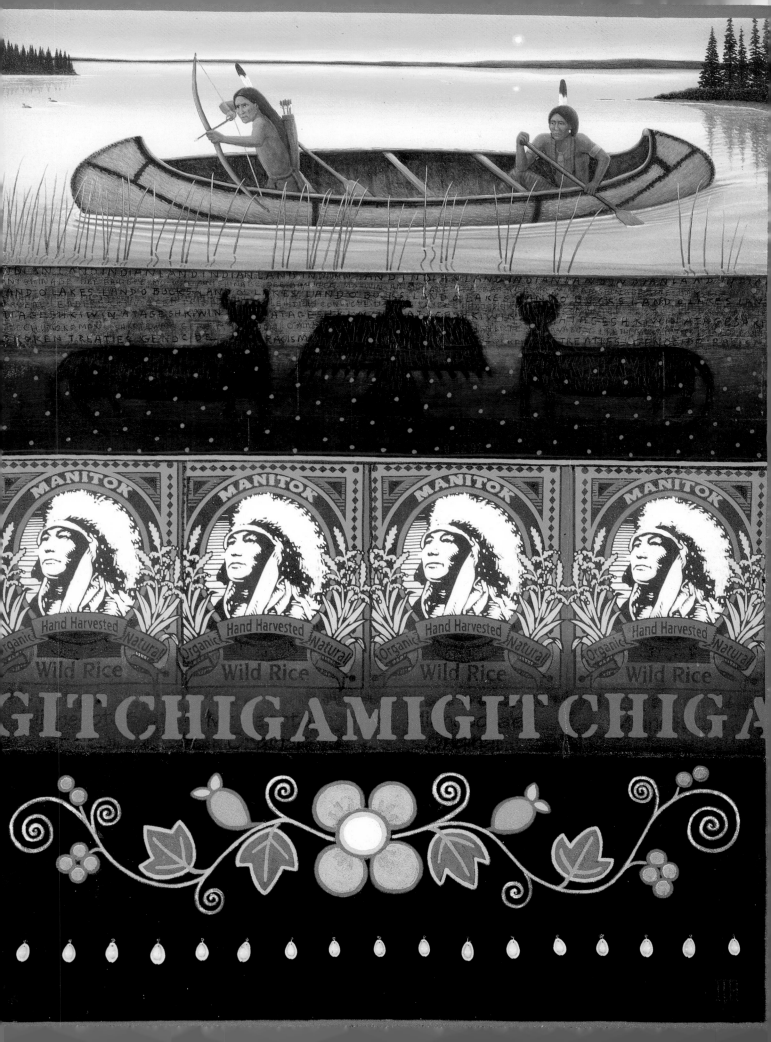

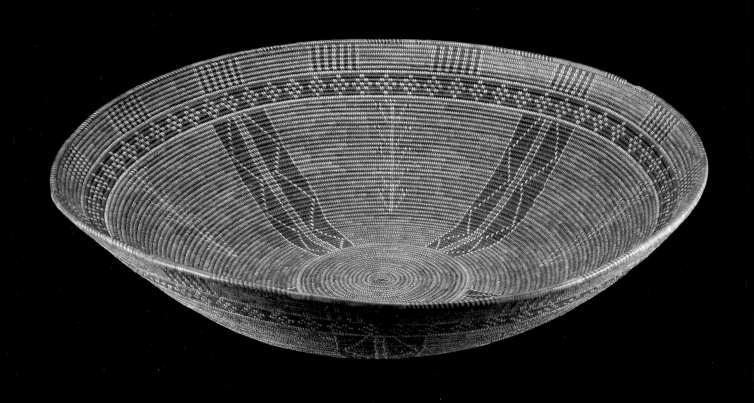

222 **Basket**
Chumash Artist

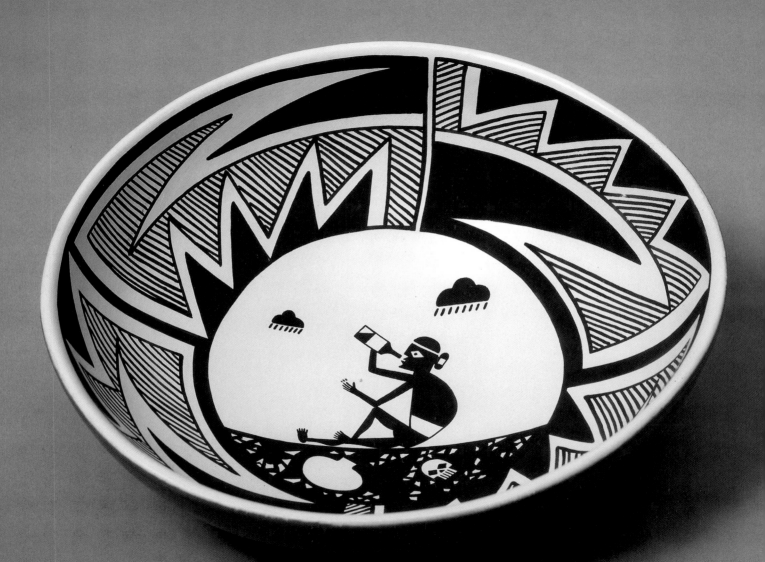

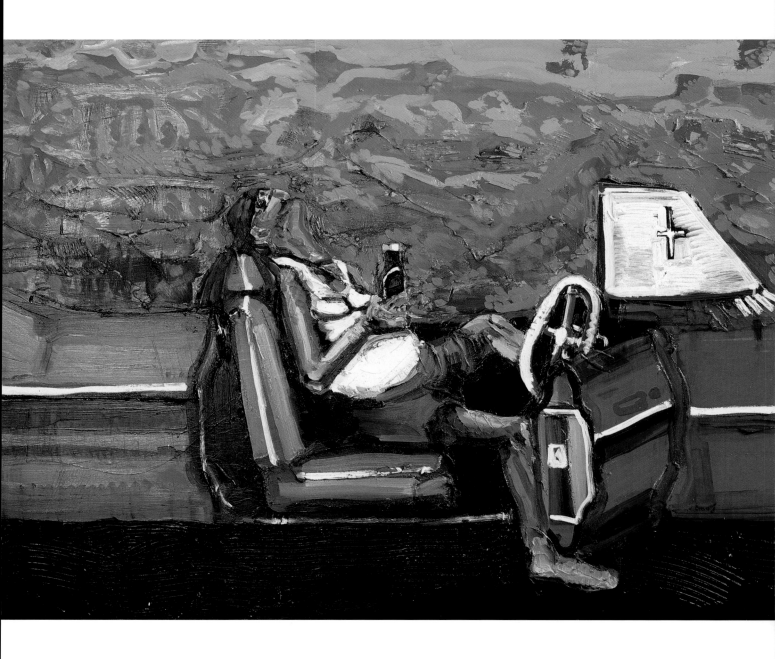

Broken Circle
Mateo Romero

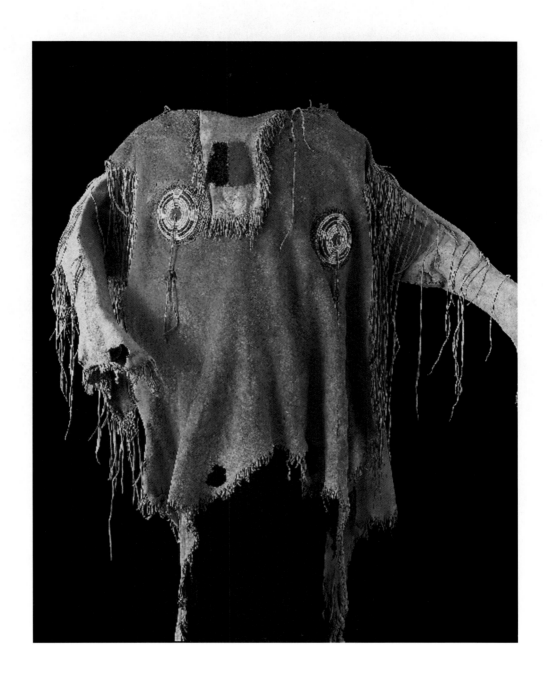

Man's Shirt
Northern Plains Artist

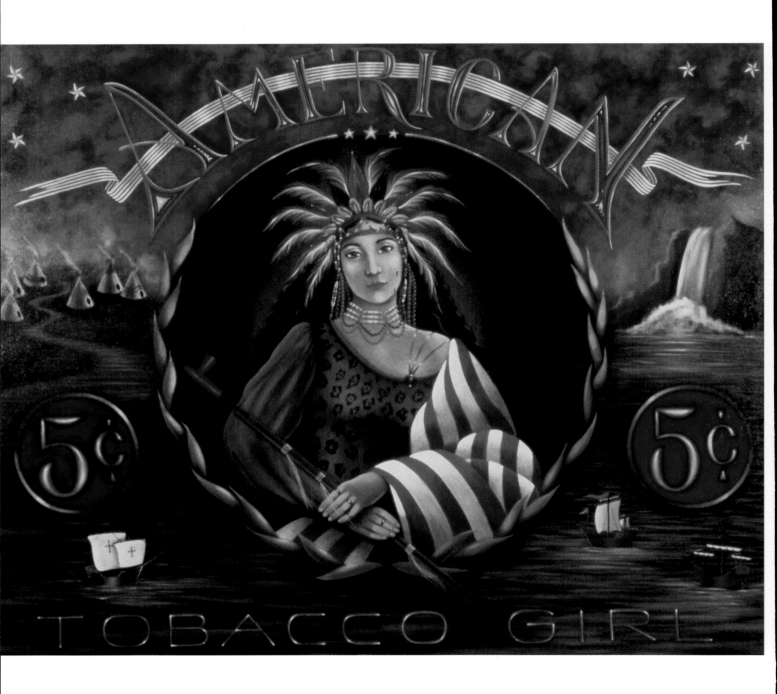

American Tobacco Girl
Judith Lowry

Tonto's Revenge Dance Party
Tom Huff
Seneca/Cayuga Artist

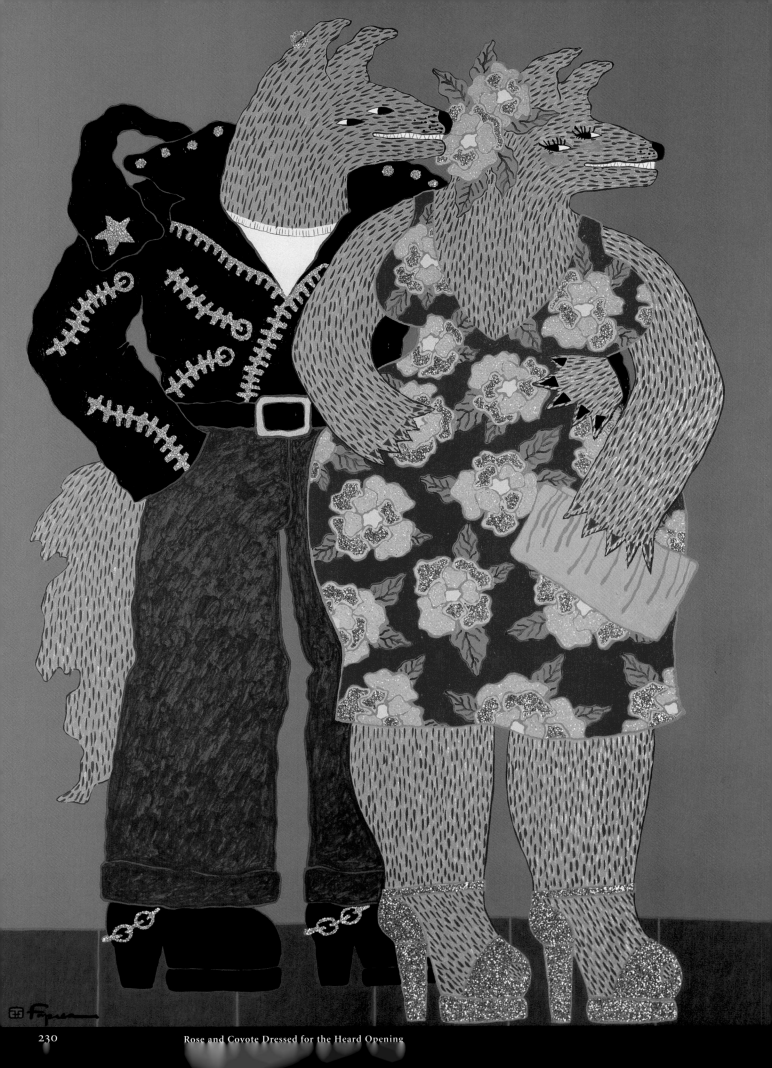

Rose and Coyote Dressed for the Heard Opening

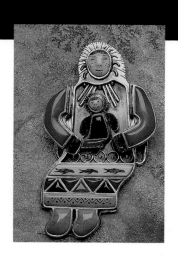

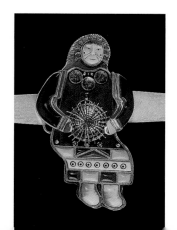

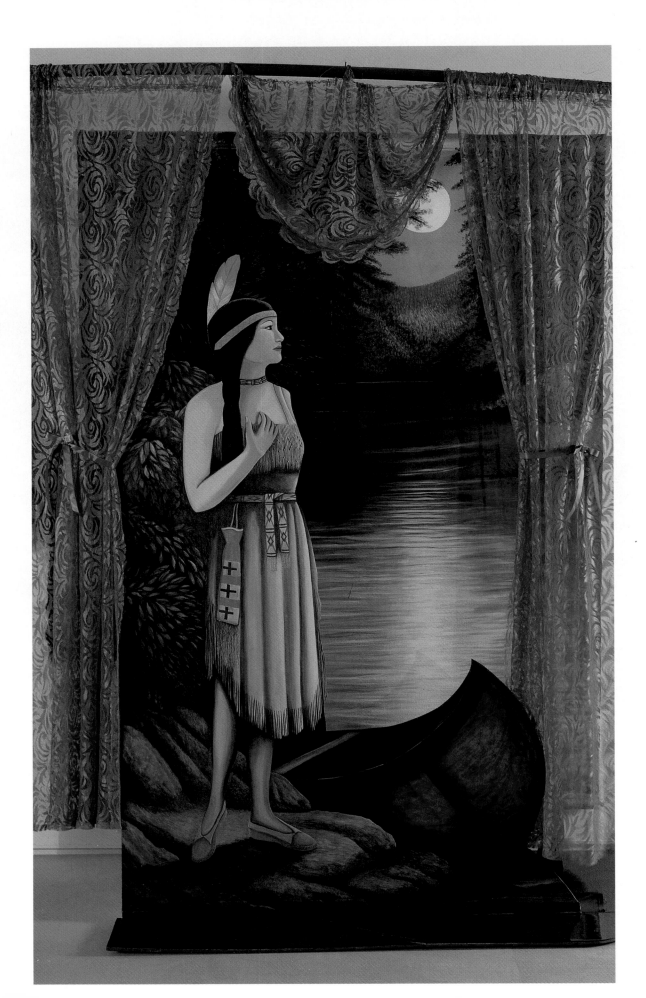

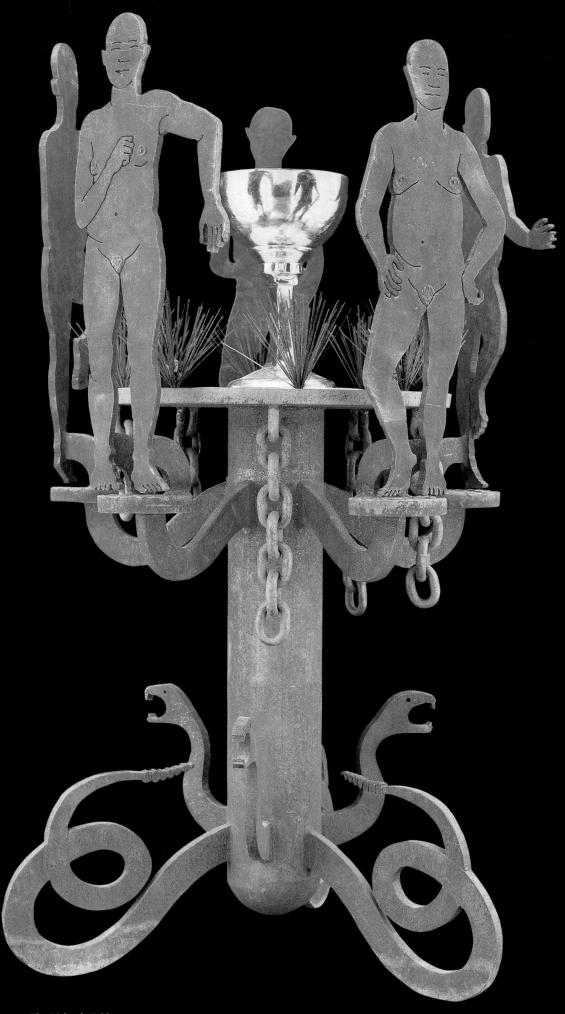

The Bishop's Table
Bob Haozous
Chiricahua Apache Artist

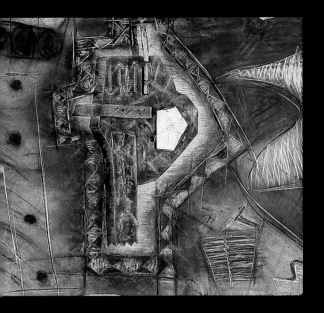

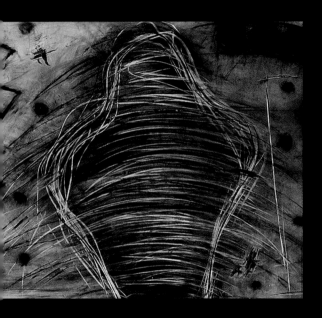

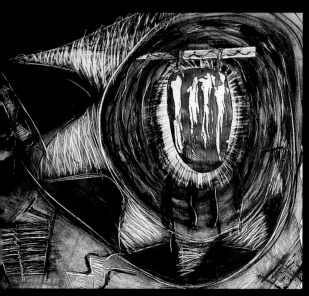

The Healing
Bently Spang
Tsistsistas (Cheyenne) Artist

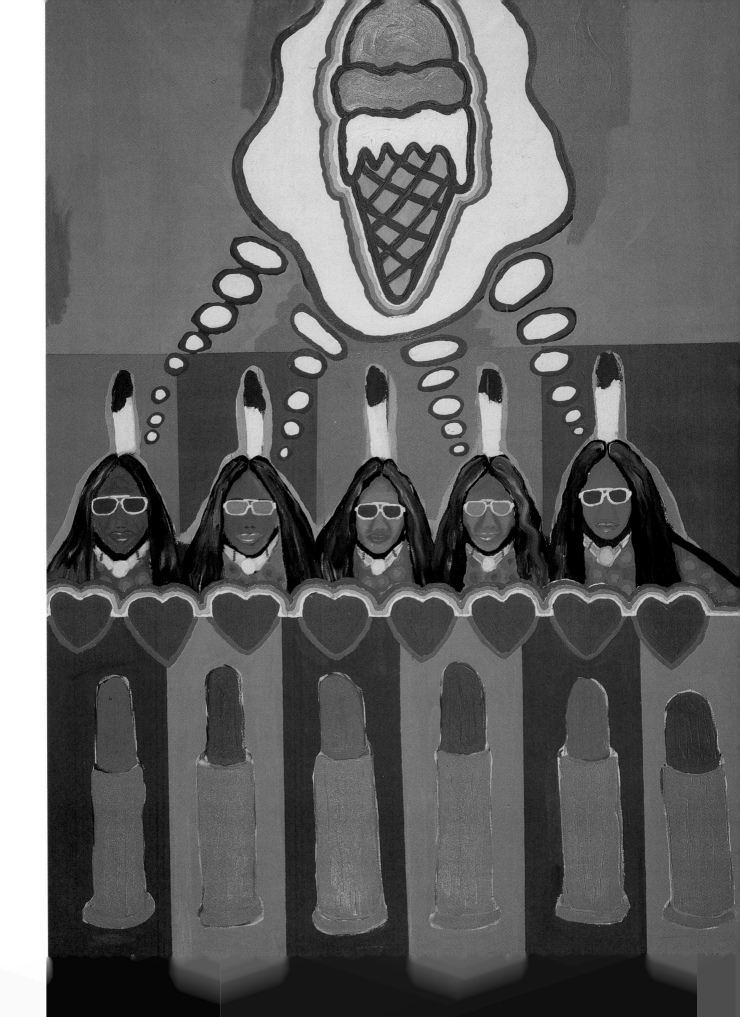

Photographic Permissions Arranged Alphabetically
by the Artist of the Work

The Great Native Dream
Photograph by Walter Digbee.
Courtesy of the Institute of American
Indian Arts, A-124.

Delmar Boni

Indian Affected by Anti-Indian Backlash
Photograph by Larry McNeil and Larry Phillips.
Courtesy of the Institute of American Indian Arts.

David P. Bradley

Wally Koshare Meets Rambo
Photograph by Larry McNeil and Larry Phillips.
Courtesy of the Institute of American Indian
Arts, PW-14.

Barry Coffin

Rose and Coyote Dressed for the Heard Opening
Photograph by Craig Smith.
Courtesy of the Heard Museum.

Harry Fonseca

**Just Because You Put Feathers in Your Hair
Don't Make You an Indian**
Photograph by Walter Bigbee. Courtesy of the Institute
of American Indian Arts, J-72 (a-d).

Laura Fragua

Ceramic Plate
Photograph by John Koza.

John Gonzales

Tony Jojola

Night Keeper
Photograph by Walter Digbee.
Courtesy of the Institute of American
Indian Arts, IS-5.

Judith Lowry

American Tobacco Girl
Photograph by Judith Lowry.

Peace, Order, and Good Government
Photograph by Geri Nolan Hilfiker.
Courtesy of the Art Gallery of Nova Scotia.

Teresa MacPhee Marshall

Spirit of the Future
Photograph by Marvin Oliver.

Marvin Oliver

Painted Deer Hide
Photograph by Don Alderman.

Martin Red Bear

The Drinker
Photograph by Lloyd Rule.
Courtesy of the Denver Art Museum.

Diego Romero

Chess Set
Photograph by John Koza.

Don Tenoso

Taking Care of What Is Mine
Courtesy of the collection of the Oakland Museum
of California, gift of the Collectors Gallery Fund.

Brian Tripp

Micaceous Jar
Courtesy of the School of American Research,
SAR 1994-7-1.

Lonnie Vigil

Craftsperson Belt
Photographs by Walter Bigbee and Mark Nohl. Courtesy of the
Institute of American Indian Arts.

Denise Wallace

Peyote Rattle
Photograph by Larry McNeil and Larry Phillips.
Courtesy of the Institute of American Indian
Arts, CHY-42.

Lutz Whitebird

Do Indian Artists Go to Santa Fe when They Die?
Photograph by Walter Bigbee. Courtesy of the Institute of
American Indian Arts, YC-13.

Richard Ray Whitman

Photographs appearing by special permission in
Richard Hill's essay:

**Detail of the Roger Townshend Monument in
Westminster Abbey**
Courtesy of the Dean and Chapter of
Westminster Abbey.

Daughter of Ely S. Parker
Courtesy of the National Museum of
the American Indian.

Tuscarora Men
Courtesy of the Smithsonian Institution.

Unless otherwise noted, the quotations that appear in this catalogue are personal statements by the artists. Citations for quotations from printed or recorded sources refer to the accompanying list.

ARTHUR AMIOTTE
Spirit of the Earth, page 14.

DELMAR BONI
American Indian Art in the 1980's, page 63.

BARRY COFFIN
Creativity Is Our Tradition, page 54.

HARRY FONSECA
Spirit of the Earth, page 14.

HARRY FONSECA
Shared Visions, page 95.

LAURA FRAGUA
Creativity Is Our Tradition, page 103.

RICHARD GLAZER-DANAY
Eight Native American Artists, page 30.

BOB HAOZOUS
Independent News Weekly, 22-28 June 1994.

HACHIVI EDGAR HEAP OF BIRDS
Land Spirit Power, page 149.

CONRAD HOUSE
Eight Native American Artists, page 34.

TOM HUFF
American Indian Art in the 1980's, page 7.

TONY JOJOLA
Fifth Biennial Native American Fine Arts Invitational, page 14.

JEAN LAMARR
Creativity Is Our Tradition, page 162.

DAN V. LOMAHAFTEWA
Indian Artist, page 104.

TERESA MACPHEE MARSHALL
Land Spirit Power, page 199.

GEORGE MORRISON
Shared Visions, page 98.

SUSAN STEWART
The Crow-Mapuche Connection, page 42.

RICHARD RAY WHITMAN
Eight Native American Artists, page 42.

Printed or Recorded Sources of Quotations

MARGARET ARCHULETA
Fifth Biennial Native American Fine Arts Invitational. Phoenix, Ariz.: Heard Museum, 1991.

MARGARET ARCHULETA AND RENNARD STRICKLAND
Shared Visions: Native American Painters and Sculptors in the Twentieth Century. New York: The New Press, 1991.

RICK HILL, NANCY MARIE MITCHELL, AND LLOYD NEW
Creativity Is Our Tradition: Three Decades of Contemporary Indian Art at the Institute of American Indian Arts. Santa Fe, N.Mex.: Institute of American Indian and Alaska Native Culture and Arts Development, 1992.

RICHARD HILL
Spirit of the Earth. Niagara Falls, N.Y.: Buscaglia-Castellani Art Gallery of Niagara University, 1980.

ROBERT HOULE, DIANA NEMIROFF, AND CHARLOTTE TOWNSEND-GAULT
Land Spirit Power: First Nations at the National Gallery of Canada. Ottawa, Ont.: National Gallery of Canada, 1992.

Indian Artist: The Magazine of Contemporary Native American Art. Volume 2 (Fall 1995).

EMILY KASS
Eight Native American Artists. Fort Wayne, Ind.: Fort Wayne Museum of Art, 1987.

LLOYD KIVA NEW
American Indian Art in the 1980's. Niagara Falls, New York: Native American Center for the Living Arts.

SUSAN STEWART AND ARVO IHO
The Crow-Mapuche Connection: A Film by Susan Stewart and Arvo Iho. Bozeman, Mont.: Native Voices Public Television Workshop, 1991.

239